ART MONSTER

ART MONSTER

ART MONSTER

ON THE IMPOSSIBILITY OF NEW YORK

MARIN KOSUT

Columbia University Press *New York*

Columbia University Press
Publishers Since 1893
New York Chichester, West Sussex
cup.columbia.edu

Copyright © 2024 Columbia University Press
All rights reserved

Library of Congress Cataloging-in-Publication Data
Names: Kosut, Marin, author.
Title: Art monster : on the impossibility of New York / Marin Kosut.
Description: New York : Columbia University Press, [2024] |
Includes index.
Identifiers: LCCN 2023053604 | ISBN 9780231186742 (hardback) |
ISBN 9780231216135 (trade paperback) | ISBN 9780231546812 (ebook)
Subjects: LCSH: Artists—Psychology. | Kosut, Marin—
Friends and associates. | Art—Economic aspects—
New York (State)—New York.
Classification: LCC N71 .K67 2024 | DDC 700.92/27471—
dc23/eng/20240228
LC record available at https://lccn.loc.gov/2023053604

Printed in the United States of America

Cover design: Julia Kushnirsky

For Andre

Sometimes when I'm walking through the streets I want my fingernails to grow long and hard so I can make scratches in the concrete or make grooves in the sidewalk or scratch windows or by concentrating real hard make all the windows shatter and rain down on the street or make cigarette smoke go back into cigarettes like a film running backwards.

—David Wojnarowicz

CONTENTS

Author Statement xi

PART 1

1 Other Art Worlds 3
2 Somewhere Else 12
3 Over 16
4 Will You Listen to the Problems of a Stranger? 22
5 Habiter 37
6 Art in America 47
7 Artists I Knew 51
8 Artistness 53

PART 2

9 Cupcake City 69
10 Poison 83
11 Neighborhood 96

12 Good Housekeeping 109
13 Handling 122
14 Melancholia 141

PART 3

15 Yes 151
16 Hierarchies of Distance 156
17 Fishing 165
18 Group Club Association 172
19 Pay Fauxn 182
20 Pay Fauxn Manifesto 203
21 Miracle 204
22 Oblique Attempts (Toward a Conclusion) 207
Postscript 208

Methodological Appendix 211
Characters 211
On Methods and Entanglements 214
CREAP Manifesto 221
Acknowledgments 223
Notes 225

AUTHOR STATEMENT

I'm trying not to think of the mice as a sign, but I can't—when I'm afraid, I get all biblical.[1] How could twenty-three mice in five weeks not mean pestilence, their squeaks within the walls aimed at me like arrows? How could their lashing bodies, tails, and legs pinned in cheap traps not be a metaphor? I know it's an old brownstone, connected to an abandoned rectory, and men are ripping out the insides of the rectory, and the animals must flee. I know about putting things out of their misery and it's never painless.

I'm trying to write a story about the promise of New York. The longer I write, the more it changes, the more I'm afraid. I'll get it all wrong, I won't shake the old habits, and they've heard the story before: they know about artists and gentrification, they know about seventies New York with the fires and the squatting, and they know about MFAs and debt, they know artists are poor. I'm not out of ideas, but I think about what a writer, a workshop instructor, once said to me: "Who gives you the authority to write like this? What is fact and what is your opinion?"

I'm trying to remember what it felt like when I went to a museum and I began to cry in front of a painting, but I stopped the tears, embarrassed. I saw a bumper sticker that said *Art Saves*

Lives and one that said *Jesus Saves*. I never wanted to buy into anything, but I still want to be consumed, and I want salvation. I don't believe in the myth of the artist as genius, but when I encounter the divine in art, I become porous, hoping it will change me for good. I wanted to write to an artist and tell them their work made me feel born again, but I didn't want to sound like some kind of disciple, your average follower.

I'm trying to describe how it feels to want to be an artist, but I just keep coming back to this memory of when I was young, around six years old. Someone asked me, "What do you want to be when you grow up?" Children answer this question and say things like astronaut and princess, but I had no answer. My father, a mechanic, said to get a good job in a glass office building. The adults I knew worked down at the plant in factories that manufactured radiators and chemicals, or owned the bars where the workers drank at the end of a shift, in the daytime and in the nighttime. I lost my way in this world, but I could remember seeing a photograph of Picasso in that black-and-white striped shirt in a *National Geographic* hemmed in yellow. Part of me wanted to go where he was—Europe? New York? I didn't know where I would go, but once I left, I could never go back. I never saw artists making art, but I had a sense of where art came from. I always got lost in the act of trying to catch a glimpse of something else—the possibility of becoming someone else.

I'm trying to write about artists without giving away their identities, so I use pseudonyms. I could never get it right, because they live their lives their way, and I narrate it my way. I could describe myself as an ambivalent ethnographer, like Chris Kraus described herself as an ambivalent journalist because she had to bond with people and then betray them by writing about them.[2] They ask, "Will you write an auto-ethnography?" and I say, I'll write a hybrid thing I can't name and I'm fine with that. This

thing is beyond verbatim dialogue and beyond thick description because I leaked in—the female/feminist "I" that causes disruption. This doesn't mean I'm attempting recklessness. I'm another character in this story.

I'm trying to enforce a new rule: I refuse to congratulate the congratulated, the fellows, the geniuses, the living artists who are the ones to watch, the dead ones who are priceless. They always appear in headlines and in criticism, and I want to weigh the possibility that other artists matter. And what if they can't make it, what will become of them and of New York. I wonder if I will have to leave and what will become of me.

PART 1

1

OTHER ART WORLDS

"**A**t least my son is a painter, how the hell can you make money off selling a poem?" I found this scribbled in a black-and-white composition book.[1] I remember meeting the mom at an opening at a Bushwick apartment gallery, and I could imagine people in my family saying the same thing with a cigarette gripped between thumb and fingers, punctuating a fact. Crass and working-class, it's a pragmatic take on the position of artists in America. The pathetic poets and painters. To choose a life in (and of) art is absurd; always has been. But today, in hypergentrified, postpandemic New York City, it feels impossible. Countless books proffer advice on how to endure the realities of living an artist's life.[2] This isn't one of them.

The chance of becoming an artist recognizable beyond the art world is statistically improbable, like trying to live off lotto scratch-offs. Without generational wealth or occasional familial support, maintaining an art practice over a lifetime forces a reevaluation of one's relationship to labor—working at work (the job) and working on art (the work). Work will devour you. To seek an art career for deep fulfillment and self-actualization opens precarity's door wider; existential anxiety and ontological

insecurity will rush in. An unflagging tenacity and tolerance for sustained rejection is vital—you'll have to work on your ego, too. Work. Work. Work. It's not surprising that the popular creative recovery self-help book *The Artist's Way* reads like the Alcoholics Anonymous *Big Book*.[3]

They still come. Hundreds of thousands of people earn degrees, trek to New York City, and try to become professional artists. This book is about some of them.

I listened to octogenarian David Hockney talking about art on the radio. "Very young people pick up a crayon and start to draw, don't they? Very, very young people," he said. "I think the idea of making pictures is deep within us."[4] I think it may be within me, but the scribbles I made as a child didn't open any art-world doors. I could never connect my kitchen-table craft projects, the macaroni I glued to boxes and spray painted black and gold, to the two words my family hammered: *good job*. I've heard other people use this phrase, but to me it's an oxymoron, in the same lineage as *wise fool* and *civil war*.

Recently, Americans abandoned their jobs en masse searching for satisfaction, safety, flexibility, and a wage that could ease the indignity of chronic instability. Workers began to imagine other ways to exist. So many American workers quit, it was called a movement and given a name: the Great Resignation. Maybe the idea of revolt is deep within us too.

I don't know why members of prehistoric societies drew figures in caves, but these marks in caves are called paintings and called art. I know they're symbols, stories about a hunt, or some Jungian key to the primordial riddle of the universe. The argument that making pictures is deep within us is pulled so far, like religion, like a cure, and some look at the doodles of kids diagnosed with ADHD and the plein air paintings of pensioners, and use the word art to describe these marks when

nothing's at stake. Drawing pictures may be a human impulse, but having an art career, making it your job, is something else. Art-world victors, like Hockney, simplistically reinforce a creation myth—making art is natural, you just tap into it and let it flow; anything's possible if you submit to the immense potential within you.

Joseph Campbell wrote that dreams are private myths, but I rarely remember my dreams, and when I do, I don't describe them to others. I'm more interested in Campbell's take on the sociological function of myth—how myth braces and validates the social order.

I hum to myself, scratch on a guitar occasionally, and make up songs while I linger in bed (*crying on your throne, dying to be known, buddy baby*), but I'm not a musician. I would never call myself a musician. Likewise, anyone who makes a thing now and again—a drawing, a video on their phone, an NFT—isn't an artist. I'm amazed at how many people call themselves artists with ease.

The artists that appear in the following pages aren't Sunday painters or those belonging to the amorphous faction of creatives, which may include designers (web, graphic, video game) and stylists (hair, fashion, food) as well as all the production industry professionals and their assistants. As I walked down Stuyvesant Avenue, I eavesdropped on two women in front of me. One said, "We need to find some creatives for the project." The other replied, "Totally, I think my friend Mackenzie knows some creatives." I remember thinking, who are these creatives, what exactly do they create (perhaps content), and where did this now-ubiquitous word originate?

George Orwell described consumer culture as the air we breathe. Just as we are born to consume, we are now born to

produce, create. Enter the era of *prosumption*, one in which everybody makes. The creative, as personality and social role, reminds me of the influencer, a monetized identity born of the tech zeitgeist a decade after social media saturation. I've heard the words *creatives* and *artists* used synonymously, but they are not the same to me.

I'm writing about people that don't make art to fill time, or when they have free time, or to feel free or alive (tap into that universal creativity), or because they're trying to change laws or end inequalities (art will not directly save the world, nor should it be taxed with this responsibility), or because it's therapeutic, although they feel miserable when they aren't making it. I'm writing about people who embody art, breathe it like air and drink it like water, like a reflex. I'm writing about people who are animated and destroyed by art.

I'm attracted to sociological deviance: behaviors and ideas that are nonnormative, irrational, or dangerous to the social order. I'm attracted to outsiders and outcasts. The betrayers of the status quo, the stigmatized, the picked-on. I'm attracted to people who don't think about 401(k)s, have spent summers doing acid and working in restaurants, and would rather spend an afternoon alone in their studio—in their own head—than go to a birthday party on a beach and play volleyball.

Instead of a top-down approach to the art world, I start from the bottom and mostly stay there. I'd rather give voice to artists who are inaudible. I'm trying to write a divergent art history, an artist's story and a New York story, a cultural critique and a confessional, but I've been told I can't do everything. I'm adverse to the idea of the elevator pitch, so how do I pitch this? A painter I interviewed for this book put it this way: "There's a million artist books and they interview that 1 percent of top roster artists represented in every major collection, but there's another New York

art world that nobody writes about. It's hidden in plain sight." Invisible art ecosystems—other art worlds—produce and sustain what we see on the surface, much like the ocean's invisible forest generates half the oxygen on earth.

I avoid the adjectives *struggling* and *starving* to describe artists. The former implies an innate floundering, a deficiency, and the latter conjures the twentieth-century starving artist weekend sale at a local hotel chain, where Bob Ross versions of Parisian street scenes sold for as low as $49.95. By resisting clichés, it's easier to reject the idea that artists are different in character, or somehow flawed, because they aren't prospering under late capitalism. There is a genre of arts management, self-help books with titles like *How to Become a Successful Artist* and *Art, Money and Success* advancing the idea that artistic success is achievable through a business model. Like all Americans, artists are encouraged to conduct a sweeping self-inventory and then flowchart and self-brand their way to fame. I've reflected on what it means to influence culture—in the way of Susan Sontag, Eileen Myles, Linda Nochlin—but I wonder if the sway of influencers is immeasurably greater. At the close of the twentieth century, my grandmother once said, "I don't know what's become of this world." I now know what she meant.

Artists I've interviewed have sold work to collectors, either through galleries or out of their studios. But as of this writing, none of them are full-time artists; they work day jobs to support their practice and make rent because they haven't been formally granted artist status via the market economy or selected to join a gallery roster. They often work within New York art worlds, not as artists, but as handlers of art or makers of art that bears the signature of someone else. Outsiders within, they're suspended within a state of liminality, a term coined by anthropologist Victor Turner in the late 1960s.[5] Turner imagined liminality in the context of rituals to describe people who were in the middle

of becoming something else: "Neither here nor there; they are betwixt and between the positions assigned and arrayed by law, custom, convention, and ceremony."[6] Even though they may be accepted as artists by peers, they have a different identity in the galleries and institutions in which they work. They participate in the construction of art worlds, but simultaneously remain at a distance from the center. They rub against power, people with authority and influence, objects with insane price tags, but at the end of a ten-hour day, they have very little, or maybe it just feels that way. Buddhists believe that comparison is suffering; in New York City comparison is inevitable because what you covet is in front of you.

Most credentialed, committed artists will never realize their ambition—a full-time art career. The few who earn enough to live off their art won't become famous. Only a fraction, less than 1 percent, will make it into the annals of art history and be remembered. The artists I interviewed grapple with publicly self-identifying as artists because they haven't achieved success in the art system. They're dedicated and active in art scenes, go to gallery openings, curate shows, and make their own galleries. They don't *live like an artist*, a corporate fiction used to sell loft-style apartments. They make art and create their own institutions to show it. New York City wouldn't be one of the most influential art cities, or the center of the Western art world, without the presence and the endless, invisible labor of these artists. I read that Yoko Ono said that people don't remember each tree in a park, but all of us benefit from the trees. Artists are the trees, the forest is the New York art world, and it is on fire. On certain days, I can't see Manhattan through a fog of smoke.[7]

When I begin research for this book, I planned to finish with a traditional ethnographic monograph anchored by a big idea about artists and urbanity. Instead, I've made a mess, I got

historical and then I got personal (hysterical?). I'm fond of what Dodie Bellamy says about desire in the essay *Barf Manifesto*: "Passion is underrated. I think we should all produce work with the urgency of outsider artists, panting and jerking off to our kinky private obsessions. Sophistication is conformist, deadening. Let's get rid of it."[8] The untidiness, the fervidness that spills out.[9] I'll go with that.

New York now, lead me back to New York then. There isn't one New York, it's too mediated and historicized and romanticized—a city haunted by images and stories of itself. In New York stories, one theme is retold like a chorus: people don't work here, they hustle. Hustling plays into the urban dream for everyone, but for artists, hustling is celebrated as a mark of a visionary experience, a rite of passage. In Patti Smith's memoir *Just Kids*, the hustle is the poetry. Ten years after it was originally published, New Yorkers chose to read it collectively for One Book, One New York, a city-sponsored book club. They couldn't get enough of the New York in which Smith renders hunger—ambition and an absence of food—as matter of fact, a way of life. I heard that Madonna was so broke and hungry during the early eighties that she lived off popcorn. All you needed was pluck and popcorn to make it in New York. Smith needed lettuce. She describes meeting Saint, her guide and fellow vagabond, near Houston Street. He showed her that it was possible to live on the streets:

> We walked to the park, sat on a bench, and divided his take: loaves of day-old bread and a head of lettuce. He had me remove the top layers of the lettuce as he broke the bread in half. Some of the lettuce was still crisp inside.
>
> "There's water in the lettuce leaves," he said. "The bread will satisfy your hunger."

> We piled the best leaves on the bread and happily ate.
> "A real prison breakfast," I said.
> "Yeah, but we are free."
> And that summed it up. He slept for a while in the grass and I just sat quietly with no fear.[10]

They were just kids. They were poor, but free. It's hard for me to imagine being a young woman, starving and living outside on the streets of New York, and feeling liberation. Imagine networking with male artists, writers, and performers back then. I try and fathom the unchained sexism and objectification fifty years before #MeToo. The misogyny, the barricades to participation in public life, the occupational sex segregation (nurse, stewardess, secretary . . .), the compulsory roles of wifehood and motherhood. In her memoir, Kim Gordon is reminded of her subordinate place as the *Girl in a Band*. Eileen Myles said, "Any woman who went through that era had a lot of problems"; referring to Smith, Myles said, "She didn't have any problems. Gimme a break, this is a complete puff piece."[11]

Picture this Instagram post. An unwashed and unhoused nineteen-year-old woman and a man she just met in Washington Square Park, also filthy and on the streets, pose on a bench dotted with pigeon shit, encircled by detritus from the garbage strike. In the background permanently unhoused people slump on shards of fetid cardboard. As they eat lunch scavenged from a nearby dumpster, they knowingly smile because they found the secret. The post reads, NO FEAR. #freedom #artists #NYC.

Just Kids goes down easy. It's not a manifesto, it's more of a love letter to the city, Smith's ambition, and her dearest friends, who happened to be great artists and remarkably photogenic (see Robert Mapplethorpe, Sam Shepard). I read it while I was in Tokyo, a few months after the 2011 earthquake, tsunami, and

nuclear reactor meltdown. Locals kept reassuring me that I was safe, everything was fine. They thanked me for being a tourist. *Just Kids* romanticism was comforting in the context of post-catastrophe Tokyo. When you're destabilized and culturally out of place, *yesterbation*—the bad habit of being overly nostalgic, and not necessarily for something that was ever experienced the first time around—is especially cathartic.[12] Everyone yesterbates privately. It's satisfying to make sense of lost time and opportunity, the impossibleness of the present, through the lens of a mythic past. This is the Patti Smith effect.

I keep coming back to what an artist told me: "I don't think you'd choose to live here unless you want more. People come here with ambitions. Like the *Midnight Cowboy* story, the classic narrative, they come here because their heroes are here. And you can go to a bar or a gallery and see someone you worship. There it is. That just doesn't happen anywhere else." I've had that feeling before and its supernatural.[13] It's like possession, being overtaken by an eerie power, and then longing to be someone else.

2

SOMEWHERE ELSE

Alex did it. He returned the rented regalia as directed, the black polyester robe, the square hat with the tassel. He lit a cigarette, inhaled with swagger. Getting a degree from the Maryland Institute College of Art (MICA) was a big deal. Rachel and David Hoffman just bought one of his thesis show paintings. They were serious collectors, on the museum board, lived in a downtown penthouse. Four thousand dollars cash, twenty-two years old. Alex was already in the Hoffman collection.

He had to clear out his studio by the end of the week, so he figured he'd visit Raul, one of his professors, before he left campus. Raul was a real painter's painter. A character, an institution, he was like sixty-five but still cool. Alex bounced into Raul's office and sat down across from him—artist to artist.

He asked straight out: "Do you have any advice? What should I do next?"

Raul shrugged: "I don't know, be a cab driver, talk to people."

* * *

After art school ended, you slogged around Baltimore. When you weren't sleeping in late or napping, you loitered. Solipsistic

and raw, you were vulnerable to criticism and terrified of rejection. No one recognized your artistic potential, your skill. You were heartened your coworkers at the tapas restaurant seemed to like you, for real. They also mocked you, dismissing your art-world aspirations. When you constructed strawberry and radish garnishes, the dishwashers, Tyrone and Manny, commented on your *fancy sculptures*.

It became unbearable to face reality, to look at your own face, the face of a sous-chef with student loans renting a grim apartment. But you knew you were a legit artist. Your time would come, and these idiots didn't have any idea. You lit a cigarette, sighed smoke, and fantasized future scenarios of the tapas people bragging about how they once knew you, like someone would talk about working with Warhol or Lichtenstein, proud to be a blip in your infamous biography, a footnote in your archives to be generously donated to a prestigious institution, maybe Yale.

A few months went by, then a year or two. You marked time by a series of unstable roommates, restaurant dramas, and blackouts, which you rationalized as part of your process. You stopped painting because there was no time; you felt pounded by a twelve-hour shift. You'd get off work and get faded with the kitchen staff. In the mania of a coke jag, you'd have a brilliant idea for a new painting and feel inspired. The next day not so much. The stretcher bars you primed remained untouched, and before you knew it, you were the kitchen staff.

You found out that Eddie, your pretentious studio mate at MICA got picked up by a Lower East Side gallery. Eddie, that hack, got a write-up up in the *New York Times*. A short blurb, a critic's pick, or shows to see this weekend, but still. In your objective opinion, Eddie's work was total bullshit. Dazed by his success, you started thinking about moving to New York. You would meet real artists, go to real galleries, and live in an artist

community, which you imagined would be like art school but way better. To try and fail in New York beats living in Baltimore, also Cleveland, Detroit, and any other city supposedly livable or artist friendly. The New York art world will save you from this loser city and yourself. You got out of there.

You can't believe you're forty. Even thinking it is cliché, but you keep thinking it, while working on an art moving truck and picking up side jobs as a freelance art handler. Your left knee keeps swelling up. The fluid-filled sac moves when you poke it. When you poke it, you recall you have no health insurance. You don't have gallery representation, and you're subletting a windowless studio in Bushwick with two other artists in their late twenties. Younger versions of you. Multiple paychecks almost cover it, credit cards maxed. New year, new lease increase. You can't find a rent-stabilized apartment, you can't pay the realtor finder's fee, Art supplies are extortionate. You'll only use a certain brand of oil paint—Old Holland. Compromise inconceivable. You still believe in the work, reminding yourself that you sold a painting two years ago, and it could happen again, at any time, possibly tomorrow. There's something to be said for integrity, which you recognize as a defining personality trait. You wear your integrity like your favorite ratty t-shirt.

At a gallery opening in some guy's apartment, a so-called art-world professional, an independent curator or art consultant or whatever, said that you should update your Instagram and post more often. You fume at the suggestion. You'll never become a brand. Also, what do they know, they're not an artist. They're artist adjacent.

You experience persistent nightmares, failure dreams. If you can just ride it out for another couple of years, something will happen. What else are you going to do anyway—move back to

Baltimore and become a consultant, someone who works with an awesome team and collects data, analyzes data, whatever. Making art in New York City is a victory. All your heroes lived in poverty and obscurity at some point—that's when they made their greatest work.

This is how the art world works. This is the artist's way.

3

OVER

People really ask: "Is Fran Lebowitz a real person?" I genuflect to her and so does Martin Scorsese, who grins and giggles at Lebowitz through the entire documentary *Pretend It's a City*. Briny and pickled, she knows the real New York and still smokes Marlboros indoors. The glasses, the big blazer, the cowboy boots. Authentic New York characters stick with a uniform.

Like Patti Smith, Lebowitz symbolizes a version of the city that's evaporating. But Lebowitz, who hasn't published in decades, is a relic, a font of criticism. Smith is a living bohemian, descendent of the Chelsea Hotel, and when she sang "People Have the Power" on New Year's Eve at the Bowery Ballroom, the audience believed it. In a moment of Durkhemian collective effervescence, I saw the crowd fuse into one social being. I watched their fists hammering the air, defiant and hopeful. My hands were at my side, but I got it. In that moment, she was a savior and an ethos—outspoken, unbound—the embodiment of tough urbanity.

A protective skin forms if you live through the bankrupt city of the seventies and the AIDS slain eighties and nineties when, as David Wojnarowicz writes, Mayor Koch "stalled, ranted and

raved" and let a generation die.[1] There's a collective shell of resiliency generated by undocumented, low-income, and working New Yorkers who endure crises after crises, from the divestment in public housing through the war on drugs, the Regan era to the MAGA era. It's always *go time*. At seven o'clock, quarantined New Yorkers opened their windows to scream and whack pots in support of exhausted health-care workers; wooooooo, yeaaaah, clank-clank. The collective racket temporarily lifted those who made it, but it didn't fix anything. It was a performance and reinforcement of attitude, a show we put on for ourselves. New Yorkers to Covid—fuck you.

I wasn't there. In 2010, when Patti Smith and Jonathan Lethem met at Cooper Union to talk about *Just Kids*, someone in the audience asked if artists could still carve out a life. Smith said New York was closed to the young and the broke. She suggested alternatives: "I don't know—Detroit, Poughkeepsie, Newark. You have to find a new place because New York City has been taken away from you. It's still a great city, but it has closed itself off from the poor and creative burgeoning society."[2] Her advice—find a new city—was a death notice and a prescription, a dominant framing story about gentrified New York. Artists didn't like being told what to do, even though the message was an earnest acknowledgment of impossible conditions. It's like Smith, or New York City itself, said *no* to your face. There was a collective knee-jerk reaction; resistance. When you pull back on a dog's leash, they pull forward even if it chokes them. They can't help themselves. The city may be impossible, but do not tell artists where to take a piss.

A few years later, David Byrne wrote a passionate editorial about how the economic 1 percent crushed cultural life. He said, "Other cities might be cleaner, more efficient or comfortable, but New York is funky, in the original sense of the

word—New York smells like sex."[3] Urban pheromones, the feral-ness in danger of extinction. He lamented the dull, corporate art in blue-chip Chelsea galleries, the increase in the cost of living, and the erosion of authentic New York. Byrne said he was thinking of leaving.[4] Artists told me that he should move or possibly venture out of his Chelsea apartment more often. They took offense with both Smith's and Byrne's claim that New York is over (or almost over), even though both clearly support artists and see art as essential to urbanity. I think artists were irked because celebrities don't regularly go to places that smell sexy, like galleries in shipping containers or apartment bathrooms. The city has structurally transformed, and Smith and Byrne have changed with it. Some bohemians are cultural heads of state; they own real estate. At the top, they're asked to speak on behalf of those at the bottom. It's been so long since they've been there, another lifetime and a different city. When mega-dealer Larry Gagosian turned seventy, Patti Smith serenaded him at Mr. Chow, his favorite New York restaurant.[5] To the salad days. Champagne glasses clink.

We should back off. Deep down we expect, or hope, that art heroes will do something. We want action; we want an effect. There's an American notion that art is good if it's instrumental. It must do something, positively impact society in an empirically verifiable way, help veterans cope with posttraumatic stress, or jazz up a concrete wall in an industrial business zone. No artist, powerful or precarious, should be tasked with fixing the city, making policy, saving democracy, changing rental laws. Making art is enough.

You can't make New York bohemian again, at least not in its original iteration in nineteenth-century Paris, which was always at odds with bourgeois life. The neoliberal city is designed for affluent, people who stand out just enough to fit in. Penny Arcade

said in her 2019 performance, "New York Values," that "bohemia has nothing to do with poverty or wealth. It is a value system that is not based on materialism. . . . There is a gentrification that happens to buildings and neighborhoods and there is a gentrification that happens to ideas."[6] Can your mind be gentrified?[7] I wonder if this is about generational clash and nostalgia: back in my day, kids these days. In *Sociological Problems of Generations*, the sociologist Karl Mannheim theorizes that when momentous events occur in the lives of a group of people at around the same period of late adolescence, they acquire a generational consciousness and participate in a common destiny. Mannheim claimed that certain generations have a distinct unity of style, and I can see it in Penny Arcade's. Someone told me that when choreographer Twyla Tharp applied for a coveted MacDowell fellowship, her artist statement was only two words—SEND MONEY.

It's objectively tougher to find a place to live (inflation) and to find a way inside the art machine (saturation), but there's more to the story of then and now, open and closed. They're more pop-up art shows and apartment galleries in New York today than in the seventies and eighties. I've never seen David Byrne at an opening at Catbox Contemporary, a gallery inside a carpeted cat tree in a Queens apartment.

New York is over the New York-is-over narrative, but stories about the loss of authenticity and losing access to the city are the ones we tell and the ones that annoyingly resonate. New generations of artists still ache for freer terrain and an atmosphere to fuck up, play around, and re-create themselves. Imagine being born and raised on precarious ground, planted in neoliberalism, wage stagnation, geopolitical markets, gig work, environmental catastrophe, bank bailouts, and then told to grow up. Economic and ecological landscapes are scorched.

We are left alone staggering in the slag, and artists, like all of us, still must eat.

To some degree, all New York stories are about real estate. If you're someone who needs proof that gentrification has sped up cycles of development historically unmatched in scale, here you go (if you get it, if you lived it, or if you don't need numbers, then jump to the next paragraph): A New York University study found that between 2000 and 2014, rents increased 22.1 percent citywide.[8] Arguably a steep increase, but possibly doable with an extra job and a stringent budget. Within fifteen areas classified as gentrifying, rent increases were absurdly higher—Williamsburg, Brooklyn, rents shot up 78.7 percent; Lower East Side/Chinatown increased 50.3 percent; and Bushwick, Brooklyn, rents climbed 44 percent in roughly fifteen years. These neighborhoods have dissimilar ethnic populations and cultural histories, but they share one commonality—in the initial phase of gentrification artists lived there.

Most artists are ordinary. Living in a never-ending state of scarcity, jerking from paycheck to paycheck with no financial cushion to absorb an emergency's shock. A sore throat or parking ticket can corkscrew into an emergency. I think the stories of ordinary people are relevant because most of us are in fact ordinary, ring lights and filters notwithstanding. We work harder and longer to get by, in hospitality, hospitals, or public university systems or for Walmart, the nation's largest employer of 1.5 million workers. By the time you read this sentence, it will likely be Amazon. In New York, the State University of New York (SUNY) system employs more people than any other company. I'm one of roughly ninety thousand workers within it. Chances are you have something in common with working-class artists or those in the collapsed middle class who won't make more money than their parents even with a college degree. They're the artist precariat, the art world's 99 percent.

If you have an inheritance, have never worked an essential job (any regular job), have never contemplated selling your body or selling drugs out of desperation, or have never ridden on a bus, then you may be turned off. I offer a bridge—look at the art decorating your walls, consider the possibility that a dog-tired, broke worker may have painted it every night for six months after they got home from their day job. Consider what it's like to have an untreated physical or mental illness or to live in abject poverty; the unseemly conditions under which your eighteenth- or nineteenth-century masterpiece was likely made. Consider the possibility that your new painting acquisition, snagged at auction, was barely touched by the artist who signed it.

4

WILL YOU LISTEN TO THE PROBLEMS OF A STRANGER?

Ray was born in Paducah, Kentucky, one of the most churched cities in America. He grew up on the other side of the Ohio River in Metropolis, Illinois, the official hometown of Superman (pop. 5,900). A fifteen-foot painted bronze statue of the fictional hero stands, hands on hips, in front of the Metropolis county courthouse, below it reads *Truth—Justice—The American Way.* The town's racial makeup is 90 percent white, and the poverty rate is higher than the national average. Metropolis and the towns nearby make up a micropolitan area, a statistical zone of four counties that are make-America-great-again territory. Metropolis isn't metropolitan, in relation to the New York art world, it's nowhere. This wasn't lost on Ray.

Ray's parents divorced when he was seven, and he stumbled through school, except for art classes. Ray won two painting awards and was voted "most talented in art" his senior year. He wanted to be an artist, but envisioning the steps to make art a *real job* was impossible. He just figured he'd attend the community college where his mom taught and that's what he did.

After graduating from community college, Ray moved into a trailer park. He enrolled in a university BFA program, was living

on his own for the first time and bottomed out. "I was sitting in a trailer, smoking weed, chain smoking cigarettes, drinking cheap Vodka, and watching movies," he remembers. He stopped painting and spent the next few years working as a busboy and dishwasher. Like a sieve, restaurant work catches people who fall through society's cracks. He ended up in Nashville where he mastered the art of making perfectly crispy French fries. This new skill, which he explained in step-by-step detail, was a practical means to an end. (The fries must be cooked twice). He saved enough money to pay for a one-way ticket to Europe. Western art history starts there, and it was as far away from the trailer park he could reach, physically and intellectually. Maybe the canon or cosmopolitanism could realign his life. He might find himself by leaving, find a home in a galaxy of expats, like the fabled lost generation, Stein and Hemingway in Paris. Artists speculate that life could make sense in Berlin or Oslo, anywhere but in America.[1]

After a month of washing in fountains and living on the streets of Paris, cellulitis wormed into Ray's legs and feet. This sent him to the emergency room and back to Nashville. But geographical distance offers perspective; he had an epiphany walking down the Champs-Élysées. Time to return to art school. Ray enrolled at the University of Kentucky, worked at a bakery and finally earned his BFA after six years of stopping and starting. Down and out in a trailer park, then down and out in Paris. He was finally a credentialed artist. Now what.

Like other working-class college grads who earn degrees that don't channel into specific jobs—literature, cinema studies, art history—Ray was lost after art school. Even with a spotty educational history, while working toward his BFA, the studio anchored him, and he received regular critiques from peers and professors. Artists spoke to him like he was one of them. For a

few years, art students can temporarily, but firmly, ground their identity through place. I've never met an art history major who introduced themself as an art historian. Art students leave off the student part.

"What's' your major?"

"I'm a *painter*." They identify as artists.

Students are artists in training, in the process of becoming, but they're treated as if. Harper, a Yale MFA grad, emphasized, "Everybody acts like it's *incredibly important* for you to make that work." Institutions construct an atmosphere of gravity and distinction. On the inside, student work is framed as consequential, it matters. The sociologist Gary Allen Fine compares art school to a medieval monastery, "a castle surrounded by a moat, keeping the barbarians out—and the select within."[2] Lines are drawn. Some students develop technique, if compelled, and at minimum, produce a body of work. They're given attention and structure, and leave with an oeuvre that cements the legitimacy of their artistic identity.

"But it's the opposite when you leave," Harper said.

I asked her what she meant.

"Everybody's just like, what are you doing with your life? Nobody cares about this stuff. Nobody wants it. That part's terrible."

A transformation from someone to no one.

In art school, stakes are high, but you can't imagine or prepare for the silence that follows. There's no interest in your work, no assignments, no colleagues, and unless you can afford it, no space to make art. Violet, a multidisciplinary artist said, "I didn't have a studio. It's this transition from having a big workspace and facilities and having to downsize to pre-grad school. I was trying to figure it out, I wasn't making anything, I was frustrated. I wasn't happy with anything." There's no afterglow. Transitioning from

one of the chosen few, to someone indiscernible, impales the self. Artists described living in a "state of psychosis," and recovering from an "art school concussion."

They know the end is coming, but they're never ready for it. Liam loved being able to paint full time in his grad program, but the question of what happens when it ended became a menacing thought. After graduating, he moved to New York and found a job at a stiff international auction house. He rented a space in a former industrial building in Brooklyn sliced up into small studios divided by flimsy sheetrock. People from his MFA program worked in the same building. I met him there after work and before he went to his friend's solo show in Chinatown to net*work*. As Liam crammed down a salad in a clear plastic container, he spoke about art school and his tenuous place within the art system. It was late summer, Florida humid, and I could see the exhaustion on his sticky face.

"What people tell you about the art world, what your teachers say, the sort of wool they pull over your eyes in art school," he says shaking his head.

"What wool?" I ask.

"The shit that happens where they're tickling your buttons, being like, you're going to love this, it's going to be great, and you're just like, Yeah, yeah. Let's paint. This is going to be fun. I'm going to sell my work." He rolls his eyes and looks out the window.

"But you get to paint all the time," I offer.

"I get to paint all the time, and be really happy. And well, how am I going to do this if no one buys my work? It doesn't matter. I'm painting all the time *right now*. I really love my work. Well, my friends are really cool. Wow, I'm really spending a lot of money. Why am I spending so much money? Oh, well, fuck it. I'm painting all the time. Who cares? I'm painting all the time, for what? Who am I painting for? Am I painting for myself anymore? Do people want to buy my work? Wait, should I want to sell my work?"

"Mm-hmm," I nod as Liam keeps going, therapeutically barfing it all out. And then he takes a breath and sip of water from the bottle in his hand.

"These rabbit holes of doubt, self-doubt and self-loathing . . . ," he trails off staring at his feet.

That's the catch. Art school provides an insulated den of freedom, but it's a temporary hideout. A's in art school aren't a barometer of whether work will make it to a gallery or a collector's penthouse. Art programs teach students how to make art, and increasingly, how to talk about their work, but don't explicitly discuss how to go about showing it or selling it, or explain what it may be worth, if anything, within the market. Anyone would doubt the value of their work outside of an institutionalized shelter. "It hits the light and suddenly looks like crap."

An artist is their work. If it has no intrinsic value, then they must negotiate the ambiguity between worth and worthlessness. Patch the self-esteem. Come up with a plan. You can move to a small city and make peace with becoming a successful regional artist. If you're seriously ambitious, get to New York and figure it out. I heard about the fourteen-month rule from a recent MFA who has been in the city for two years. He was surprised I didn't know it.

"Everyone knows it takes fourteen months just to get your bearings. Find a job, find a studio, find a place to live. Then you can really start working on your career. If you can make it through that fourteen months, then it gets better, presumably."

When I asked if that was his experience, he laughed, "Yeah, I guess." After a moment he said, "I think maybe it's getting easier, maybe, maybe." I never saw him again.

After art school, Ray didn't make any money from his art. He just sat there. Newly lettered, he had no art-world connections,

no network to network. Galleries didn't place want ads on Craigslist for newly minted artists to join their rosters. Dealers and curators weren't a part of Ray's Kentucky social circle. Like other working-class grads, he wasn't discovered by someone who could help him access a career. Billie, a painter, mentioned the fantasy of being discovered by a gallery.

"If you made it out of art school, there's a lot of false perceptions. Like being discovered," he said.

"The discovery narrative. What about that?" I asked.

"Sometimes prominent dealers pluck people directly out of undergrad and grad schools. If you make it out of graduate school—Columbia, or Yale, or anywhere else—and you went all the way through and somebody hasn't picked you, you're not already worth $1 million, and you're sweeping the front stoop of a gallery, there's already a failure there. You're already an automatic failure."

"You could be twenty-five years old and you're a failure?" I asked.

"Yes," he said expressionless.

Paying dues, developing your practice, and networking can be avoided if someone discovers you. Discovery may come after death or forty years of obscurity. Age can be an advantage if you're under thirty or over seventy. Video and conceptual artist Martha Rosler said it's impossible for women to get recognition in middle-age. You enter a zone of invisibility and unmarketability. The gender/age/devaluation equation is part of the culture; a social fact.

There's the shiny *art star* and the stalwart *been around*. In theory (fantasy), a dealer or more recently, a billionaire collector, will point their superhuman finger as in Michelangelo's *The Creation of Adam*—it's you. Mathew Barney got the finger. In 1991, at the age of twenty-four, he had a solo show at Barbara Gladstone gallery in New York and at the San Francisco Museum

of art the same year. Gladstone said of Barney, "I knew he had a destiny after talking to him for fifteen minutes."[3] A former J Crew model and Yale grad Barney made an impression that made his career. It officially soldered in 1999 when the then-chief *New York Times* art critic Michael Kimmelman wrote the article "The Importance of Matthew Barney," christening him the most significant artist of his generation.[4] Barney achieved the art-world trifecta—a place in the art market, a place in museums, and exalting reviews.[5] Billy described it as "a complete and total circle jerk."

More recently, Oscar Murillo was picked up by David Zwirner Gallery when he was twenty-seven without ever having a solo show in New York. Columbian born and London educated, Murillo seemed to come out of nowhere. Instead of climbing the ladder, exhibiting work and being subject to critical review, Murillo was championed by 1 percent collectors, among them Don and Mera Rubell, "two of the most influential and perhaps most beloved contemporary art collectors of our time,"[6] who hoarded enough art to open their own private museum in Miami. He was questionably compared to Jean Michel Basquiat.[7] Despite his instant ascent, Murillo isn't universally lauded by critics, and there are grumblings about his work. It's harder to spot genius these days. The market is deluged with artists, many of whom know the value of a seductive studio selfie. Perhaps this is all irrelevant. Murillo was selected by a global dealer; he's in. Gallerists and collectors govern access to the market/canon, critics and art historians watch and weigh in.

Most artists with careers (who show work, sell work, get written up) have been around—art is an endurance experiment. Do the time, stomach the dents, pluck the grays. Wade Guyton, known for his inkjet paintings, worked as a security guard at Dia Beacon and was twice rejected by the prestigious Whitney

Independent Studio Program before his career took off in his late thirties. For painter Joyce Pensato, who worked at an art-supply store, discovery came much later. She was in her late fifties before her gigantic paintings of cartoon characters caught on. Pensato had been around forever. She grew up in Bushwick and never left the neighborhood, riding it out from *really tough* to really expensive.[8] If you get picked up by a gallery, working at an art-supply store or as a security guard transforms from pathetic to noble. A boring or demoralizing job is retrofitted as evidence of grit. The commitment of a true artist—they'll do anything. Here's the proof.

The boot-straps story sells well as a lingering effect of meritocracy. Someone is always trotted out as an example of how it's possible to be picked out of the anonymous pile. You gotta be in it to win it. It's like the perceived democracy of YouTube, Instagram, TikTok, or whatever social media platform is ubiquitous right now. Have a life? Have an iPhone? If you have faith, you'll be saved from anonymity. Pentecostal Christians believe in the tradition of handling poisonous snakes. If you're anointed by god, a true believer, you won't be bitten when it's your turn to fondle the serpent. To continue making art, believing in art itself is akin to any fundamentalist religious belief that seems ridiculous or dangerous to the uninitiated. An artist must have blind faith, believe they have a destiny. Not easy to do when you spend forty hours a week standing behind a cash register.

When you're out of luck, you fall back on what you know you can do. Ray knew how to paint, draw, make videos, pilot a deep fryer and a dish pit. His incongruous high–low skill set didn't offer opportunity in the global economy. He dragged around student loan debt. With a BFA in hand, the only job Ray could land was as a cashier at Schnucks, a mid-Western

grocery store chain. His biography is punctuated by stereotypical starving artist moments, but this job struck me as doomed. It's easy to confuse the letter *n* with *m*—Schnucks or schmucks, no difference. He described his commute and setup: "I would walk to work in my Schnucks uniform, which consisted of a denim shirt with Schnucks embroidered on it and khaki pants (in) the freezing cold wind. . . . I started drinking heavily again. I didn't buy any furniture for my apartment. I had an air mattress and one chair." Schnucks stamped him down. Deeply embarrassed and miserable, Ray was suicidal. "I lost all hope for a future." This was only a few months after the American real estate–banking crises, a historical moment that marred the economic and mental life of a generation that never got bailed out.

Then the script flipped. Ray applied and got accepted into Yale University Graduate School for Painting and Printmaking. Yale is consistently ranked number one for painting, followed by Rhode Island School of Design and the Art Institute of Chicago, and peddled as one of the ten most influential MFA programs in the world.[9] The question of whether an MFA matters is intensely debated. It can be used to sell an artist's work as proof of provenance and future potential.[10] Some argue art schools are unethical, extortionate. MFA critics warn that debt will definine your life and strangle your practice if you're working class. Sounds right.

An Artnet article provides convincing evidence that art school is worth it, if you go to Yale. Over a fifty-year period, Yale's Graduate School of Art pumped out nearly 10 percent of all successful artists in their study.[11] Ray was elated when he came home from work and found the acceptance letter in his mailbox. He said: "I started crying on the floor of my

apartment. I had felt like a fuckup for so long and now I finally felt validated. I always felt like my dad viewed art as something that wouldn't lead to anything. This was something." He wept when he told his father over the phone. Ray signed the letter that same day; he remembers "not walking, but floating, to the post office to mail it."

After Yale, Ray moved to New York City. With a prestigious degree in hand and his soon-to-be wife by his side (whom he met at grad school), the drinking, the trailer park, and Schnuck's receded like a hangover. Most of his friends were moving to New York: "I'm an artist and she's an opera singer, so we thought it was the place for us to be." He never entertained going back to Kentucky or Southern Illinois. Ray's head was in the future: "I had fantasized about living in New York City for a long time and now it was actually possible." Time to be an artist.

Ray couldn't find a dealer, and his work never hung in a gallery. Nobody discovered him. He took a job in a downtown Manhattan art-supply store and commuted two hours a day from his shoddy apartment in Queens. The employees all had art degrees, too. Some of them hung their paintings on the wall above the cash register. Art must find an audience or a chance encounter. Legendary artists, actors, and musicians bought supplies at the store; some knew the employees by name. You don't meet celebrities at Schnucks. As John Waters said at his RISD graduation address, there could be that *one person who says get in and then you're off*. It's possible that a wealthy regular might take pity and buy a worker's painting. This had happened before, albeit a long time ago. Randomly selling one painting a year keeps you sane; you're still in the game. Ray never considered exhibiting his paintings at the art store, a humiliating descent from Yale to retail. He got why others did.

Ray withstood standing around the art store for a few years. Demoralized by the job, exhausted by the devouring tempo of the city, there wasn't enough time to make art, have a meaningful relationship with his wife, and cover rent. Ray was spent. "When I would finally get home from my job, I would feel so drained that it was hard to paint, but I would do it. I'd draw and write every morning on the subway on my way to work and on my way home at night. I would paint on the weekends." Nights and weekends, the drill of the second shift.

Likewise, Violet worked in a fabrication shop, and her rule was to set her alarm for seven hours after she fell asleep: "If I go to bed at 10:00, I will set my alarm for 5:00 A.M. It might be a groggy wake-up, but I'll just have my coffee going. I get at least two hours of studio work in before I leave for my job." Listening to these stories, I wondered how long they could keep this pace before imploding, wrecking relationships, wrecking their liver. If they'll be able to be around long enough to be discovered. At the time, Ray and Violet were in their thirties and without kids. Most people I knew where in a similar position: unmarried, unstrapped by familial obligations. Extra time and money habitually channeled toward making art. Personal relationships shaved to a minimum or put in storage. Pets, needy others demanding food, water, and walking, a surrender. I think even when artists are in your presence, they're absent. The work is where they desire to be, and where they are.

The sociologist Alison Gerber writes in *The Work of Art* that you must balance the stories of artists because they can easily devolve into caricature.[12] Ray is an embodied stereotype. The misunderstood messed-up artist who doesn't fit anywhere, inside or outside of the art world. I haven't told all of Ray's story. Parts

of his biography were truncated, including, but not limited to, a brief addiction to crystal meth, a storage unit fire that burned years of work, his belief in transhumanism, and a hope that science will one day make gender fluidity possible so he can morph into a female body. On the surface, he's just another white male artist with an MFA trying to professionalize in New York City. MFAs are akin to PhDs; prestigious titles on paper. He's unremarkable, blending within an ever-expanding army of competitors. Younger, more commercially attractive, better connected, the pool of artists swells like water rising to the top of a clogged sink. The system out of order.

At the age of thirty-five, Ray and his wife divorced, and he left New York to live with his family. His dad drove from Kentucky with a U-Haul trailer tied to the back of his truck and helped him pack up. He felt like a "fucking failure." After he adjusted to going in reverse, back to where he came from, Ray's relationship to time, place, and money synched. He said: "The biggest gift Yale School of Art gave me was the gift of time. Time to think. Time to work. I wouldn't get this gift again until I left." There is a trade-off moving from urban to elsewhere. He said: "All I do is paint and make videos now. My rent is really cheap. . . . I get fear of missing out when I look at Instagram and see my friends going to shows. . . . Living in Kentucky, all I can do is like the post." Liking might be enough.

A family name ascribed at birth is free material, a label charged with symbolism, like a cross. As an art project, Ray legally changed his name to Xenophanes. He compared filling out the government forms and navigating the endless bureaucratic hoops to a performance. Xenophanes deleted Ray. Snagged the social script. In a Chinatown gallery, I overheard someone ask him incredulously, "Is that your real name?" Without explanation, he answered, "Yes."

He was met with a dead stare and no follow-up. It was awkward. I loved it.

Abandoning New York, his marriage, and the name Ray, Xenophanes wiped his life clean. With more time to make art, he found his way back. Xenophanes began posting on Facebook and found artist-run spaces interested in his work. In 2016, he traveled fourteen hours by train to exhibit a sculpture at Pay Fauxn, a gallery I started in an abandoned pay phone at a bus stop in Bedford-Stuyvesant, Brooklyn. He reached out into the ether and introduced himself. Just like the sticker: Hello my name is _____. The proposal was titled "Will You Listen to the Problems of a Stranger?"

WILL YOU LISTEN TO THE PROBLEMS OF A STRANGER?

He was an evil piece of shit. He went to sleep every night on his Charlotte Thomas bedding and dreamt the most pleasant dreams. Not one thought of his Wall Street job crept in or how he ruined so many lives. He didn't care. Of all his possessions, empathy was not one. When the protests were happening he considered it whining. He could give a fuck about their problems.

So when he woke up staring at the bus stop he let out a scream that would make you sick. If you didn't vomit from the scream, then you would have from the sight of what he had become.

If you were standing at that bus stop, you would have seen flesh in the shape of a payphone. His eye was straining to see out of the coin slot. He still had some of his beautiful hair but not much. He yelled out his problems but no one listened. He tried to whisper but that also terrified people. He pleaded for someone to help him. I saw people put out their cigarettes on him. I witnessed men urinate on him and laugh. Children would throw trash at him and run away and play. He cried but not one tear came.

WILL YOU LISTEN TO THE PROBLEMS OF A STRANGER? • 35

INSTALLATION DESCRIPTION & MATERIALS

- Platinum cure silicone rubber sculpture in the form of a payphone
- Speaker and mp3 player that plays audio of stranger
- Glass eye
- Synthetic hair
- Cigarettes

FIGURE 4.1 September Diencephalon, *Will You Listen to the Problems of a Stranger?* Author's photograph, 2017.

On a bitter March evening during rush hour, the day after a storm unloaded a foot of heavy snow, Xenophanes installed his sculpture: a cast flesh-colored silicone replica of a pay phone he bought off the internet. Horrific like a Cronenberg prop, the deskinned and human-like sculpture's one blue eye peered out from the phone's coin slot. A hidden speaker shouted: "Will you help me? You, right there! Can I please talk to you?" on a continuous loop at people running by or stuck waiting for the bus. Some ignored it, others took a quick glance, and a few stopped to look. I don't think most commuters saw it as art. A group of middle-school kids, mostly boys, cautiously walked up to hear the maniacal voice pleading from within.

"That shit talking?"

"Yeah."

"That shit got an eyeball!"

A couple kids poked at the single blue eye; another flicked the receiver.

"Ya'll touched it. What it feel like?"

"Nasty."

"That shits Bed-Stuy alive."

As they photographed the sculpture with their phones, Xenophanes, his ex-wife, and Andre and I stood back about twenty feet away and watched. We were the only visitors adjacent to the art world in attendance. He said exhibiting at Pay Fauxn changed his life. I believed him.[13]

5

HABITER

Sunday is gallery night and trash night on the Lower East Side. I'm hanging out in front of Bible, the black-cube basement gallery I run with Andre. Like other galleries nearby, it can fit about ten people and a rat we name Pierre. Rancid cardboard boxes that once held vegetables and meat, the trash from the weekend excursionists who hang out at Mr. Fong's "the unassuming watering hole featuring Chinese inspired bar bites and cocktails," generate an arcade of postconsumption. Mounds of garbage bags leak their fluids, mirroring the spillage of the neighborhood. A bent man in a bathrobe and slippers rummages inside a parked minivan that's jammed in back—plaid plastic bags, hangers, shoes, power outlets, stuffed animals, a potato masher—and walks back to his apartment building carrying an orange rope. I've seen him before while gallery sitting. I've watched other people root through their cars like junk drawers. The architecture in this slice of Manhattan can't house all the humans and their stuff, never could. Now the galleries display a few objects in a district where a broom closet is a luxury.

Amid the flotsam we're sorted out: smoking, vaping, scrolling, texting, networking. Noticing and not noticing, each other

FIGURE 5.1 Author at Bible gallery entrance.
Andre Yvon, 2018.

and the trash, everyone with a thinly disguised agenda. The sociologist Georg Simmel called this a blasé attitude—the psychological indifference of overstimulated urbanites. It's that, and hustling.

A man of indeterminate age (forties to sixties?) walks up to me. Thud. I see shorts, a gray t-shirt, and combed hair. He doesn't speak but commands my attention. Thud. I introduce myself first and immediately regret being so polite, smiling too much. The old feminine habits resurface, and I perform *nice* on cue. All my ire, all the feminist theory I've read is throttled by custom.

"I'm Jeffrey," he says, as if his last name is Deitch. I wonder if I should recognize him.

He asks, "Where you from?"

"I live in Brooklyn," I reply.

"You're not from here." *I know the direction we are going.*

"Where were you *born*?"

I've stopped smiling. He got me.

Jeffrey was born on the Upper East Side, and he tells me "this neighborhood is called Two Bridges." I know where I'm geographically situated, but stay silent while he launches into a Lower East Side/Chinatown border history lesson. I'm being schooled, also tested. He interrogates me about an obscure restaurant that has authentic pork buns. *I did not know. More evidence.* He's got beef with me and probably everyone else outside the gallery. I imagine he saw us—artists, writers, curators, day-job people—as a menace to the real culture of the city, marring the present, staining the future. A sign of everything wrong with Uber-gentrified New York. He'd read the stories about how artists tip a neighborhood, or he's seen it with his own eyes. He was documenting right now, like Weegee without a flash. Through a certain lens at the right angle, a gallery opening could look like a crime scene. Or he could be one of those men who go alone to art openings to scrounge free beer—either way, Jeffrey was on the case. I shoved a can of beer toward him and darted.

This isn't the first time I've been singled out by a real New Yorker for my illegitimacy. I usually take this personally, but

I'm aware those born and raised in New York hold a passport granting them an innate right to the city. The sociologist Henri Lefebvre theorized the right to the city as one of the most important forms of modern democratic rights, including "liberty, individualization in socialization, environs (*habitat*) and way of living (*habiter*)."[1] The right to the city isn't only about having freedom to access urban resources, it also enables self-determination, the liberty to make and remake ourselves.

When I moved to New York, I felt emancipated from the estrangement of suburbia and the cliques of smaller cities. I hadn't lived in these places, I vegetated. Elected officials talk of collecting tolls at all the bridges, limiting access to lower Manhattan like a gated community or a theme park. I keep paying to play, paying for freedom, paying for my right to the city.

I don't know how to earn the right to be here, to take up space on a sidewalk. It may come down to time if you believe the ten-year rule, which I don't. I was emerald when I arrived, and now I'm the shade of blood on a Band-Aid. In color theory, opposing colors intensify each other. New York altered my composition.

I wonder if I have a right to live in Brooklyn, to put on art shows in a basement in Chinatown, or even in the busted shell of a pay phone. I think I'm contributing to the culture of the city. Making these spaces arises from the extreme environment because other people are doing it, because you have to do it. The city *forces* you to be more creative. When you're always avoiding obstructions, looking for that crack into high culture, standing near people with money and connections who were born into it, you get crafty, like a New Yorker.

I've collected stories about space—finding it, affording it, applying for it—and place. Space is measured in square feet and can

be quantified and boiled down to an economic equation. Cut and dry. You will need first month's rent, a security deposit, references from previous landlords, employers, bank statements, W2 forms, and the twenty-dollar fee to apply. It's nothing personal. Place, in contrast, is sensate, a rhythm within and between people and the built environment. Most New Yorker's are renters and don't own a piece of the city, but the sidewalks, parks, buildings, and signs around us are "encoded in localized and historically specific systems of sociospatial semiotics."[2] My translation—urban landscapes aren't the setting of our stories; they're the text, an assemblage of lonely words jostling to form sentences.

Place lands in the bones. I've felt out of place in New York because of my bodily capital, too much or not enough. I've also felt more like myself in the city than in the company of many humans. When people say, "I had to get out of here because *I'm losing my mind*," but are relieved to return, I get it. Flying into JFK and looking down at the arteries of cars, pulsing and clogged, I see blood running through *it*. I entered a relationship with *it*, and like some relationships, its textbook dysfunctional, financially and emotionally abusive, but never monotonous.

I love New York, but not like the bumper sticker or the t-shirt. Like Lucy Sante who writes, "I had never gotten around to changing my nationality from the one assigned at birth, but I would have declared myself a citizen of New York City had such a stateless state existed, its flag a solid black."[3] I can't go back. I'm an ex-pat.

After twenty years, I smirk when I meet someone who's been here for two. What have they seen? Not the incinerated paper and ash snow-flaking the sidewalk that September, not the medical masks and the surgical gloves that first March. These memories are my education, my currency, my identity. New York

will costar in my obituary as an accomplishment, this monstrous thing that I did, that did something to me.

My neighbors remember what it was like in the fifties, the seventies, or before September 11. I remember the 2008 real estate bubble, the banking crises erasing 401(k)s, and my friend getting fired by their boss, a Chelsea gallerist who lost fourteen

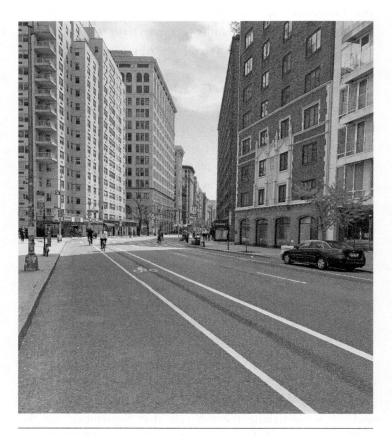

FIGURE 5.2 Broadway, near Union Square facing South. Author's photograph, 2020.

million. I'll tell stories about the first weeks of the contagion, how I could stand in the center of Broadway a block down from Union Square on a mild sunny Saturday. I took a picture so I could prove the staggering halt of work and commerce. The apocalyptic stillness, the possibility.[4]

Territories taken for granted: bodega that sells your kind of coffee, laundromat with the hot dryers. When they shutter, I think about my mortality, remembering life has an edge. I remember when Williamsburg had no galleries, and there was one coffee shop on Bedford Avenue, the L Cafe. I remember when there weren't adult kickball leagues and nannies strolling with babies in McCarren park. I remember going to Bushwick in 2006 and being on guard walking from the Jefferson L subway to a warehouse party two blocks away, fearing I would get jumped or shot or spit on. I remember when I first moved here, and I was so far away from *the city*, in the middle of nowhere, and when I couldn't afford to live out there anymore. Over a decade, I migrated down the L line searching for cheaper rent: Bedford Avenue, then Graham Avenue, then Jefferson Street, then Myrtle-Wyckoff. I joked that eventually I would be slapped to the end of the L. The last stop is Canarsie-Rockaway at the Atlantic Ocean. People say if you get stuck in an undertow, stay calm, float, and your body will pop up in a place where you can swim. This feels counterintuitive when you're drowning.

New York is an IV drip that almost delivers enough fluid. Billie, a painter, said, "New York City itself is an institution, the canon isn't rhetoric, its physical, you can feel it." He continued, "It's not like church where you're being told this and that, here you're standing in front of Warhol's last studio, you're shopping at the same art store that Keith Haring worked at." The concreteness of history grounds the shabbiness of the present.

It must be here. The capriciousness of it all, watching people you know get picked up by a gallery, and then dropped. Going to shows, meeting someone who could revise your life, feeling as if you will ascend, more, more; it feeds you and leaves you ravenous. In a *New Yorker* profile, Hanya Yanagihara said, "one of the life bloods of the city is a low-key hum of professional jealousy."[5] Billie said: "You go to gallery openings and you're in the room with people who are in MOMA's permanent collection. If you are an artist, you feel at home in that room."

They say, "I would stop making art if I moved upstate or moved to [insert any state]."

I consider what would happen if I left, if my ambition would drain and I'd develop new concerns, like mowing the lawn. Perhaps that's reductive, but I recall from my childhood a lot of drama and discussion about grass and its upkeep. Straight lines are mowed into front yards like police tape, outlining areas where nothing is meant to happen.

"I've told people that if I didn't live in the city, I probably wouldn't make art. They are like *really*? But it's true. I can go see new art every night and it energizes me. In the suburbs or small cities, there is not enough to look at. Looking inspires you to make your own art," Billie explained.

"You'll stick it out no matter what?" I asked.

"If you aren't from New York, there's no point in living here unless you already have a project. The high rent, the shittiness and trouble that comes with living in the city. It makes sense to be insanely driven here," he said.

Billie never directly answered the question about the prospect of leaving, instead we talk politely about how ambition can sour to desperation. After a beat, he said: "Nine million people, of course, other things happen. The working-class age out. They need space for their kids or they crave the stability

of a mortgage." How much space and stability does one need. The markers of mainstream success get whittled down in the city. I don't have much space or stability; I'm a professor with occupational prestige and a steady check, for now. In suburbia, I've been introduced by family members as a *New York City professor* like it's a big deal or a put-down—maybe it's both.

"What do you think about migrating upstate?" I asked Billie.

"It's a compromise. It's like a mature thing to do when you hit forty and you've been on the streets for ten years and do the best you can do and nobody cares. You have a certain amount of time. In this country, you have from twenty-one to maybe forty to make shit happen," he said. Forty sounds right. Americans in their forties are in their *prime* earning years. Billie continued: "If it's not happening, then you should probably make another plan. Hang out, continue making art or writing poetry, keep it up, do it when you can. Hopefully you can enjoy the life that's happening to you." The sociologists Peter Berger and Thomas Luckmann theorize that all human activity is subject to habitualization, a process that "carries with it the important psychological gain that choices are narrowed."[6] Life can become a pleasant habit; new routines develop effortlessly, but when you leave New York, the cut is clean—it's over.

The city doesn't desire or require you. Like Joan Didion, people age out and then it's goodbye to all that. She wasn't going back to Ohio to live in her parents' split level or to Jersey City because it was cheaper; a choice is different than a concession. Didion and her husband John Dunne (of the Connecticut Dunne's, Princeton 1954), in their corvette and ramshackle Hollywood mansion, floated back and forth from Manhattan to LA, effortlessly. They returned after all that California, and Didion spent the last years of her life in a "classic pre-war construction just off Madison Ave."[7] Her treasures—Celine

sunglasses, works by Ruscha and Rauschenberg, fine-dining accoutrements—were on view before being auctioned off. A final fetishization, last-chance artifacts, and proof of a skillfully curated life.

Back to reality. Olive, artist and seasoned MET security guard, was raised in the city. She talked of love when I asked her about leaving.

"I'm very lucky. I've had a very supportive family. I have friends here," she said.

"You got your hook up, support system," I said.

"But I think that I just love the city. I feel like I belong here. It's where I'm supposed to be. I don't question that, *ever*."

"You love it, I mean *love it* love it," I said.

"It's what I live for, and my main thing is to figure out how to make my art here."

"But it has to be here. It has to be in New York?" I asked.

"Yes," she said.

I shook my head theatrically, bobbed it up and down. I wanted her to say more, deliver a lyrical *real* New Yorker quote, give me some poetry. "Yes" isn't enough for interesting dialogue. Tick, tick, tick. I'm thinking, *don't fool with me.* Then Olive leaned down toward my phone on the unstable table between us, righted by sugar packets, and flatly said, "I don't drive." Her face forming, in the parlance of my father, a shit-eating grin.

6

ART IN AMERICA

Vito Acconci hid underneath the floor of an empty SoHo gallery and masturbated for three weeks, eight hours a day. As visitors walked above him, he peered up through the cracks in the floorboards, responding to their footsteps. You couldn't see Acconci masturbating, but you could hear him panting.

"You're on my left . . .

You're moving away but I'm pushing my body against you, into the corner . . .

You're bending your head down, over me . . .

I'm pressing my eyes into your hair."[1]

Captured in gravelly black-and-white film, "Seedbed," a remnant of the seventies downtown art scene was panned and lauded by critics. It elicits an intense emotional response when I show it in class. Once, a student shouted, "This is why people hate art!" Other comments: "misogynist," "macho," "offensive," "stupid." Point taken. Acconci is the producer and receiver of the work's pleasure.[2] Volumes of speculation document the perceived success and failure of Acconci's performance. Contemporary art criticism doesn't connect with the way people buy into culture; they love something or hate it—accept it, reject it, cancel it.

Conceptual and performance art are easily dismissed as pretentious, nonsensical. I recall exasperation after twenty minutes of watching a naked white male artist roll around in a pile of mud inside of a gallery. He eventually washed or baptized himself, but by then I'd made several to-do lists in my head as well as suggestions for nearby restaurants. As my friend and I clapped at the end of the performance, I shouted, "Bunna Café?" Not the first time I've acted tactlessly, not the artist's final dirt-centric performance.

Outside the realms of the urban, the elite, the intellectual, many Americans born in the twentieth century learn to equate art with oil on canvas. A painting is art. Regardless of whether you think it's magnificent or tacky, you know its purpose is to hang somewhere. You've seen them in museums or at a Cracker Barrel. While a five-year-old could have painted it—the old chestnut, the go-to—a painting is aesthetically perceptible. It means something to someone, as decoration or investment, even if it's not you.

My most profound encounters with art were accidental. I had a Duchampian rendezvous with a site-specific sculpture called *SUB BURB*, an underground upside-down house Vito Acconci built at Artpark, a sculpture park in an upstate New York town.[3] Art critic Richard Huntington describes it like I remember it: "With its sliding Astroturf panels, its American flag imagery . . . and its mocking white-clouded blue skies, it was something of a nightmare place where the American Dream was systematically dismantled and, piece by piece, held up for critique."[4] It reminded me of *Twin Peaks*, at times surreal and mordant. A horrific door I happily opened.

While the town was asleep, a friend and I broke into *SUB BURB* and smoked PCP for the first time. We entered through

the ceiling flush with the ground, stepping down into a room divided by moving stalls. Text on the slatted wood doors said pig or piss, mother or father, you could mix and match. I had a teenage underground-angel-dust-art epiphany. My simplistic working-class understanding was undone—art could exist outside of a frame, a sterile white room, a museum in a big city. I realized art could be good for society, meaning my own sense of self, much like a burgeoning awareness of feminism I couldn't academically name. Art not only provided beauty or proof of refined taste but could also shred mainstream cultural values and symbolically disrupt normalcy. I liked how art could make people that I didn't like terribly uncomfortable. John Cage said, "Art is sort of an experimental station in which one tries out living."[5] *SUB BURB* inspired me to consider how I wanted to live.

Critic Irving Sandler became an art writer after an encounter with one painting,[6] *Chief* by Franz Klein. While he walked in the Museum of Modern Art in 1952, he said he was "dumb struck by a black and white picture." He writes: "*Chief* began my life-in-art, the life that has really counted for me. . . . It was like releasing the floodgates of seeing." He was re-born. "I looked to art for meaning, for the illumination of my life—and by extension, of my society. Art became the content of my life, to paraphrase Malevich, and even a kind of surrogate religion." When I read this passage, I didn't know who Malevich was, but I circled it and wrote *truth* in the margins.

Anika, a sculptor and former MET security guard, believes making art advances culture. She said: "At the end of the day, it's more than self-expression. I see art contributing to human progress. If you can get to that point, that's a high mark. I think it's a progressive act to move the culture, or ideas, forward. I might not be feeding the poor, but I'm doing something that contributes."

I asked her, "contribute to what exactly?"

She said, "Shit, that's hard to measure."

I agree. I'm often asked to assess, quantify, and evaluate what I do, according to institutional metrics. In this way, most art will never measure up.

In an introduction to an *Art 21* episode, John Waters explains his love for collecting art is rooted in the simple fact that it makes people insane. He says his childhood friends and family hated the Miro print he bought at the Baltimore Museum of Art giftshop when he was eight years old. The philistines said the playful mass-produced image was awful, ugly, and stupid. Their gut reaction: no. I imagine Waters's face, his thinly drawn-on mustache grinning: yes.

Contemporary art mystifies. Wrapped in visual codes and theoretical discourse, it's an opaque language requiring translation. Museums escort viewers with didactic panels, audio guides, and vinyl wall text. Morsels from the artist's bio, the social and art historical context of the work. It must be rendered more meaningful. I came across a blog post called "The Art of the Didactic Panel." I laughed at the art of explaining art, but these panels are taken very seriously, much like footnotes, which in my experience are venerated or disregarded.

Why do we need art? If I can answer that question, I can craft an argument for why we should support artists. The salience of art is keenly felt in its erasure. When a society inhibits artistic freedom, jails artists, or censors their work, you can feel the necessity of art like a pulse. When museums, theaters, music venues, comedy clubs, bars that host readings, and off-off-off-Broadway and avant-garde spaces shut down at the start of the pandemic, the absence of art (big A, little a, all of it) turned the city into an abandoned backlot. It felt like New York was in a coma.

I can make a case for the value of art in society. Artists are another story.

7

ARTISTS I KNEW

The artist who made a square helmet out of plywood that looked like a 1960s robot head and wore it to basketball courts and tried to join pick-up games while his girlfriend filmed.[1]

The artist who secretly lived in her studio, peed in a white plastic five-gallon bucket and washed her bras in the bucket.

The artist who painted bananas and wheel chairs, who was mainly interested in cats as subject matter.

The artist who had an aneurysm and didn't die, who taught himself how to draw while he recovered and the swelling receded.

The artist who made a full-size replica of herself and brought the doppelganger to Sears to take a family holiday portrait with it.

The artist who painted tree stumps, who never watched or read anything to avoid being influenced by the culture.

The artist who used the lexicon of black metal and death metal imagery to sew crowning paintings, because giving birth is metal as fuck.

The artist who choreographed a human foosball game next to an abandoned warehouse, while a chef roasted a pig behind the goalpost.

The artist who preferred to play inside an attic room and a hidden crawl space as a kid, who spent six months building an elaborate two-story replica of his childhood home inside a gallery.

The artist who went undercover as the heir to a fashion dynasty for a year, who went to New York celebrity parties and posed for pictures with Hillary Clinton and Puff Daddy.

The artist who collaborated with his indigent father to attempt to assemble a 13,200-piece jigsaw puzzle depicting *The Creation of Adam* as a three-week public gallery performance, who unexpectedly died five years later, at the age of thirty-three, within a year of his father's death.

The artist who threw a painting in a field, found it a year later and said it was better and it was finished.

The artist in me who was buried, and the artist who raised her to light.

8

ARTISTNESS

The word *artist* is a dumpster. You can throw anything inside of it.

I Google "I hate artists" and find a Huffington Post article "Nineteen Reasons Why Artists Are the Worst," a blog post "Why I Hate Artists," and endless Reddit discussions. The venom confirms my hostility hypothesis. Some of the wrath conflates artists with the art system, as if artists themselves created the art world. The cost of high art confirms how idiotic all of it is—the art world, so-called art, the people who make it. It's easy to mock. Ai Weiwei recreates the photo of a drowned Syrian infant to "engage with the refugee crises" the same year (2015) that Willem de Kooning's *Interchange* sells for three hundred million dollars. No doubt this year, the one you're living in, will deliver controversy. Art can be a symptom of grotesque excess. Against the backdrop of postpandemic problems like inequality, eviction, homelessness, and unemployment, it's appalling.

We are encouraged to be an *artist* or to be a *creative*. Identities fused into a lump of artistness. Creativity—a style (*modality*) of artistness—can and should be applied to any aspect of existence. The art of cooking, the art of war, the art of the deal, the art

of possibility, the art of saying no. TED Talks promote art as something anyone can do, an essential tool to hack your life. The sociologist Nathalie Heinich describes the process in which the boundary between art and non-art are breached by other activities, many of which lie midway between artisanry and commerce.[1] It's called artification.

A short detour on the word *hacking*. As a noun, it's an artist (a *hack*) who makes mediocre work chasing commercial success. As a verb, it means to blow, strike, slash. As a self-help tool, it means life-hacking. I read that *self-hacking* is a practice consisting of diverse assignments that make you consider and objectively reflect on your life, your choices. I don't want to hack anything. It sounds violent, and it's another form of unpaid labor.

I searched the word *creativity* on Ted.com and find 2,010 results. When I searched for *art*, 5,281 results came up, including The Art of Puzzles, The Art of Stillness, Political Art, Great Cars Are Great Art, The Art of Being Human, The Art of Asking, The Art of the Eco-Mindshift, and Why Art Is a Tool for Hope. *Death* returned 1,515 hits and *sex* a mere 1,277. The only place sex doesn't sell is a TED Talk.

My long hair blocks the bathroom sink every few weeks. When the water rises high and spills into the over hole, I untangle it with pliers and a homemade coat-hanger tool, like a plumber. I know two anthropologists who've called themselves artists. They don't have a studio, a practice, or exhibit work in galleries of any kind. (Is an academic peer-reviewed journal a gallery?) They've been to a museum or two, likely given a talk, sat on a panel. They've seen Chelsea shows and had drinks afterward. Look at art sometimes, think about it, sometimes. Andre said: "I would never call myself an anthropologist. That would be laughable." No one laughs though.

Maybe these anthropologists are *creatives*. Jeff Goins, bestselling author of *Real Artists Don't Starve*, explains that a creative is "someone who sees the world a little differently than others." Given the subjective nature of reality, this definition applies to anyone with a self. Relatedly, the diagnosis HSP, *highly sensitive person*, first coined in 1997, is equally broad in its reach but gaining traction these days.[2] To be creative in law, science, business, sports, anthropology, and art—creativity is ubiquitous and absent. I work at a college whose brand is "Think Wide Open." A creative attempt to suggest an atmosphere of thinking outside the box. The *Think Wide Open* homepage looks like an amalgam of the DMV website and a Facebook wall.

"How many of you are an artist? Have a friend who's an artist?" I ask. Every hand in the classroom goes up. "Do they show their work in a gallery?" The students shake their heads no. "Do they have a studio, a practice, an oeuvre?" This question is met with confusion. "How do you know they're an artist?" Because they're *creative*; they doodle, collage, make memes, make zines, take photos on their phone, post their pictures. Then a student, Zeus with his lightning bolt, says, "Anyone who says they're an artist is an artist." Boom. They're all nodding affirmatively, groovin' on the truth.

I'm defeated, but grin like a clown, like they're making a great point. In a way, they are. Penny Arcade said, "Being an artist was a particular way for a particular segment of the population to try to make a living. Now being an artist is an identity. People can say they're an artist and they don't actually do anything."[3] The key word—anything.

True story. Half of the people I've met in New York describe themselves as writers. They don't submit or publish, but they

send e-mails and journal. They're avid readers. They love books. Sometimes they join writing groups or enroll in workshops where they're mostly praised. They pay for eight weeks of deadlines and cheerleading. In one such workshop, a draft of this chapter garnered the following editorial notes in the margins; *strong* fourteen times, *brilliant* twice, and one *perfect*. Everyone gets patted on the back until they purr. Then they go back to grinding and dump their drafts in a folder labeled IDEAS. My ideas folder has twenty-seven documents, with labels like suicide.doc and scratchedbuttholes.doc.

Five thousand dollars no questions asked, no receipts, and no reports of artistic activity. Consider the application instructions for an emergency Covid artist relief grant on New York Foundation for the Arts: "While we understand that creative practices are defined broadly, due to limited capacity and an overwhelming volume of applications, we are not reviewing submissions by commercial merchants, occupations, or vendors working in auto maintenance, baking, balloon, barbering, cosmetology, event planning and production, fitness, food makers, henna, horticulture, magic, marketing, massage and healing therapy, modeling, nail design, professional speaking, soap making, etc."[4]

Artists = mechanics, landscapers, barbers, and soap makers? It's just another chance at a money grab, and workers should try and wrench a droplet from the oceanic stimulus package. The list of disqualified professions isn't absurd considering the artists who've made sculptures out of cars, cooked elaborate meals and served them to gallery guests, cultivated cells, moved boulders, built houses, and filled galleries with soil and water. There's the sculptor who arranged motorcycles upright or laying down on the immaculate gallery floors. And the painter who makes fingernail art, and the performance artist who's a model. Artists dip

into all occupational fields, steal, and borrow, with reverence or not. They team up with (pay) biologists, robotics engineers, custom auto painters, and unhoused people to render any activity, object, or experience into art. Their art. But what is art. Another dumpster.

Another nonstarter—anything can be art. It's all subjective. Sure, art is socially constructed through institutions, markets, and discourses; it has a history, but most of my students will revert to this maxim. I assign Howard Becker's *Art Worlds*, which theorizes art is created through networks of people and places, hubs of social activity, and divisions of labor.[5] From a sociological lens, art making isn't a solitary endeavor and an artwork isn't miraculously birthed through the hands of a genius. Objects defined as art are collectively constructed in both a literal and symbolic sense (all of this is on the test). Notwithstanding, in American society, the focus lands on individual rather than socially contextualized explanations. And when it comes to evaluating art, individual taste is the default. In a post-Yelp culture, we are encouraged to review, in great detail, every product and service available. We offer opinions on all experiences and services. There's a momentum, a sense that everyone can be, should be, and is an expert. Consuming ignites the impetus to wield opinions; one-star ratings are submitted with grandiose micro power. If you're online, then you're a critic. This is the democratization of taste. The genius of the crowd.

The consumer is always right, but when rightness is of public record, it's righteous. A review by a professional critic still holds a degree of significance, but garnering praise from the public is critical. Ratings are consulted before we buy. Are the tacos good there? Let's see what 876 anonymous reviewers have to say. After I get my teeth cleaned, my dentist sends an e-mail reminding

me to post a review and like him on Facebook. The best dentist, the best sellers, the best laundry detergent, the best museums. When I was in Paris, I was trying to find the time the Louvre opened and I came across a two-star Yelp review from Ryan L. of Astoria, Queens: "A must see if you're a big fan of Jesus and Ugly Renaissance babies, Its [sic] almost definitely the worlds [sic] largest collection. If not, its [sic] an easy pass. You also get the pleasure of seeing the most overrated painting of all time, the Mona Lisa (Spoiler: its [sic] even uglier in person). The building itself is pretty huge and impressive though. Extra star for that despite the very poor use of space."

Artist as Halloween costume: Warhol's wig, van Gogh's ear, Kahlo's eyebrow.

Kahlo and van Gogh are mummified in their tragic biographies. We see the physical and mental suffering clearly painted on canvas. We know that depression, crippling disease, and early death are the biographical requirements of the Great Artists. Salma Hayek was nominated for an academy award for playing Frida Kahlo, and Willem Dafoe's version of van Gogh earned him a best actor nomination. I walked out of the theater after an hour of watching Dafoe as stoned Jesus squinting for the right light. Artists are more cinematic if they were exploited, ignored, and impoverished when they died. You can't argue with a saint.[6]

Popular corny ideas of art are built on cinematic representations of artists at work, caught in the act of creating. Artistic labor as splashy performance, mess, the more shambolic the studio the better. Like other famous white male actors, Jim Carrey is now a painter. A video shows Carrey creating in his colossal studio. It resembles a stage, or cathedral, lit by enormous windows and

skylights. Wearing paint-splattered pants, he bends, reaches, stretches, and kneels over canvases. He worships paint and color, the basic elements that capture eyes in the infinite image feed. As money is no object, an abundance of paint is put to service. He tosses and squeezes it, with a brush, straight out of the can, right out of the tube. Splurt.

Carrey the artist. The tropes of the great twentieth-century white male painter performed without irony. His ape-like gesticulation channels Jackson Pollock's action painting. He says he's a night painter; he's removed from the nine-to-five yoke that shackles the common worker. Painting at 3:30 A.M. so deep in the flow that sleep and time vaporize. He's also working through a difficult split, reproducing the bromide that making art is therapeutic, cathartic. People with less means buy adult coloring books. They go to town with a box of colored pencils and magic markers.

Art as therapy, a hobby: This has something to do with feelings. Making art and expressing yourself (those emotive AbExers) feels good. It brings pleasure. It kills and fills time. And after, you have a thing (you call art) to show friends or followers. Proof that you're creative. Lost in the canvas or the ceramic project, and before you know it, five hours gone. Should you paint that square blue or red? Your favorite color is purple—go with both. You don't have to know color theory to make an aesthetic choice. Children and hobbyists are told, "You're so artistic!" And that's good enough. Dabblers say, "I feel alive—free!" It's a feel-good fest because there's nothing at stake; it's not going to pay January's rent. I'm trying to tell you there's nothing at stake.

I forward the Jim Carrey video to Andre while he works at a Chelsea gallery.

Subject: Jim Carrey is an Artist.

He replies immediately:

> I forget how archaic the pop understandings of "art" are. How the myth of "inner expression" and "windows to the soul" are inherited like reflex. Color = Beauty / Brush stroke = passion / Canvas = soul / Paint on surface = Art. Jim Carrey might be a psychopath.
>
> (SEE ALSO SYLVESTER STALLONE, ADRIAN BRODY, JAMES FRANCO, BRAD PITT)

At a backyard party in Brooklyn, I found myself talking to two people who work in *fashion*. They kept saying *fashion*. Greta, a forty-something German-born photographer who shot many covers for *Vogue* and *Vanity Fair* (she emphasized the word *cover* a few times), was originally from Germany, living in Williamsburg. Blair, a makeup artist, had a blond streak lightening-bolting his brown hair. Both were wearing identical costumes: state-of-the-art t-shirts and rigid denim. A few minutes into the conversation, I tired of hearing about models and actresses (Charlize Theron is stunning in person, FYI) and asked them about art. Maybe I could glean something for this book.

I asked Greta, "If you could buy a work by any artist what would you get?"

She paused and said, "Agnes Martin."

"Ah, you like the monochrome." I wasn't surprised by her answer.

"I don't like color. I can't stand it. If you gave me a Warhol, I would sell it. I would get rid of it. All of those yellows and pinks," she said.

Art as an accessory, as part of her cultivated black-and-white aesthetic palate. The cliche collector picking art to match the couch.

"And you Blair?" I asked.

"Monet for sure. I'm totally serious," he said.

"You better save your money if you're going to Sotheby's," I said.

I thought only the middle-brow went for Monet. Those pins, tote bags, coffee mugs, and mouse pads. A few moments later Blair said: "I take that back. It would be abstract art. Black and white with a big brushy swish. You know, abstractions with bold black lines and angles." His hands waving in the air, I imagined him jumping up and down in front of a Franz Kline painting. It would match perfectly with his clothing and high design décor, also everything Ikea.

Blair and Greta were into Modernism: art as style, art from a coffee-table book. They work on coffee-table books, and I use them to prop up my computer up when I Zoom. I don't open or read them often, but they bestow my apartment with the appearance of being magazine ready. Aspiration and design within reach of a coffee-table book.

What's the point. They're just fashion people at a party. Creative players in elite cultural production and consumption, people with agents who know where to eat in LA or London. They liked art that looked like art: Art in museums and movies. Art as a commodity, as an accessory aligned with Instagram. Art as lifestyle, as hashtag. An infinity pool seamlessly leveling out.

In "Eating the Other," bell hooks describes how ethnicity is a spice used to jazz up any cultural dish, sell pure primitiveness,

and get in touch with the wild green world. Urban Outfitters sells American Indian-ness as fashion—headbands and necklaces made of feathers, erasing extinction through consumption and celebration. The models romp around Coachella, channeling the sixties ethos while freely nodding to genocide. The cutting and pasting of indigenous culture is the blindness of white privilege. It's a gobbling up, using, and discarding of the body and culture of the Other. I overheard someone say, "I tried Ethiopian food and ate it with my hands!" Quickly wiped clean with the wet nap provided table side.

I made a video. I took a photo. I'm an artist! Artistness is a commodity, an identity, a fashion statement. Art has been a commodity since the nineteenth century, but we are in a new frontier in which claiming to be an artist is a sign of individuality. Artistness is a way to express yourself. Try it on, wear it for a day, return it to the box. People say that they are really into nature or really into fashion or really into art. Art is a t-shirt. T-shirts have never made me weep.

Everybody has the means to make, signaling the democratization of creativity. Apple badgered us to "Think Different" in 1997. The ad campaign armored the ascendency of the brand by deploying the image of artists: Jack Kerouac, Jimi Hendrix, Pablo Picasso, Bob Dylan, and John and Yoko in bed bearing flowers. Artistness sells products and sells itself. The borders between visual art, graphic design, advertising, and branding continue to bleed. Everyone is a curator now. Curate your life, your relationships, your shoes, your time. What to pick and what to omit; pillows, plants, make-up, music. There are food curators, wine curators, landscaping curators. Your apartment (your identity) is all modern.

Loft living.[7] Before people could pay to live like an artist, artists lived where they could. They squatted or legally rented paint factories or buildings used for manufacturing: pillows, fortune cookies, shoe polish, rope. They cleaned them up, built walls, installed bathrooms. They made it livable, by their standards, which are probably below mainstream expectations of comfort. I've known artists who built showers in slop sinks rigged with a garden hose. A creative fix, the original hack. Imagine having to remove a pile of dishes to shower. A mini fridge, hot plate, electric kettle, camping equipment. An outdated term you don't see much anymore, an *efficiency*. A colleague reads this passage and says it's "all very good," but wonders if I could also engage with a bit about how nostalgia is dangerous, too.

Cultural workers are cast as role models within twenty-first-century capitalism because they're entrepreneurial, risk-taking, and juggle multiple jobs. Navigating the boundaries between work and nonwork is no problem. This creative class model of ideal workers leaked into the larger labor market. The gig economy is dependent on flexible workers who work out how to get by. Workers mandated to creatively approach employment.

The corporate ethos of being a company man, committed to the job heart and soul for life, has been replaced by the creative DIY individual. Do it yourself was an alternative call to arms: do it on the fly, for cheap, the way you want. For Gen X, do it yourself meant do it without asking permission. I recently asked students in my "Art Worlds and Their Discontents" course the first thing they thought of when I said DIY. A student yelled *a mom*. The entire class lolz'd in agreement. Remember Martha Stewart and her step-by-step guides to making homemade candles and preserving flowers in resin? This DIY domesticity encourages

us (mostly women and feminine people) to creatively approach unpaid reproductive labor. Of course, anyone can be creative in taking on a task, like organizing your closet or editing your fridge contents.

In a post-McDonaldized society, consumers are expected to do it themselves. We pump our own gas, check out and bag our own groceries, take our own blood pressure and measure our blood sugar, and deposit and withdraw money because it's convenient and rational. It's the way it is. Consumers are doing more work in the name of efficiency and technological advancement. Likewise, workers now do more work to be and stay employed. Perpetually finding jobs (freelancers), tracking invoices and payment, negotiating multiple people and systems of management within the bullshit job sector. We're supposed to have more control within the creative gig economy and more agency to suit our individual needs, albeit with no insurance, no stability, no 401(k), no future. The answer, the tonic: be creative.

Photography began as a social utility in the early twentieth century, as pure recording, a medium stamping place and people. Evidence of the life course, it was an act of love and proof of it—growing up, first day of school, blowing out candles. A catalog of affection with an implicit moral imperative. Imagine a person saying that their parents never took pictures of them as a kid. On a societal level, photography showed us what was happening in *the culture*, that social change was possible, and that change involved blood, tears, and horror: war, celebrities, criminality (the mug shot), politicians waving, Times Square kiss, the American flag on the moon, the American flag on the 9/11 rubble. As Susan Sontag said, everything exists to end in a photograph.[8]

As an occupation, photography was a utilitarian craft for photo journalists and professional portrait photographers. Bound by conventions and expectations, it was mostly pedestrian until the seventies. Photography had a tricky time folding into the fine arts, a complicated artification process. All of this is ancient history, of which my digital native students have very little knowledge. When phones came equipped with cameras (2004); the world blew up and synched up. Social media ascended, empirical reality eclipsed. We used to say IRL. Enter the digital public sphere where we network, find sex and love, and fake news is real. The tech in our pockets is a platform (exposed and public, intimate and private) to make content, to make the self. Bold Glamour, Facetune, YouCam Perfect, Crying Face Filter. The glut of apps. To not sign in is to be curmudgeonly or just old. Luddites carry dumb phones.

Essayist William Deresiewicz argues that the shrewdest way to peddle expensive tools is by convincing people that we all have "something unique and urgent to express."[9] He calls it producerism, the latest offshoot of consumerism. "What we're now persuaded to consume, most conspicuously, are the means to create . . . no one has the right (or inclination) to tell us when our work is bad."[10] We consult tutorials to adjust the angles, tweak the lighting, edit the background from bathroom to beach. We learn how to make food look good and how to make art look good. Or ask AI to do it. Every human activity from the banal (making coffee) to the magnificent (giving birth) can and must be creatively produced. Everything, the whole ball of wax, even an actual wax ball, is potential content. Dr. Emily Taylor (@dr_ear_wax), an *earwax enthusiast* with 130,000 Instagram followers, posts video montages of earwax removal. *Scoop earwax with me!*

But what is content exactly? I was curious. As defined by Business Dictionary:

1. Content is both information and *communication*: the sum total of the *freshness*, readability, relevancy, and usefulness of the information presented, and the manner in which it is presented.
2. *Essence* of a communicated message or discourse, as comprehended or received by its intended audience.
3. Glue that makes a website "*sticky*" makes visitors return, and keeps them from leaving.

I read this over and over, like an Orwellian phantasm—freshness, essence, stickiness. Scrabble words from hell.

PART 2

9

CUPCAKE CITY

Whoever is born in New York is ill-equipped to deal with any other city: all other cities seem, at best, a mistake, and, at worst, a fraud. No other city is so spitefully incoherent.
—James Baldwin

New York City: A home for the shamefully wealthy or the generationally poor, the center of cultural progress or a pit of social problems, always in a state of becoming and coming to an end. Five boroughs and hundreds of neighborhoods boiled down to three words. I'm tempted to use dichotomies to describe New York and easily fall into the trap of either/or. It's a character, a caricature, a real place, and an abstraction. I'm trying to wrangle it.

Nobody ever told me about New York. Long before I moved here, I perceived it cinematically, a city reduced to worn-out props—Statue of Liberty, fluorescent subway cars, gum-stained sidewalks, the Brooklyn Bridge. I was haunted by a version of New York as seedy metropolis, *The Naked City*, popularized in the 1948 film, which I've never seen. I wasn't dissuaded by the city of urban decline, teeming with lowlifes and creeps. A state

of disrepair. I imagined the police barely feigning interest in social control, disorder the norm. I imagined if you went out, you prepared for pimps, drug dealers, and strangers waiting to stab you for your wallet or for no reason at all. I thought everyone had knives. Half empty and ablaze, landlords torching vacant properties to collect insurance money. I imagined it was normal to see flames across the city. Now massive construction cranes lurk in the skyline, dangling like wasp legs.

The Naked City is the one occupied by America's others—immigrants, people of color, the unhoused, and the poor—those to fear or blame for social problems. The others who lacked the desire or the resources to flea in white flight. The Naked City is what remains after the affluent retreat to the suburbs, escapee danger, and locate top-drawer schools for their kids. It felt as if New York was briefly naked at the start of the pandemic. It's been naked before.

I went to the Tenement Museum to see how ordinary people lived, *How the Other Half Lives*. At the turn of the nineteenth century, Five Points in lower Manhattan surged beyond its capacity. Emigrants arrived from Italy, Ireland, China, and later from Germany and Eastern Europe. They lived like some New Yorkers do today in inhumanely crowded apartments; without access to clean water, heat, or ventilation; and with only rudimentary health care. Five Points is synonymous with criminality, brutality, corruption, rioting, and infectious diseases (yellow fever and cholera). It's an urban slice of hell on earth from a xenophobic view—foreigners as cause of societal sepsis rather than its victims. Newspapers sold copies by amplifying the vice, especially alcoholism and opium dens.[1] I imagine the stories were as seductive as ruin porn. Instead of derelict buildings succumbing to wild, unruly nature, thuggish immigrants (an invasive species),

like weeds and vines, choked the moral order and verticality of the modern metropolis.

Tyler Anbinder's *Five Points* portrays a nuanced version of the district: how its problems came from a constellation of forces—too many people, systemic abandonment. There was street crime and political corruption as always. Of course, as Anbinder writes, "Americans found it repulsive, they also found it fascinating."[2] Nightlife thrived in Five Points: all the saloons, dance halls, and bare-fisted pugilism wouldn't be out of place in Bohemian Paris. When day-to-day life is brutal, night offers release.

In *Mean Streets*, *Warriors*, and *Midnight Cowboy*, the Naked City is more than a backdrop, it's a character driving the plot. This depiction of New York, like any other, is contrived of fact and fiction. New York was dangerous, but it wasn't a people problem (the bad apples). As Bob Nickas writes, "Although the city has always been an unruly, infantile child, and in polite society, children are best seen and not heard, social breakdown doesn't usually start with the kids, but with the system itself."[3] Rather than viewing New York and its people as worth saving, much like a troubled teenager, it was temporarily disowned.

Kathy Acker's New York of the seventies was a "pit-hole," inhabited by "artists, Puerto Ricans who can't afford to move and rich Europeans who fleeing the terrorists don't give a shit about New York." She wrote: "Meanwhile the temperature is getting hotter and hotter so no one can think clearly. No one perceives. No one cares."[4] I read that this year was the hottest year on planet earth. And we are still not thinking clearly.

1975 was quite a year. President Ford gave a speech denying federal funds to keep New York out of bankruptcy. The next

day, the headline of the *Daily News* read "FORD TO CITY: DROP DEAD." It was the end. Rampant government failure was blatantly social Darwinist. In a memo to President Nixon, adviser Daniel Patrick Moynihan suggested that the so-called race problem (housing projects, drugs, violence) could benefit from a policy of "benign neglect."[5] Mayor Abraham Beame proposed major cuts to municipal services. The Council for Public Safety, composed of frustrated police and firefighter's unions, published their own pamphlet to discourage tourists from visiting New York. Below a black skull, the cover read: "Welcome to Fear City: A Survival Guide for Visitors to the City of New York." It was never distributed but still circulates. There were other fatalistic nicknames: "Default City," "Stink City" (sanitation unions), and my favorite, "Stupid City" (teachers unions).

A few years earlier, *New York* magazine had published a wistful list of reasons to keep sticking up for New York: "101 Signs That the City Isn't Dying," as if it was a body on life support. In the twenty-first century, people talk about what makes a city *livable*, a now-ubiquitous term. Livability, according to geographers, is a city's ability to meet the psychological and physical needs of its residents.

A tangent. The din in the subway, walk-running to catch a train, looooong steps, like leaps. Eddies of sound, industrial bucket drum kit, karaoke machine croaking off-key, Classical cellists, jazz trumpeters, acoustic singer-songwriters with homemade compact discs in guitar cases, toe tap dancers, and that blond mandolin player in a tight white muscle tee, black vest, and bowler hat at the Bedford L. Accidental soundtracks zigzag the crowds, rushing and decelerating with the rhythm. A reason why it's New York: the racket and randomness of walking into human percussion.

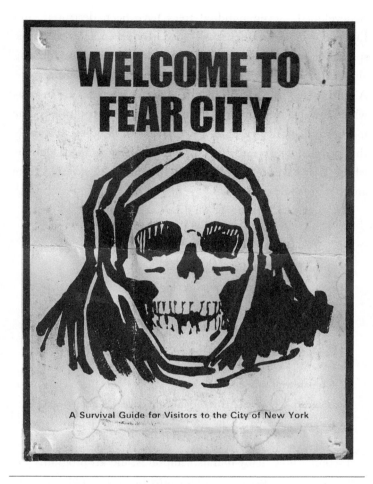

FIGURE 9.1 Fear City poster, 1970s. Open Source.

Proof that New York wasn't a corpse: a list of "urban encouragements."[6] Parks, an oceanography center, a public pool, daycare centers, the opening of LaGuardia Community college. Public goods, basic services to be provided without profit to all members of a society. As of this writing, East River Park is being

"redeveloped," seven hundred trees have been destroyed, and Lower East Side residents will lose fifty-seven acres of public space. I've heard parks described as a city's lungs, trees filtering air, their shade providing relief from intensifying temperature. Air, like space, isn't free. Maps show how sparse trees are in areas where low-income families and people of color try to live. The mayor's office calls it a *resiliency plan* against flooding. It's ironic that people living nearby will have to be more resilient. Demolishing East River Park will garrote the Lower East Side, create another green desert.

Art as evidence of life. From the *New York* article:

> Reason 29: art school gets funding at Brooklyn Museum ("rebirth at the Brooklyn Museum")
> Reason 30: the donation of 6 sculptures by local businessmen ("the business of art")
> Reason 52: murals in the subway tunnels ("underground art")
> Reason 83: an expansion of the MET ("art for the having")
> Reason 84: paintings on building on the Lower East Side and Chinatown ("outdoor art")
> Reason 87: Creative Artists Public Service Program—CAPS ("starving artists, eat!")[7]

I wonder how many murals, sculptures, and art programs you need to save a city. I think about how hip-hop, punk, no wave cinema, and the East Village School mushroomed in unlivable conditions, growing out of ruins. All of these art movements hatched in neglect. Previous signifiers of precariousness, especially graffiti, aestheticized to the point of emptiness.

Cities are dying, artists are an endangered species. I wonder if this is the story I want to tell. People age out, or opt out to find a suitable place to live. They move from experimentation into

so-called adulthood. And nobody feels their loss, nobody says come back, because somebody else is moving to the city right now, and they will rent your bedroom and your studio, and they will take your place. All you will have is your *I used to live in New York in the early aughts* stories. This may haunt you and date you in ways that are uncomfortable.

Artists move on. The seventies art scene migrated to SoHo, deserted and available. A generation distanced itself from emotive AbExers and the orthodoxy of the canvas through performance and hybridity. Gordon Matta Clark started the experimental restaurant Food in 1971, a hangout for artists and place to eat weird food. Clark served sushi, at the time exotic and dangerous in juxtaposition to TV-dinner and Jell-O-mold America. Chris Burden's 1974 performance "Back to You" was staged in a SoHo freight elevator. Burden, naked to the waist, invited participants to push thumbtacks anywhere on his torso, and as the elevator went up and down, people watched on a monitor. It would be hard to mess with restaurants and elevators today, without considering profit and safety, without collaborating with a brand or a corporate *group* (a community of companies).

A parallel and overlapping celebrity nightlife bloomed— Studio 54, musicians, models, artists, and the aesthetic orbit around Warhol's factory. He did make art there: paintings, screen-prints, banal films lasting ten hours, a preview of life online. Captured in a sublime glow, the visual archive tirelessly recirculates, the center of a universe still holds. There were fewer artists at the time and more places and ways to live: squatting illegally, living in collective semisqualor, paying cheap-cheap-cheap rent. Now in New York, you can't squat in an abandoned building in the East Village (there are none), and making do by panhandling and couch surfing doesn't hold any cache for graduates of prestigious art schools.

What hasn't changed: museums, public sculptures, symphonies, theaters, and music venues, what the city government and "I heart New York" tourism promotes as *art*. Institutions, clearly delineated on a map, often served with directions to better enhance the direct experience, mostly after buying a ticket. This year the Whitney Museum of Art and the Guggenheim both raised their ticket prices to thirty dollars (from twenty-five). If you make minimum wage in New York City, you will have to work for *more than* two hours to afford entry, if you deduct for federal, state, and city taxes. A public good the public can't afford.

I love what Laurie Anderson said: "There's just as much chaos as there ever was. It just looks different."[8] Now the brutality of New York lies beyond a trash can fire or the bedlam of crime—it's in the shine and the gleam. The threat is a ten-dollar container of organic raspberries and a five-thousand-dollar-a-month studio apartment. These are signs of who belongs, those who have made it. Even though I teach the *Capitalist Manifesto* and consciously reject wealth as an indicator of success, its displays sometimes hypnotize me. If I can't afford to shop at (name of expensive place), then I don't have *it*. I need to work harder, try harder, sacrifice more to get *it*. I'm the problem (so are you, possibly). Even though the lines between have and have-not aren't razor-blade sharp, I'm bleeding all over this page.

When the affluent went running for fresh air during the first wave of the pandemic—because they choose to and could afford to relocate to a safer more comfortable suburbia with gates, detached houses, and private land for their children—I was smiling. Get the fuck out. I imagined suburban America fearing the city again. Carlo McCormick said: "I hope they stay scared. The worst part of 9/11 was when America decided they loved New York. It was so much better when they thought we were a

bunch of junkies and cocksuckers."[9] Of course, they came back, and rents soared by 15 percent. As of August 2023, I'm writing from the *most expensive city in the world*.[10]

The New Rome is the other New York frame: city as civilization; commerce and culture merging in harmony. This magic kingdom is prosperous and productive, economic opportunity everywhere. It provides all the cultural resources, global art museums, obscure film festivals, blah, blah, blah. It's a distilled urban version of the American Dream, the cliched melting pot that harmoniously teems with diversity and never spatters the stove. This urban utopia couldn't exist because it's more of an idea, just as much as it's a feeling. John Lennon is said to have said: "If I'd lived in Roman times, I'd have lived in Rome. Where else? Today, America is the Roman empire, and New York is Rome itself. New York is the center of the earth." Roman emperors were slain in battle; Lennon was shot in the archway of his Central Park apartment building.

History reveals that the ordinary New Yorker has more in common with the ordinary Roman citizen. Rome "was not a stunning cosmopolis of marble temples and showy fora; it was a squalid, fetid, unsanitary, noisy, and generous amalgam of people, animals, wastes, germs, diseases, and suffering."[11] I see what I've done here, setting up the Naked City and the New Rome as opposites. I know the city is cagey; it'll always slip out of the boxes we put it in.

Plague year three: As we have recently experienced on a global scale, the idea of safety is socially constructed. I bleached light switches and wiped down jars of spaghetti sauce like life or death. It's comical in hindsight. Remember when doctors, white men in white coats, recommended certain brands of cigarettes

for their healthiness? Medical experts promoted Camels and Lucky Strikes as fresh and mild. Parents weren't concerned about cigarettes when their kids could fall prey to reefer madness and the immorality of comic books. Safety is always political—the mask, the vaccine, the virus itself.

Many people, except those raised in conditions of extreme urban neglect, born into generational poverty, would have difficulty living in New York in the seventies—even for a week or a day. We live in a culture that's smothering us in a blanket of safety. If you have the means, you will take measures to be safe: build your own wall, buy a camera and position it to shoot, install a ring alarm, download the Citizen app. We protect homes, bodies, and our data as industries flourish around anxieties. We consume safety. The global home security systems market is predicted to increase from fifty-two billion dollars in 2021 to eighty-five billion by 2027.[12] As we build safe rooms and firewalls, in America, we are coming to terms with how unsafe it is, and has always been, for people of color, trans and queer people, women. Safety is a privilege and a preoccupation. If a city is in danger, where do we begin? Who decides what is worth protecting and what shall be saved? I don't know how to keep a city safe from monoculture and hypergentrification, enemies of working people, diversity, neighborhoods, and beautiful old trees. These are rhetorical questions. In this moment, I just need to put them on the page.

Bohemian New York granted freedom from social constraints—a safer environment to be queer, to be wasted, to be a broke artist, to be yourself. Decades after the gay rights movement and AIDS crises, and the birth of queer studies in the academy, there is more freedom to be out in New York. Pot is legal in many states, and even in New York, home of the Rockefeller drug laws, I'm

often caught in a tandem cloud of smoke in the middle of the afternoon because you can get Skittles and weed at the corner store. At the same time, Disneyfication has spread, transforming many areas of the city into landscapes of consumption founded on fairytales. Tourists increasingly want prophylactic fun, that which is safe from surprises, homogenous, virtuous, and heteronormative-family friendly. There's an implicit moral imperative in the soullessness of standardized amusement.

In *Time Square Red, Times Square Blue*, Samuel Delany writes of frequenting porn theaters, peep shows, and gay bars that thrived for more than forty years. They were vital to the greater urban community, fostering empathy and social cohesion across class boundaries that wouldn't happen otherwise. Rejecting the notion of deviant public sex cultures, Delany carnally renders disparate bodies overlapping for pleasure and companionship: sex workers, sidewalk vendors, and all kinds of men—gay, straight, bi, white, Black, brown, young, old, white-collar professionals, and the unhoused. You can almost smell the musk, the glueyness. Times Square offered a pocket of safety for random moments of intimacy, a zone of contact free from mores and overpolicing. From Delany's perspective, it was a kind of queer Jane Jacobs community. A social safety valve in the center of New York.

Today in Times Square, the hustlers dressed in knockoff Disney costumes are the street walkers, audaciously tricking in daylight. After complaints from tourists who felt threatened by their aggressive sales tactics, the city created "activity zones" for the outlaw Mickey or Goofy to stand in and ask for tips for a picture. The famed naked cowboy, a fit man in underwear playing a guitar, and other buskers working under the radar were roped in. Selfie hustling must take place in the painted areas or by permit. I was delighted to read that a year after the activity zones were created, a Hello Kitty and two Cookie Monsters

were huddled a few blocks away, out of the zone, breaking the law trying to make rent. The restrictive zones protect tourists threatened by rogue cartoons, their humanness at odds with the enchantment of the fictional characters.

New Yorkers and tourists are safer on the streets today; even dissent is regulated. Protesters, too, must stay in designated areas called protest zones. There is strength in numbers just as there is strength in heavy police escort; protesters are herded and corralled and contained. If you come to a nationally organized protest in New York, be prepared to stand obediently in place and chant. Five hours will pass, and if you're lucky, you'll be at the end of the block. While protest is built into the American psyche as a right, political action in urban public space is diffused by forced inaction on the ground. Those who march and assemble unlawfully (without permit, police escort, out of the zone) risk arrest and assault via fists, knees, police cruisers, batons, and chemical weapons, as we've seen in Black Lives Matter marches. Our right to collectively assemble in public has eroded, and I wonder what good can come from orderly protest, what the new zone will be.

The Big Apple is a rotten metaphor. Penny Arcade calls it the Big Cupcake. She explains how the apple was a symbol of knowledge, and when Eve audaciously bit into it, she understood sin: "People coming to New York because they wanted sex, they wanted glamor, they wanted experience, they wanted to expand their horizons, they wanted to reinvent themselves— How did it go from that to people who want to come to New York because they watch *Sex and the City* and they want a cupcake?"[13] I've asked myself the same question. I wonder if there's a tipping point when a city becomes so suburbanized that it no longer qualifies as urban and if artists can shield the city from the saccharine.

Arcade breaks it down: "If you came to New York before, 1995, let's say, there was an intact bohemia . . . one third artists with two thirds people who live an artistic life but do not make art, but for whom art is very important."[14] She argues that's what made New York so dynamic, centering life around art. Audiences who were *connoisseurs* of writing, painting, and theater, not likers. I imagine someone dressing in the same color palate of a painting, say in a jungle print, and taking a picture in front of a Henri Rousseau painting. There are costume contests at museums now—visitors incentivized to dress like their favorite artist or work of art. The art selfie era. Consumers rewarded for their participation, for buying, for knowing what's trending, for posting a pic.

This is a problem. The Big Cupcake is a couthy place for creatives and cultural entrepreneurs, not for artists, for countercultural movements allied with bohemian New York, or for Penny Arcade herself. In the Big Cupcake, "mediocrity is the new black" and resistance to the status quo isn't well tolerated. In the Big Cupcake, everyone is artsy, but there's hostility toward rebellion, artistic conviction, or people who dare to transgress too much. In the Big Cupcake, art is easily consumed like *Barbie* feminism. It shall be entertaining, a little edgy, palatable, and universally approved.[15]

Artsy consumers will stand overnight in a will-call line for Hamilton tickets, the hottest historical hip-hop musical ever. They'll "Gogh" to the *original* immersive van Gogh multimedia spectacle, where they'll be treated to five hundred thousand cubic feet of projections, more than sixty thousand frames of video, a winking van Gogh portrait, vertiginous sunflower room, and an app.[16] They'll queue for five hours at David Zwirner gallery to take selfies in the Kusama Infinity Room. Five hours in frigid February for ten minutes of iPhone photos in a mirrored room with shiny balls. Wind tunnels of Chelsea be damned.

An art worker, a painter with an MFA, described how he periodically closed the Infinity Room to vacuum hair and street dirt. Must be pristine for photos. When he reopened it, they breathlessly rushed in and postured for selfies. He said, "People who were bent out of shape and hangry suddenly transformed, like show biz!" It feels as if there are few spaces that haven't been Instagrammed. New York City was a post card, now it's a post.

The assertion seems plausible that "we may be coming to the end of a period where being an artist was synonymous with being urban."[17] This is a pessimistic take, maybe. I will say that cupcakes are a sign of gentrification—of the mind, of the urban, of every part of life you can think of. Life itself must be as photogenic as a cupcake.

10

POISON

I was a townie. I grew up in the town of Niagara (population eight thousand) and the town of Lewiston (population sixteen thousand), rural/suburban hamlets situated a few miles from Niagara Falls, New York, moored by America's largest waterfall, one of earth's ecological wonders. The falls still attract tourists, but the decline in heavy industry and manufacturing jobs hemorrhaged the city in the seventies and eighties. It drained like Detroit and Flint. Growing up, I watched the downtown businesses wither, the factory outlets and Dollar Stores bloom. Main Street is boarded in plywood, except for a rundown Burger King and the B&B Cigar Store, which my Uncle Fred owns. Been there for thirty years. He doesn't sell cigars anymore, mostly lottery tickets, bags of chips, cans of Coke. He hung a piece of cardboard in the window that says, "NO BUMS." Despite the stunning geography, and my attraction to decay, I knew I'd abandon the rust belt. I couldn't swallow the desertion.

I moved to New York in the summer of 1999 to go to graduate school, earn a doctorate in sociology, and see what happened next. I went to a party thrown by a stylist in a studio apartment in Hell's Kitchen. We squeezed into the

three-hundred-square-foot space and smoked. The décor was urbane New York: midcentury modernist furniture, vintage lamps from the seventies, mismatched drinking glasses with space-age patterns, sophisticated ashtrays. These *pieces* had been *found* at the Sunday Chelsea flea market. The median age of partygoers was around twenty-seven, but they acted and appeared younger, untied by marriage or kids. They worked in fashion and their avant-garde haircuts and shoes corroborated it. Everything was curated. I entered the art of lifestyle.

People always talked about their apartments, which they called spaces, or someone else's space and where it was located. Space: finding it, measuring it, paying for it. I'd later understand why renters have a one-track mind.

I remember one conversation: A woman with matte red lipstick and sharp bangs asked me where I lived. I told her Williamsburg with some confidence, because at the time, it was known as an artist neighborhood.[1] The birthplace of the trucker-hat-wearing, Pabst-Blue-Ribbon-swilling hipster.

"You mean in *Brooklyn*?" she asked.

"Yeah, why do you say it like that?"

"I *never* leave the island," she said.

The island. What island was she talking about. I didn't think of crossing the Williamsburg Bridge from Brooklyn into Manhattan as a journey from an outpost to the mainland. It struck me in the back seat of a cab, one in which I had to beseech the driver to take me back to Brooklyn, that Manhattan was New York. I didn't live in New York. I lived on the other side of the bridge, in a bordering territory of no real interest, somewhere too far away to count. This was political.

Five years later. My friend and his fiancé were visiting from San Francisco. We went to dinner at Diner, a now iconic farm-to-table restaurant underneath the Williamsburg Bridge, before

farm-to-table was a thing and people were foodies. The fiancé, affluent and in her mid-twenties at the time, said: "I remember living in Manhattan in the nineties while I was at Columbia, it never even occurred to me to go to Brooklyn. Nobody *ever* went to Brooklyn. Why would they? There was nothing there." Sal and Franca DeRossi, my second-generation Italian landlords, the kids in the handball courts, hardware stores with dusty padlocks and tape, bodegas selling kielbasa, bars with lotto, artists. In a decade, nothing converted into something.

In the eighties, the first wave of artists migrated to Williamsburg for cheap space, converting industrial warehouses into serviceable live/work lofts. The cliché kind you see in films with high ceilings and concrete floors, the heavy freight elevator that's hard to close, a wall of lead-glass windows, panoramic skyline view. No coffee houses; just coffee in a Styrofoam cup. No cafes with candles and seasonal vegan entrées; just restaurants. Williamsburg was too crude, blue-collar, and ethnic for those raised in American cul-de-sacs. No culture, nothing to buy.[2] Developers had yet to symbolically use art to rebrand the neighborhood.

Williamsburg is in its postdiscovery stage, financially out of reach for the underfunded. According to the NYC.gov website, artists own the businesses. This could be true, considering the murkiness of the label. I knew a painter with an MFA who opened a bar in Williamsburg in the early aughts with some friends. He stopped painting. The bar is closed now.

I took a photo of a spray-painted message, "don't fall in love with buildings they will only break your heart." The building, an abandoned industrial site on the Williamsburg waterfront, was demolished shortly thereafter. The neighborhood has transformed so many times since then I'm not even sure what's in its place: a Chase bank, luxury high-rise, J Crew. It doesn't make

a difference because it's impossible to register the dissimilitude between new developments born of monopoly money and monoculture. Tastefully designed, all monochrome.

I'm one of the gentrifiers who hung on long enough to get gentrified. A Third Estate upgrade.[3] Artists factored in the flipping of Williamsburg, but the gallery scene never took.[4] At one time, there were around sixty artist-run and commercial galleries. Now makeup and drug stores simulate galleries.[5]

Artists are cast as villains or victims. A generic urban demographic, they serve myriad uses. Their visual presence a selling point on the side of a building or in the form of a polite public cow sculpture. The term *artwashing*, coined in an *Atlantic* article, describes how government officials and developers in East London courted artists to live and work near a twenty-eight-story high-rise tower built in the sixties. They culturally photoshopped the state-owned complex by offering artists' affordable rent, but never intended to permanently subsidize an artist's community. When commercial projects are artwashed, artists are used as props "to add a cursory sheen to a place's transformation," a process framed as a "journey from neglect to creativity."[6] Artists are an ethos, and a stock image. A symbolic commodity, much like New York.

The year was 1961. Jane Jacobs's *The Death and Life of Great American Cities* was published—the bible of ethical urbanity, a go-to source for sociologists, urban planners, and political scientists. A straightforward call to arms. The word *gentrification* does not appear once in the book. It didn't have a name yet.[7] It was first called redevelopment and then real estate conversion. The year is 2024. We use the term *hypergentrification* now, fitting for an era of hype beasts, sociopathic extravagance, and super yachts. I overheard a man at Stonefruit, a vegan café in

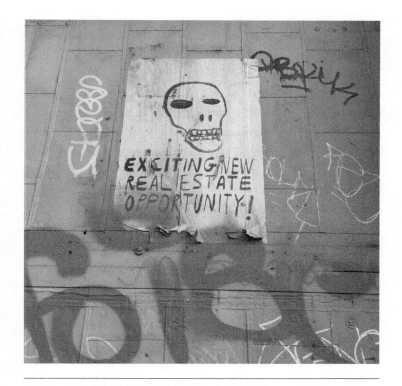

FIGURE 10.1 Bushwick graffiti. Author's photograph, 2019.

Brooklyn, say, "It's called progress, if you don't like it then leave!" On his feet, Gucci loafers. His accent, French?

I interview myself:

A reader said that you must figure out a way to persuade people that artists make a city "special." How will you do that?

That's so very American. I refuse to do that.

You can anthropomorphize and wax lyrical about New York's lost soul.

Can't I be straightforward and say that wealthy people suck Kathy Acker style?

That will be read as bitter.

A reader said I was bitchy; another said I was snarky "in a good way."

What do you want to say? Just say it.

I want to filch the rich, not only their trusts and real estate, but also their time and sanity. I want to steal their art, art acquired as asset, the art that goes with their asshole couch. I want to make them work essential jobs for minimum wage, make them scrounge for change, make them wait for the bus, make them watch their uniforms circle at the laundromat. Then I want to watch them drag their laundry back onto the bus, up four flights of stairs (no elevator, no doorman) to their bedbug apartment, and the faucet will be leaking and it will be ninety-nine degrees, and the air conditioner will be useless, and their ankles will swell, and the dog on the other side of the wall will be BARKING, BARKING. THE DOG BARKS AN HONEST DAYS' WORK THE WAY THE WORLD WORKS PAYCHECK PAYCHECK PAY PAY PAY PAY.

What did she say?

New York City will become alive again when the people begin to speak to each other again not with information but with real emotion. A grave is spreading its legs and begging for love.[8]

THEN I MOVED TO BUSHWICK

The most luxurious real estate in the city borders Central Park—the Upper West Side and Fifth Avenue. You know this. I'm just reminding you. It was built in the 1880s by Manhattanites who required a promenade to stroll in, a bit of country in the city. It's an idyllic version of nature and a respite, a gap of

green escape, a landscape. John Berger was critical of landscape paintings. Thomas Gainsborough's *Mr. and Mrs. Andrews* (1748), in his eyes, represented an image of power. The newlyweds in their silken finery "are not a couple in Nature as Rousseau imagined nature," Berger writes. "They are landowners and their proprietary attitude to what surrounds them is visible in their stance and their expressions."[9]

The park is a social experiment. In the pathways that snake its edges, joggers and tourists steer around nannies pushing scions of privilege in Bergdorf prams. It's been said that Central Park is the city's heart, people living nearby are pumped. A man told me with pride that his granddaughter Beatrix lives a few blocks from where Jackie Kennedy grew up, plays in central Park, and visits the Metropolitan Museum of Art *all the time*. Beatrix isn't a visitor, a sightseer from Queens. The park is her backyard and the MET is her playroom. She is not out of place. Beatrix, like her peers mothered by female staff, will never be evicted from their penthouses in prewar buildings. The cities elite institutions, museums she visits and schools she will attend, will never shut down because of a lack of funding or because her classmates didn't collectively score high enough on standardized tests. Beatrix's New York is a landmarked bell jar, a generational shelter. A prediction: Beatrix earns an MFA from Yale, and her first solo show in Chelsea sells out.

Maria Hernandez Park is Bushwick's version of Central Park. I lived there for five years, and I was always less than a half a block away. I spent afternoons sitting on the benches, taking notes without writing anything down. In 2009, when I moved in, most people who hung out at the park spoke Spanish. Vendors, mainly women in long-sleeve t-shirts and baseball hats, sold flavored ice in paper cups and mango slices in plastic

bags. Unhoused men and women napped underneath trees until police started kicking them out.

On most weekends, extended families set up their own temporary provinces. Territories demarcated by Dominican or Puerto Rican flags, folding tables, lawn chairs, black grills, badminton and volleyball nets, and playpens crowded with kids and toys. Baroquely displayed food; bags of Doritos and potato chips, large aluminum containers of meat and rice, Costco-size condiments. They came to Maria Hernandez like they were moving in. One summer, I watched a family blow up a large inflatable pool with an air compressor and fill it with water from a fire hydrant. The kids splashed until dark, cars parked a few feet away.

The first time I sat on a bench in Maria Hernandez Park I was killing time before meeting the man who became my new landlord. I kept checking my flip phone for a text, trying to be nonchalant, avoiding eye contact with a few guys guzzling beers in paper bags. They grunted at me muttering *mami* this, *mami* that. I thought *be careful*, watch out for these men. Looking at their gnarled hands, the stained fingernails, I imagined what they'd done and what they could do.

I heard stories about how tough Bushwick was. Jackson had a studio in Bushwick before the demographics of the neighborhood changed. He recalled:

> The striking memory of being there, that first year, I was just feeling ghetto. It had that sort of apocalyptic empty feeling that New York felt like in the seventies. Not much traffic. Not much other artists coming around. This upscale white woman was just walking obliviously down Broadway, in this couture outfit and heels, and then this Puerto Rican woman, or her daughter, maybe, on the side of the street that I was on yelling "Hey, Blondie!" And

if this woman had acknowledged her, I think she would have run across the street and punched her in the face. Just this animosity of classes and it was so black and white back in 'o1. Was sort of like, "Whoa!"

I was naïve about who to watch out for. I understood who to fear after being evicted and pushed around by white men in white buttoned-down shirts. They always drove black SUVs and traveled in pairs, efficient as soldiers. I rented a one-bedroom railroad for twelve hundred a month. By the time I left the park, five years later, I lived in a one-bedroom a block away and paid eighteen hundred. There were no garbage cans out front, so tenants put their trash in the grim unlit hallways. As I lay on my bed, I watched mice sniff around the buckling kitchen floor. A pigeon set up a nest on top of my air conditioner and laid eggs. Gusts of feathers and feces. As the apartment deteriorated, the rent continued rising, and the park weekend vendors changed. More artists rented studios and started their own galleries wherever they could—abandoned storefronts, living rooms, and basements. I did too.

Someone slid a letter under the kitchen door. My old landlord, Mr. Kroker, sold the building to a London based LLC. My new landlord, the LLC, said I had two weeks to vacate. Boom, I was scrambling again. By that time, the weekend farmer's market sold cold brew coffee. If you had an extra twenty dollars, you could pick up artisanal goat cheese and raw wildflower honey. The chicharrons lady was off to the side and white people in their twenties and thirties read novels on straw yoga mats. As the neighborhood was labeled *up and coming* and *trendy*, the police increased. Cops started to show up every night, driving slowly on the sidewalk, eyeing up local teenagers skateboarding in the center area, a public square shaped in a circle. A concrete

amphitheater to blow off steam or eat your lunch became a panopticon, a point of surveillance and control. Increased policing is overlooked in gentrification stories, but it's directly connected to an uptick in newcomers, especially white ones in mostly Black and Latinx neighborhoods. Build it and they will protect it.

The teenagers were corralled and kept in check, and the newly erected dog park became a hub of public sociality that didn't require an economic exchange. The young professional transplants were there day and night eyeballing their phones while their dogs pooped and humped in the gravel. I sat nearby and executed ethnographic fieldwork, a form of institutionalized people watching. The Frenchies and Poms multiplied. Dog names, like baby names, speak to their owners tastes and social location. They called them Larry, Milo, Henrietta. Working-class residents often walked pit bull mixes on weighty silver chains. They called them Brutus and Brooklyn.

I fondly remember two of my Bushwick neighbors, Poison and Nacho. Nacho and his family had a fleet of old American cars, models like LeBaron and Eldorado. I think there were two, but their length and chrome dominated the street. Nacho's job was watching the cars and moving them for street cleaning four times a week. He told a story about taking one of his cars into Manhattan, like it was across the country. I have no idea what happened to Nacho or to his extended family and his cars. All of it went down so fast; the neighborly ecosystem detonated. I can't remember if his building was sold before mine. The new tenants have a video camera and intercom so they can control who they want to let in. MINI Coopers and Volvos with adventure racks now line the block in a jaunty procession.

I don't know what building Poison lived in, but I saw her all the time on Knickerbocker Avenue. Poison hung out in front of the laundromat and shouted, "Hey Honey!" when she saw me. She wore black stretch pants and a black tank top harmonizing

with her box-black hair. She had two dogs, a Rottweiler and a Chihuahua mutt. I remember her closeness to her dogs, how she spoke sweet to them. I told her I liked their bling (her dogs wore scarfs and hats). She beamed, "They're my babies." I haven't seen her in years, but I heard from a student who's from Bushwick that Poison was living in a homeless shelter. Poison was broken up, with tears in her eyes, she said: "Look at what these artists did to me. I'm out on the streets because of them."

Bushwick's geography, architecture, and cultural history resist whitewashing. A literal cleanup is impossible—within a few blocks of the Morgan L dubbed *Morgantown* by developers, sits

FIGURE 10.2 Bushwick studio building next to cement factory. Andre Yvon, 2023.

an enormous garbage transfer station. Trucks jammed with trash blast in and out, rendering a thick stink-cloud that smothers four square blocks. In the mugginess of summer, I get caught up in it. I hold my breath and gag. Some artists, in their twenties and without jobs, rent studios for seven thousand dollars a month. I gag.

Within Morgantown's radius, sit three concrete plants. Cement mixers ravage the roads creating sinkholes that maim cars. When they go by, the cement trucks stir up dust tornados and clip conversations. The noise, the filth, adds a dash of grit-ability for sightseers. The brunching classes and street art tourists from Milan and Tokyo are too relaxed to care. Right now, there are 1,700,00 posts for #bushwick and 78,000 for #bushwickstreetart on Instagram.

After Bushwick, I rented an apartment in Ridgewood, Queens, for one year, a neighborhood that directly borders it. A group of artists started a gallery called Regina Rex on the Ridegewood/Bushwick line, and artists flowed over. Breyer P-Orridge, pandrogyne, founder of COUM transmissions, lead singer of Throbbing Gristle and Psychic TV, lived in Ridgewood long before Regina Rex and coffee shops like Milk & Pull. I've heard people describe Ridgewood as a *cute town*. When I lived there, people didn't smile or look at me when I passed them on the sidewalks. The landlord and his wife were from Poland; they spoke little English, at least not to me. She had streaked blond hair that never moved, carried a toy dog with a pink bow under one arm. The only time she grinned was when her dog snapped at me in the hallway. Her disdain was cinematic.

Ridgewood contains lots of cars and very few spaces to park them; the ratio similar to lower Manhattan, where people camp in their cars for hours pending a space to be set free.

The competition unleashed road rage. Red distorted faces, middle fingers, mangled bumpers. My car insurance went up even though I only moved a mile away. It was hyped as the new Bushwick. The *New York Times* gave it a prefab name—Quooklyn—a lisp that never stuck.

When I moved out of the Ridgewood apartment, I found bright turquoise droppings along the baseboards, underneath the bed, and in the kitchen cupboards but never any dead mice. The bait transformed in shape, had been eaten and digested. I fed those mice for a year. Like humans, they develop immunity to poison.

11

NEIGHBORHOOD

I'm out of place. The train stops on the Upper West Side and everybody bolts for the exits, except me. Most subway stations are on street corners, but 96th Street funnels passengers upward into the middle of Broadway and spits them out. I turn around a few times, trying to figure out where's east or west, uptown or downtown. Squinting down at my phone, I'm a tourist—that person in the crowd who looks like they don't know where they're going, who doesn't belong. Like a cockroach, I respect how the city flicks me back into my place. New Yorkers forever scramble to find a safe corner.

We don't faint at the sight of celebrities or acknowledge tourists, there's no balking, no stopping. We develop a detached but alert way of being in the world, our own techniques of sociality to crisscross space. I remember when I first saw little kids dropping subway tokens; now I see them swiping their metro cards like they own the place. Riding the subway, acquiring getting-around skills, is a way kids and new transplants start to identify as street smart. Subways are too expensive, overcrowded, and mostly filthy, but there are poetic moments: "Veteran riders often mention the feeling of pride and belonging they experience when standing on its elevated platforms

toward sunset, they watch a silver ribbon of cars against the city's gleaming skyline,"[1] and likewise, the viral video of the pizza rat dragging a dollar slice down the subway's cement steps.[2] New Yorkers are always in transit, habitual movement is a way of life.

Change isn't palpable on the Upper West Side as compared with the renovated Teflon and metallic landscapes of the Williamsburg waterfront or Hudson Yards. This neighborhood is marble, a sculpture elegantly aging. The crowds are civilized and homogenous in fine leather shoes, their button-downs tucked inside belted khakis, ready for a piano recital or bird watching. The uniforms convey a calm assurance of belonging. A few young women in spandex and bubble trainers are out jogging with and without babies. Fitness, physical and financial, is paramount. Sonic disruptions occur (ambulance sirens, idling delivery trucks) but are muted by an orderliness and a residential pall. I imagine the last of the distinguished professors of Columbia University own apartments on these blocks. It doesn't look like a place where artists live, whatever that means today.

 I'm uptown to meet Jackson, a sculptor and painter in his fifties, at his rent-controlled apartment. His block is lined with grand well-maintained buildings; garbage is rarely given an opportunity to collect on the sidewalk. He grew up here, inheriting the lease from his artist parents. I'm envious of his provenance, not that it shielded him from the ebb and flow of art—being broke and then not as broke. Of course, broke is a relative term. I've paid the bar tab for a friend who was "so broke" after returning from a trip to Paris and given my unhoused neighbor pocket change for a can of beer and a loosie. Even with the protection of rent control, Jackson lives mostly off the fumes of a commission or side job, never banking on art to pay.

There's no doorman, but a guy cleaning up the hallway tells me Jackson's on the fourth floor and the elevator's ready. Jackson invites me in and asks me to take my shoes off, although I doubt the floor regularly makes contact with a Swiffer. I doubt women live here. I'm in a long hallway filled with so many objects it's impossible to fix my eyes on just one thing. All surfaces are blanketed in a curated kind of hoard; plastic action figurines and toys border the mirror [check]; a frame of random arms, legs, torsos, and heads [check]. The interior of the apartment doesn't connect with the neighborhood, in a good way. At more than fifteen hundred square feet, it's the most spacious New York residential apartment I've been inside that's occupied by a working person, and I'm sure he can see I'm ogling all the square footage. I feel lewd inside so much space, like he let me in on a secret.

Jackson has a live/work setup, and his apartment doubles as his studio, art storage, library of books and records, and a multichambered cabinet of curiosities. In one small room off the hallway, the walls and ceiling are hidden by layers and stacks of stuff: pliers, all kinds of tape, drills, cords, hammers, files, screws. I poke my head in: "So this is the war room." Jackson nods. I admire how used it is. A clandestine garage where he pounds, saws, drills, cuts, and hammers whenever he feels like it, when other people in the building are sleeping or taking a bath. He doesn't own it, but this apartment is his.

We sit down in an expansive open room that would likely be staged as a formal dining room if it was put on the market. Aside from two chairs and a table pushed to the side, there are no decorations, no store-bought stuff. Oversize figureless paintings hang side by side on the walls and a dozen bulky metal sculptures border the room. It's like being in the backroom of a museum of the self. Jackson says that the landlord is trying to evict him, trying to bring the apartment up to market rate. He points in

my direction: "That chair you're sitting on got thrown out of the apartment by the old lady on the third floor that took the buyout and went back to live in Israel."

"Sooo, they're offering buyouts?" I ask.

"There are about thirty apartments in the building. We're down to about seven people like me, but they're all way older."

"Sooo, they're like, I'm in my eighties or something. And I'm going to stay here. Fuck you." *Why can't I stop saying* so, *I know filler words slow everything down. The expletives, how cheap. I have my own junk I can't rid myself of.*

"Mostly, yeah."

I've heard some version of this story before. I could personally relate, perhaps too much. "Yeah, well I don't blame them. I can imagine spending most of my life in New York and being eighty and being like, this is mine. I'm not going to go live in Hudson or someplace with a yard," I said.

He looks directly at me. "I have friends in Hudson. They used to live on Avenue A."

In the eighties and nineties artists lived on Avenue A, one of the four streets that make up the East Village's alphabet city. In twenty years, I've never heard anyone say *I'm going to Alphabet City.* I didn't know about Gracie Mansion's gallery, how she was living on Saint Marks Place and started showing her friends art in her bathroom, having "mini-shows." "In the bathroom?" I asked. I thought bathroom art galleries were something new, conditions were so dire now that artists had to show work in bathrooms, or it was an affront to the mainstream art system, a Mike Kelley abjection.

Jackson explained: "She's like, this is going okay. I think I'll rent a space on Avenue A. And then she took off, moved to a bigger space, and just got a lot of media attention because of her name. Gracie Mansion, what's that? She was able to turn her

stable into a kind of mainstream artist stable. We had big collectors pulling up in limos there in the early eighties. That was the same time as Fun Gallery, but a different type of art, graffiti versus eclectic, somewhat older artists from outside of New York, this crazy thing."

Big collectors aren't pulling up anymore; instead, they go to art fairs on private planes and in private cars. I don't think there are many *crazy things* anymore, but what does crazy mean in the art world or in twenty-first-century New York? I came across a description of Gracie Mansion's bathroom gallery and the eighties East Village in *People* magazine (imagine a story about artist-run spaces in *People* today):

> Six years ago, Joanne Mayhew of Pittsburgh followed hundreds of unknown, unconventional artists to Manhattan's scummy East Village in search of low rent. There she made the smartest decision of her life: She took on the funny name Gracie Mansion (after the New York City mayor's residence), quit painting and became one of the first art dealers to set up shop in the burned-out, druggy area. Today both Mayhew's struggles and the East Village's unrelieved scuzziness belong to the dim past. New East Village galleries are opening faster than anyone can count: Nearly 100 of them form the world's newest artists' ghetto and serve as a magnet for style-conscious youth everywhere. Several nights a week, seedily chic hordes cluster on neighborhood streets waiting to squish into gallery openings to socialize and maybe see some art.[3]

Words that stand out to me: burned-out, scuzziness, artist ghetto, seedily, hordes. Nobody writes about art scenes like this today. *New York* magazine's sightseers guide to galleries uses descriptors reminiscent of QVC, America's flagship shopping

channel: "edgy and established," "finger on the pulse," "progressive and playful," "cool and quiet," and "international flair."[4]

The most famous, historic neighborhoods have at some point been home to painters, writers, musicians, dissidents, mess manufacturers. The East Village, like SoHo, Harlem, and Washington Square Park, were pollinated by artists. Cultural production, experimentation, and artistic labor gave them life, made them matter. Now these neighborhoods are landscapes of consumption, hijacked by urban developers catering to the tastes and wealth of the consuming class. Antigentrification activist and author Jeremiah Moss laments the East Village he knew and lost: "A long sought-after refuge for those who never quite felt at home anywhere else. Reclusive misanthropes and creative exhibitionists, builders of junk towers and makers of psychedelic gardens, poets, punks, queers, activists and anarchists, dominatrices and drug addicts, graffitist, nudists, and underground cartoonists. . . . A barricade of deviance and grit kept much of the straight world out, protecting the neighborhood's unconventional character. But at the end of the twentieth century, the East Village was invaded, its territory seized."[5]

The East Village's art scene is mostly extinct, inhabited by the last survivors with rent control and an unremitting tide of students and future execs attracted to new condos and gut renos perpetuating the post-frat lifestyle. Fledgling bankers, tech workers, and publicists party on their balconies and rooftops. You can hear them screaming at night, thrilled to be alive. Laurie Anderson said:

> I didn't expect to see guys in herds running up and down the river. . . . You see them mostly on their lunch hour, young stockbrokers, and they're running in herds. This is a big, huge

difference from when I got here. New York was a city you went to alone. You didn't go with your school friends. You came by yourself, and you started over. I don't get that sense with these guys. They're herd guys. . . . let's go to New York, we'll room together, we'll run together. . . . we'll make a ton of money together. And then there they are. Go and watch them. It's really wild.[6]

Most of the street noise doesn't spill out from band practice or scuzzy taverns, it's channeled through sound systems, lubricated by theme martinis and artisanal this or that. A few dinosaurs still roam the streets, and if you're lucky, you might see one riding their ten-speed bike in a gold lame jumpsuit wearing a ferret as a scarf. I swear I saw this, an apparition moving through the homogenous hungover brunching crowds, window shopping for authentic deconstructed t-shirts.

Back at Jackson's, I ask: "I want to get your thoughts on the proclamation that New York is over for artists. Find yourself another city. All that. Have you read some of these articles? Now it's a story that nobody questions."

"Yeah, but that line was being spoken in eighty-four. Carlo McCormick and Walter Robinson wrote some article called 'New York Is Dead.'"

"But do you think it's the same as it was in the eighties or the nineties?" *My tone is incredulous. Ethnographers aren't supposed to challenge their informants.*

"I think it's something that is constantly being said." He laughs a little. "As it dies more and more . . . it's sort of like lava, it bubbles up a little on the edges and then you see a flash of light." *The cities on fire, the trees on fire, the Yoko Ono quote.*

Quickly I add: "I've heard this before too. But I think that since, well, the past ten years and definitely after the crash, that

it's become increasingly more difficult to find a space to live here and find a space to make art."

"Yeah, well, it's economics. American capitalism is founded on this idea of growth. And to do that you have to tear the old stuff down," he says.

"Yes. I think there is something to it, I mean, that you can track. The rising of rents, and the process of gentrification, the eighteen-dollar hamburger that just keeps going up. And if you compare it to the eighties or the nineties, there's never been a period in which rents have increased in the neighborhood 800 or 400 percent in ten years like Williamsburg, It's pretty extraordinary." *I had so many facts and statistics in my head, as if I could deploy them to make sense of the city. Like I had an agenda.*

Jackson clarifies: "But it *felt* like 8 or 900 [percent] when it was happening in the early mid-eighties. Anton van Dalen did this sort of Monopoly game based on the East Village, where it was like okay, one sushi restaurant, one art gallery, one health club moves into your block. You're that much closer to the bottom of the gentrification." *I forget that feelings are data, solid as numbers.*

"I was just talking about this. How many cafes or artist-owned spaces per four-square block before it tips?" I ask.

"There's a tipping point."

"You've heard this before." *I think everyone has heard this before.*

"It just gets more severe and pronounced as this bubble increases. It reminds me of the Nazi party dancing off a cliff even in the last days of the war. This delusion that somehow this flawed system is going to persevere." He stops for a moment. "Okay, so the apocalypse comes and that would throw me back into the world I walked into when I left college and the East Village was burned-out buildings."

Apocalypse is a theatrical descriptor. Lately, I often read the words *collapse* and *catastrophe*.

The more the city physically and culturally transforms, old-school New Yorkers become cemented. Some become territorial and difficult to move, like eighty-five-year-old Adele Sarno, a Little Italy resident who received a notice to vacate her apartment on Mulberry and Grand Streets where she'd lived for more than fifty years. Crowned queen of the San Gennaro feast in 1945, when her rent-controlled apartment was raised from $820 to $3,500 a month, Sarno refused to yield to developers looking to sell the building for fifteen million. Rallying lawyers and antigentrification advocates to speak on her behalf, she made Little Italy history, not because she won, but because she fought for her right to the city like a New Yorker. Some people can't fathom leaving. They say, *where the hell am I going to go*. More of a statement of fact than a question. Artists feel the same way. If they leave the city, they abandon part of themselves.

"I'm always curious, if you have rent stabilization, they can't touch you, right?" I ask.

"Well, they can start baseless lawsuits and harassment. Take all your time. It's a hard fight."

"I felt threatened when my apartment building was sold. I didn't have rent stabilization. . . . I had a brief taste of it. And it was fucking horrible. It made me sick and sad," I say. *Oversharing again. I was trying to flex my New York-ness. Maybe this is how disparate New Yorkers find connection, a conversational thread. Bad luck and barricades.*

"Yeah. The way walking into the housing and court building makes you feel for a few days. My lawyer lives in the

neighborhood, and she's sort of a legend who was helping tenants," he says.

"She knows who the good judges are, how to work the system?" I ask.

"Not that that's any reassurance; you might not win the case because the judge turns out to be an asshole. But I won the case." He shakes his head, "and now, they're still fucking with me. So, whatever. Keep fucking with me."

If you don't want to be nomadic, waste afternoons researching rental laws and calling 311, and have your soul mangled by the iron cage of bureaucracy, then New York City isn't for you. I think of it as forced flexibility. You'll deal with a broken elevator if the heat still works. The landlord increases the rent a hundred dollars a month without written notification, but you don't call him out on it because you can't afford to move. These situations, as told to me, and experienced by me, aren't unusual or specific to artists. New York isn't artist friendly, nor is it friendly to the working class or the undocumented—those who build, repair, deliver. It's easy to say, "deal with change and endless cost of living increases." This always defines the urban, now and forever. Like when Eileen Myles said: "People talk about the city not being the place it was, and I think that's not true. That's a very service-y take on New York."[7] I'm not sure what they mean by service-y, maybe the city is here to serve your needs if you show up: I'm in New York now. Something good will happen. It'll pan out.

Myles has a rent-controlled East Village apartment they've been living in since the seventies. Rent so low they describe it as "pornographic."[8] When I'm feeling destructive, I rummage Zillow for market-rate yearly lease apartments in Myles's neighborhood. The descriptions use familiar bait: exposed brick walls, washer/dryer in unit, hardwood floors, prime location.

The hard-core amenities apartment *won't last!* I can't afford it, I don't want to rent it, and I know it's already gone.

"The people [who] you hung out with when you were first out of college and starting art spaces with, are most of them still doing art?" I ask Jackson.

"Yeah, I'd say so. I don't know if anyone's still in the city so much. Maybe 10 or 20 percent were able to stay." *I should have asked where they went.*

"Some people say they need to be in New York City to make art. Can you relate?"

"I don't know, I haven't tried it." he says. *I sense that my question is annoying.*

"Could you imagine it?"

"It's a scary proposition." He stops there. Tick, tick, tick. *Keep your mouth shut.*

He continues: "I feel like the charge might go out of the whole creative process. I have a studio upstate, and I go up there with an idea and jam out for three or four days until I'm burned out, but I think of actually living up there, what that would be like week to week, month to month. . . . It's an unknown prospect. Maybe I'd get up there and all my shit would be up there and I'd get into it, or it'd be completely alienating."

Fair enough. But I want him to tell me straight up that he needs New York. Explain why it's so important to be here and not somewhere else. I want artists, musicians, writers, performers to fight for it. All in, this is mine, strength in numbers. Never saying goodbye, never giving up.

"It's the lack of sociality, of just even noise and chaos and whatever it is about New York, gives you some sort of an energy," I say.

"Yeah, definitely. It's very inspiring here. Friends, colleagues, contemporaries doing stuff over time, getting the overview.

There's this gallery on 2nd Street, Howl! Gallery, that's stepped up to promoting and helping with the old- or original-school East Village, Lower East Side artist community going back to Ginsberg and people like Alan Vega."

I saw Alan Vega at a Polish discothèque in Greenpoint in 2004? 2005? On a weeknight, a Tuesday, I think. We waited for hours drinking vodka sodas out of thin plastic cups, clear not red, and he came on after midnight growling and screeching. He smacked his mic against his body, like he was tapping into, summoning, a more degenerate self so he could beat it up. I couldn't make out what Vega shrieked, and it didn't matter. Now I say I saw him before he died like it's some kind of trophy. I saw him in New York, well, in Brooklyn, and it's like he was skulking back to where he began, born 1938 in Bensonhurst, Brooklyn—Boruch Alan Bermowitz. Vega changed his name to fit who he wanted to become. I was part of his community that night and there were about ten of us.

The word *community* is a vacuum, like its counterpart—creative. I read the phrase "vibrant arts community" in academic publications, arts foundation boilerplate, and real estate copy. On Corcoran.com, a section advertising Gowanus reads: "abundant loft space has proved magnetic for *creative exploits*: Gowanus boasts one of the most vibrant artist communities anywhere in New York City." I know *exploit* is meant to be synonymous with activity or adventure (look at the zany artists), but I read it ironically, to mis-use and manipulate.

I read that in the fifties in New York, you could work one day a month and make rent. That's when the West Village was still a village, and painters and poets hung out at the "magical" Cedar bar eulogized in Mary Gabriel's *Ninth Street Women* as a "blank canvas animated each night between ten P.M. and four A.M. with talk, laughter and the occasional brawl."[9] Like the

Chelsea Hotel or a nineteenth-century Latin Quarter cafe, the Cedar generated a scene where "a young Monet might sit at the table and listen to his elder, Courbet,"[10] while getting drunk on fifteen-cent beers.[11] Twenty-first-century artists have no mythic Cedar, no fairytale place.[12] The city is too overpopulated with creatives and wine bars, and a professionalized artist, a genius, or a fellow wouldn't slaver nights away at a corner bar. Nobody has the time and vomit isn't grammable.

The idea of an artist community is lobbed around and taken for granted, a given, like democracy. I've seen microcommunities, with a small *c*, tenuous and short-lived. When I read about artists' communities, they sound BIG, zones where thousands of artists permanently live. When I was renting in Bushwick between 2009 and 2018, there were probably hundreds. Communities scatter, and within ten years, I witnessed the flip—rental turnover, a new legion of artist-graduates, a recession, a virus. In the past, cheap housing anchored artist communities. Painters, poets, and musicians could hang out, come together, break up, collide on the sidewalk. This isn't some mythic bohemia, or an artist utopia, it's just a neighborhood. I've felt like a phantom walking through gentrified districts, as if erased in post-neighborhoods, someone with no place.

Professors tell students their classmates will be their community after the MFA ends. An institutional tribe bound by prestige, they'll support one another, do studio visits, show up at openings, curate each other into exhibitions at artist-run spaces. For some cohorts this works, for others, the social lifeline vaporizes. Harper said: "You can't buy a real community of friends for a hundred grand. Communities, or friendships happen over time by accident, you need to bump into people." I bump into people, but I don't know what most of my transient neighbors do—production? finance? freelance? We make eye contact, wave, keep walking.

12

GOOD HOUSEKEEPING

Prepare for hyperbole. The Chelsea Hotel was the greatest experiment in Bohemian living in the history of New York. If you're not convinced, there's evidence to prove it. Sift through the songs, books, poems, paintings, and films made at or about the hotel. Consider all the black-and-white photos. They drape and list onto each other and the fire escape that suspends them above West 23rd Street; they slink on beds like cats. Their style unalloyed and erogenous—low-rise jeans, chopped hair, turtlenecks, cheek bones.

Like sonic headstones, Joni Mitchell's *Chelsea Morning*, Leonard Cohen's *Chelsea Hotel #2*, and Lou Reed's *Chelsea Girls* memorialize. William Burroughs wrote much of his junk-lit novel *Naked Lunch* at the hotel, and Valerie Solanas worked on *SCUM Manifesto* and *Up Your Ass*, the play Warhol refused to produce. Niki de Saint Phalle made one of her shooting paintings there, firing bullets into bags of paint attached to canvas.

A kind of fabled Atlantis, it's hard to resist mapping out New York's lost Bohemia by room number. Writer Dylan Thomas drank himself to death in room 205 in 1953. Twenty-five years later, Sid Vicious probably stabbed his lover Nancy Spungen to death in room 100. Robert Mapplethorpe took

his first photograph in room 1017, and Warholian socialite Edie Sedgwick set room 105 on fire. At the Chelsea Hotel, the worst moments are hailed as its finest. With time, creation and destruction achieve equivalency, verifying artists as mythically tormented and badly behaved, everything we expect from Bohemians. We'll never kill our darlings.

In Dee Dee Ramone's *Chelsea Horror Hotel*, the protagonist is always high or feening.[1] The gigantic roaches that plague the hotel refuse to be killed and are only pissed off by bug spray. Like human New Yorkers, they adapt to the most hostile conditions. The sepia tap water reeks of sewage, and satanic rituals are performed in a tongue-in-cheek blood bath in the basement. Throughout the book, the manager manically hunts down hotel guests looking for rent, indifferent to the decomposition. It's hallucinatory auto-fiction born of the Chelsea as it sputtered in and out. The black bile of the punk poet, I can't resist it. The hotel's residents can't remember every detail, nor can I. All that matters is how you tell the story.

There would be no Chelsea without Stanley Bard, the "Robinhood of innkeepers."[2] Under Bard's management, for more than forty years, the Chelsea was a semi-safe house that set off all kinds of queer interaction. A place to rent a room by the day or for a few nights, and a transient home for artists who lived there for months, or years. A sanctuary and a dump, some stayed on. Designer Betsey Johnson left her husband in 1969 and arrived with a toothbrush planning to stay only for a few days; she stayed for eight months.[3] Viva, painter, actress, and Warhol superstar, lived at the Chelsea on and off for two decades. She recalls: "Stanley paid attention to artists, he loved them, but couldn't see that the dust on the staircase banister was always two inches thick. Not once, did Stanley open the filthy venetian blinds in

his office the whole time he was there."[4] Arthur Miller, who lived there for six years in the sixties, said: "This hotel does not belong to America. There are no vacuum cleaners, no rules and no shame." An ideal spot for people running away, or recovering from, the cultural oppression of fifties mainstream America. The stifling normality illustrated in the quest for perfect Hoover lines on suburban carpets. It welcomed generations of eccentric outsiders: beats, hippies, punks, drag queens, and perpetually precarious New Yorkers who Bard liked. People dropped out and made a mess of themselves and the hotel. He ranted; he shrugged.

The Chelsea reveled in its own dirt—the particulate matter and the gossip it generated. In many ways, it was born from it. There's a French saying, *nostalgie de la boue*, a yearning for the mud, a longing for a less civilized and structured life. Mud is unbound from social constraints. Self-indulgence and freedom, any kind of artistic calling, usually leaves a stain behind. Much of New York nostalgia is congealed in layers of sediment.

Not an apartment building or a hotel, the Chelsea was something else, encouraging sociality unlike any rental unit I've lived in. Suzanne Lipschutz, who formerly owned a vintage store in the West Village that many artists frequented, moved in there in the early nineties. A resident for more than two decades, she has one of the few rent-stabilized apartments left, and the current owners offered to relocate her to another floor. Lipschutz is staying put. "We had so much fun. . . . If you were sad about something, you could get in your nightgown and go to someone's apartment and cry. If someone was cooking, they'd share their food. . . . You were never alone," she said.[5] The idea of boundaries didn't apply when it came to personal or physical space. Bard let Lipschutz collage the hallway leading to her apartment with obscure vintage wallpaper from her collection. Every room and

floor customizable, whether Bard gave the okay or not. There was no such thing as a security deposit. It's like everyone owned or stole a piece of it.

I stare at my hand, take a deep breath, timidly press the numbers. The phone rings three times.
"Hi, is this Viva?" I ask.
"Yes." She says, like WTF, of course it is.
"I got your number from my friend Alisoun. She said you said I could call you."
"Ohhh, *okay*, I remember her saying something about that. A book or something. Wait, what is it that you're doing?" I imagine Viva's been asked the same questions for decades, pigeonholed into superstar history. Whatever I told her I was doing was satisfactory, and then we were off. We spoke for well over an hour, almost two, and then Viva snappishly announced she had to go, "paint is drying." "Call me back tomorrow!" Click.

Viva (born Janet Susan Mary Hoffman in 1938) can't remember everything and has little interest in dates and details, which I appreciate. In conversation, she easily ricochets off topic as if the next train of thought is more interesting than what she's articulating right now. Her association with Warhol will always be a "raincloud" that trails her. Do not ask Viva what Andy was like. She has no patience for nostalgia. I get that. Enough has been written about Warhol, and his role in pop culture (he predicted the Kardashians and would love them, obviously) and contemporary art. His cultural impact and persona overshadow everyone he worked with, especially the women he *chose* to be *his* superstars. Viva, like Brigid Berlin, Candy Darling, Ultra Violet, and Edie Sedgwick, broke free of the mid-century gender roles that girdled them.

Warhol made them celebrities, but their bravura made Warhol, too.

In the arts, as in most occupations, women had to fight, sneak their way in, or gain entry by proxy. Before they could attend art academies in the early twentieth century, and after, successful women artists were linked to men who held cultural power. The feminist art historian Linda Nochlin laid it out in 1971, when she answered the question she herself posed: "Why Have There Been No Great Women Artists?"[6] Many who made it inside had intimate connections to a famous man as friend, lover, or father. See Diego Rivera and Frida Kahlo, although now people discover Rivera's work because they are first introduced to Kahlo's. After death, it's his connection to her that seals his legacy as a great artist.

Viva's mercurial tie to the Chelsea extended over twenty years. In the sixties, she moved in for the first time with her sister for just three months. Bard padlocked her out of her apartment because she didn't pay the rent. Then she was "off to Europe to work on films." She can't remember the particulars. Then she was back living at the hotel with her husband, filmmaker and artist Michel Auder, whom she "didn't realize was a drug addict" when she married him.

"Wait, I have to ask, did you collaborate with Michel or other artists?" I interrupted.

"I think that's been exaggerated, people making art together at the Chelsea," she said. Not everyone agrees on what happened or how it happened; the details get lost in the collective memory. Stories of daring collaboration are more memorable than banal solitary efforts.

Bard ran the hotel *un*professionally. If someone was dictating operational procedures, he chose to ignore them. He didn't manage the Chelsea as much as curate it in an ad hoc style based on his tastes in people and art, like his own Bohemian atelier—an exhibition costarring artists, addicts, outcasts, intellectuals, and

wealthy dilettantes. It was New York's rogue artist residency program with a batty admissions process. He had his favorites. Viva remembers he especially liked Larry Rivers, who "came in one day to sign a painting and you could see Stanley was *soooo* proud of Larry." His relation to capital was good for artists but unsustainable. Stanley himself said: "Over the years people here have created some really beautiful, meaningful things, and they just needed that little bit of help to be able to do it. This hotel has heart and soul and it's not all about the bottom line!"[7] As Bohemia's dysfunctional daddy, Bard supplied an incubator, albeit one without temperature control and sharp stucco walls.[8]

Families are conjoined by emotions and economics. Viva was usually broke and late on rent, and Stanley threatened and chased after her. At one point, she owed so much that he stole a one-thousand-dollar check, money she earned from "some photo shoot with leather." Viva lived there again in the eighties with her two daughters. She was constantly in court with Stanley, as were others. "The whole place was illegal, well *maybe* eight legal rooms" in the entire hotel. Illegality meant hassle and paperwork, collecting evidence of neglect in the form of mold and holes. Tenaciousness did eventually pay off. "One day someone with a big apartment moved out, and Gaby (her daughter) and I went up there with a sledge hammer and knocked down some walls," said Viva nonchalantly. Simple as that. A free upgrade for the family, delivered by muscle and moxie. Shall we tear it down? Of course. That's what's striking: she didn't agonize about being kicked out on the street. If the city didn't have room for artists, they'd make it themselves. That's just the way it was. I read somewhere that Viva owed two years of back rent at nine hundred dollars a month. Eviction wasn't an epidemic back then.

I asked Viva if she thinks it's more difficult for artists to get by in New York. I told her that was what I was writing about,

now and then. She said: "It was always hard for artists. We were always running from landlords. It may be more sped up today, but it *felt* the same back then to us. Nothing's really changed." It always feels precarious. In the sixties, they said it was cheaper and easier to live in the fifties. Go back a decade or two or a few years before you moved here. Nobody has ever told me it was easy to live as an artist in the city, regardless of the sociopolitical conditions or the historical moment. This is how they remember it; what it felt like.

What they lacked, a permanent place to live and a stable nine-to-five job, are the ingredients that made the myth. Unlike today's academy-trained, creative entrepreneurs who are compelled to work 24/7, artists could be unprofessional and broke. Bohemianism was antithetical to being LinkedIn. The refusal to conform to the indignities of a crummy job seemed possible and acceptable. Jean-Michel Basquiat came home after one day of art handling for wealthy collectors and said, "I'm not going to work for the master."[9] Dropping out is doable if you make the right moves at the right historical time period in the right place. It's also easier if you don't have school loans and can skip out on the rent for a while without worrying about your credit score. Old-school networking works, too, especially if you find a hookup and make the rounds—sleep with musicians, playwrights, photographers, wealthy collectors, and gallerists. You can get written up and photographed into history. The Chelsea Bohemians dialed into self-promotion before the age of creating content, but even some of them couldn't escape from being "hyped to death."[10]

Stanley Bard died in Florida in 2017. "His whole reason for being and identity was the Chelsea, and when that was taken away, he fell apart," Viva said. So did his Bohemian experiment.

The hotel sold for two hundred and fifty million dollars to the owners of the Bowery, a boutique hotel named after the street and the area once called skid row, home of Bowery bums and bread lines. In April 2022, the Chelsea emerged as a Disney-fied urbane landmark, much like the Bowery where you can be a Bowery King for $455 a night. (A reader said this is what hotels cost these days, and $455 didn't register as a big deal. He advised me to cut this bit.) At the new Chelsea, you'll stay in the room where Sid stabbed Nancy, with amenities. You'll sleep soundly where Dylan and Morrison stayed up all night. The affective power of Bohemia repackaged as a priceless gold-card experience. From punk to posh: a night in the Bohemian museum. Tourists are eager to book it, post it, like it, and review it: "Loved the vibe of this boutique hotel. The staff were awesome! *Loved* my suite and enjoyed time in the bath. Bed was super comfy" (Farrah, Bookings.com).

Every generation—the greatest generation; baby boomers; Gens X, Y, and Z—is said to have a certain personality formed when vastly different people pass through time together. In living through societal changes, a generation shares certain memories and develops a collective consciousness that anchors the self in not only *I* remember but also *we* remember. Monumental generational moments bond to death and technology. Some people remember Myspace and flip phones, others recall where they were when Bobby Kennedy and Dr. Martin Luther King were shot. In New York, people remember when the subway cars were covered in graffiti, when men cruised the Chelsea Piers for sex, and when the riots exploded in Tompkins Square Park. Generations of artists remember certain spots: CBGB, Stonewall Inn, Saint Mark's Place, Max's Kansas City, the Chelsea.

We used to agree that time flows in one direction. A collective perception measured in three intervals—past, present, future.

Technology has unbolted our relationship to time, dissolving time and space, tempting us with the ability to fact-check our memories or wallow in search of another time that is/was/is always preferrable to the present. Ancestory.com is personal deep time, and genealogy is a past time. We can go back and root around for answers (fact-check). If your memory doesn't serve you, just ask Google, consult Wikipedia, ask Alexa.

What is a Bohemian? Urban Dictionary defines it as "An individual looked upon in society as strange and different. Imagination controls a Bohemian's life, a lot of the time destroying them in the process. Bohemians care very little for money and (some) stay secluded spending their lives creating art, music, and literature. Without Bohemians, the world would be a complete bore."[11]

Many famous creations were that of a Bohemian. #Artist #fruit #musician #loner #eccentric

The Chelsea was more mausoleum than movie set when I spent a night there in 2007, the same year that Stanley Bard's family and the board of directors wrestled it from his hands. I came to celebrate the publication of a book about Vali Meyers, an Australian artist who squatted in a valley in Il Porto, Italy, for almost forty years with dozens of feral dogs, cats, chickens, goats, and a very old turtle. A regular at the Chelsea when she annually traveled to New York to sell her work, Vali was known for her trippy paintings made late at night, tattooing Patti Smith's leg, and communing intimately with downtown artists and musicians. Vali was mostly remembered for the way she was. In Dee Dee Ramone's words: "extreme, a shocking sight," with her ratted red hair, cerulean eyes circled in black kohl, and peasant costumes (layers of lace, silk, amulets, and on occasion, a trench coat), suggesting she was coming fashionably undone.[12]

She also walked around Manhattan barefoot, tattoos all over her hands, feet, and face. I think that's the shocker, Vali had the temerity to mark that beautiful face.

Radiating the right kind of feral, Vali embodied the aura of the Chelsea. At the book launch, part party and part wake, we hung out in Vali's old room, which someone said was Dee Dee's former apartment. The space was cluttered with nostalgia and stuff. A crystal chandelier highlighted the grand disorder: stacks of books shoved wherever there was room, drawings, paintings, mirrors, and photos hung salon style. I've come to think of clutter as the insulin of New Yorkers, a means of regulating energy. The older male guests sparkled when they talked about Vali. They asked me how I knew her, and I kept saying I never did. Their stories laced with certain words: mystical, beautiful, witch. Vali was a "real fox," who herself had domesticated a fox she named Foxy. I read she kept Foxy as a pet for fourteen years and was invited by Donovan to dance to "Season of the Witch" at the Royal Albert Hall in 1967. In a photo, Vali cradles the fox to her chest and both glare directly into the camera. You will never capture us.

Out of time and place, I was a stranger in Vali's world of the living. Scanning the room, I recognized poet Ira Cohen, who I interviewed a few months earlier about Vali. I was invited to write about her for a book on New York's lost tattoo history that never got published, also lost. Ira and I spent a breezeless August afternoon in his musky Upper West Side apartment. Ira held court, plunking down on his couch in an oily dent that quickly molded to his body. Sinking deeper, the piles of books and yellowed clippings surrounding him seemed to grow higher.

I pressed the record button. Like many other men I spoke with, he was still infatuated with Vali or what she represented—freedom. A woman who would never settle for only one man

or stay in one place. His Vali stories veered randomly to Jimi Hendrix, William Burroughs, Paul Bowles, Jean Genet, and Tangiers. He took me so far out. He then advised me not to get any more tattoos, not to go overboard and "ruin my body." Before I left, Ira handed me a book of his poems and inscribed them to me. A dash of holy water. Fortunate to be baptized by the old guard, an authentic New York Bohemian, I also felt covered in a film of macho hippy grime. The poetry book went missing the four or fifth time I had to vacate apartments because the building was sold or the rent wildly increased. In my experience, moving boxes from the liquor store never contain all their contents.

But, in that moment, in Vali's room at the Chelsea, Ira either didn't remember me or have any interest in small talk, barely grunting in my direction. Ira remained stuck to the couch the whole night, looking cranky and unwell. I thought he might be near the end, like the hotel and the last of the Bohemians. The more mobile guests perked up when someone entered the room, a gaunt woman with a miniature black top hat angled on the side of her head, and a couple in their sixties who looked like they lived down the hall or in a storage closet. There were two older kids dashing in and out, maybe eleven and thirteen, comfortable mingling with adults, excited to breathe in second-hand weed. It wasn't their first time at a party. They were New York kids, raised in Bohemia's dust.

After a few hours, when someone new appeared with liquor, glasses enthusiastically raised in the air. The cheapest vodka, screw-top wine, and canned beer—yes, please, fill it up.

Pinned in the tiny kitchen, I leaned against the fridge and began to feel the hotel's élan. It didn't come over me in some cosmic wave, more like water dripping from a broke faucet. I watched Edgar, poet and playwright, a delicate man with a pronounced widow's peak. He does not have one, but this is

what I saw. He looked like a cross between a Transylvanian aristocrat and someone on the streets. Edgar spoke like he lived in a kingdom by the sea, lost in reveries rather than a walk-up on East 10th Street. He rented that apartment for thirty-five years, until his building was sold and he took the buyout.

Edgar didn't speak loudly, but his voice was so theatrical that every single word mattered. Each *sssillllllable* was off—slowed down and nearly mispronounced. His delivery tinged with a goth southern drawl, *Vaaaalli was, of courrrse, quiiite exceptionallll.* Toward the end of the night, I watched Edgar's hunched silhouette, his body and its reflection on the window behind him melt into the New York skyline. I thought of the allegory of the cave and how we experience the world through our own shadows.

I e-mailed my friend Alisoun a year later because I couldn't remember his name. That guy, I wrote, "Do you remember that guy with the incredible voice we were hanging out with at the Chelsea?" Al responded immediately with this message that remains in my inbox:

Edgar Oliver (212-XXX-XXXX)
would you care to call him? i wish that i could right now.

I never called him or went back to the Chelsea. I made one memory, and it was enough. I didn't want to go trolling for another experience. I wasn't looking for more content.

Roughly a decade later, a man who once stayed at the Chelsea found beat-up graffitied doors in the trash, insisting they be saved. In 2018, the doors to the most infamous rooms were auctioned off for upwards of one hundred thousand dollars. The door to where Warhol filmed Edie Sedgwick for his 1966 film *Chelsea Girls* sold for fifty-two thousand. As pieces of the hotel disappeared or were ceremoniously relocated to well-to-do residences,

Edgar Oliver became a regular on the Moth Stories series, the live NPR podcast. I've watched his archived performances online, Bohemia channeled through another screen, delivered at my convenience. Edgar on the TV, a click away.

I want to believe poets still speak in narrow rooms with tin ceilings. I want to believe people still go downtown to hear a poet speak.

Appropriated and commodified, an umbilical cord that was never attached, the Chelsea as mirage is easy to access. Yesterbaters and artists—always on the run from rent, always waiting to get a gallery, always applying for another puny grant—can take shelter in New York's imaginary home.

13

HANDLING

"The term collector is really *weird*," Andre said as we idled in bed, refusing work.

"Because anything can be collected—stamps, baseball cards, bags of trash?" I asked.

"No, it sounds creepy to me. Like a serial killer collecting human bodies in their basement. It sounds creepy, doesn't it?" he said.

"People use to collect shrunken heads from the Amazon," I said. Andre eyed the chipped coffee cup in his hand I collected from the faculty kitchenette in the dean's office.

"I'm a collector. That's a slippery word because collectors typically aren't just collectors. They're moguls of industry. They get their money from somewhere," he said.

"It's a way to make more money, a hobby, a birthright, all that," I said.

"Maybe there's a correlation there. In the way that you're saying artists aren't just artists," he said.

"Meaning they do different jobs to make rent?" I asked.

"Right and collectors do multiple things to buy outrageously expensive art, and artists need to be other things, like dishwashers or art handlers, because they can't count on selling

their art. Everyone in the art world has a secret side hustle," he said.

"It's vulgar to disclose a need for cash, or to flaunt its accumulation," I said.

"Everyone keeps the secret," he said.

The light pollution bleaches out the stars. Even on the third floor, I can't find them at night. I only see blinking red lights on planes hovering toward LaGuardia. I know stars are somewhere in the sky, just like I know space is mostly dark matter.[1] Invisible and elusive, its gravitational force keeps the universe from flying into pieces. I also know it's statistically safe to fly in a plane, which I have done many times, but in my imagination, I continuously explode in a disintegration loop when I'm in the air.

The activist/artist Gregory Sholette describes the artist 99 percent as the dark matter of the art system. This constellation—the un- or underprofessionalized—accounts for most of the artistic activity produced in postindustrial society.[2] He writes: "This activity is invisible primarily to those who lay claim to management and interpretation of culture—the critics, art historians, collectors, dealers, museums, curators and arts administrators."[3] While astrophysicists are committed to figuring out what dark matter is and how it works, gatekeepers are apathetic to the labor they're dependent on. Art workers are lost in the spaces they make.[4]

Half of the professorial work I'm expected to perform is repetitive, bureaucratic, and emotionally onerous. I have a good job: one high in prestige, lower in pay and increasingly precarious. I recognize, as I'm told frequently, that I'm lucky. I'm not an adjunct, a member of the expanding, exploited contingent labor force that is academia's dark matter. Credentialed, titled,

and tenured, I often fantasize about quitting. I daydream about making work rather than doing the job I'm required to do, where I'm surveilled, penalized, and can be "turned in" for saying something triggering or too political, or furloughed and cut as nonessential in the process of strategic realignment. There are those who say buck up, this is the adult world of work. A job isn't play. To consider the notion of happiness while on the clock smacks of privilege.

Time to lean, time to clean. Bosses have said this to me. I learned there's no downtime as a waitress and food-court employee. Always a ketchup bottle to wipe down and refill, napkins to fold in half. I learned I must never stand still or I could be accused of stealing time. Letting your body lean, allowing your mind to drift, is criminal, unless you're engaging in a repetitive activity like wiping and folding. I've always had issues with the clock, especially after being instructed to punch one. In *SCUM Manifesto*, Valerie Solanas implores women to disobediently reject working within patriarchy, to become members of the UNwork force.[5] I remember reading this for the first time and clutching *SCUM* like a sacred text—*vade mecum*, Latin for *go with me*. I still want to scum the system. I want to UNwork.

Artists should disguise the fact that they work a job.[6] Labor under the radar to keep the worker-self distinct from the artist-self: two discordant identities. Avoid being identified as a hired hand—handler of art, mover of art, but not a maker of art. To have to work signals your art isn't selling, you're lacking in generational wealth, or you're an average downwardly mobile, overeducated millennial. Andre explained: "Being wealthy is seen as normal, and if you're the guy on a ladder in a gallery, you're a guy on a ladder. Nothing more." I wonder if this ties to the artist-as-genius myth. A genius

couldn't be expected to spackle walls and lift bulky crates off the back of a delivery truck. It's a waste of brilliance.

Don't be anything in the art world but an artist. That said, working in an office as an assistant registrar or photo assistant is a half-step up the occupational staircase. White-collar workers are often paid less, but to *assist* sounds more genteel than being charged with moving or installing. To be a mover is to be anyone who can lift a heavy thing. Consider this from a New York Foundation for the Arts (NYFA) job advertisement for an art handler: "Ability to safely lift 70 pounds and maneuver objects of substantial size and weight on a daily basis without damage to object or person, including the ability to push and pull 150 pounds." A body that can relocate objects, an extension of other instrumental machines employed in the movement of art—a forklift, a dolly, a c-bin.

When I asked Liam if being an art handler could harm his career chances, he knew what I was getting at. He said it was risky. I wanted to know if he thought about being damaged by physical labor, but we veered off into the dynamics of class.

"I think it's right. I think the market economy that I'm learning about, and I'm seeing, is closer to the fashion industry. It's a very classist industry," he said.

"In what way?" I asked.

"It's like, *Oh, don't talk to the help*. It's like the same people that would go to a restaurant and treat the waiters like shit are the same people that buy artwork that sells for millions of dollars. And the people that I interact with on the corporate level are collectors, usually. So there's an elliptical kind of thing, but these are also the assholes that people are afraid of," he said.

"But what do you think about being seen as a worker rather than an artist?" *I'm trying to steer him back to my original*

question. I think I was supposed to ask the follow-up: "Why are they afraid?"

"I don't know, but there's a staff show coming up, and they give the staff an opportunity to show their work. And I'm really skeptical. I'm really dubious because it almost seems like there's a manipulative or under-the-table scheme going on where it's like, 'Okay, we know this person is never going to get representation. In reality, this person is never going to get seen,'" Liam said.

"Why do you think they're thinking that?" I asked.

"Well, because you have your observations and then there's inferences, and then there's the truth. Sometimes those things add up in a way that's just really embarrassing to me as a person and a young painter who's been through a lot of art school, a lot of actual work. . . . It's a classicist thing that's disturbing to me."

"What do you mean by *the truth*?" I asked.

"It's just by seeing it. It's just by going up to people that are specialists at the auction house. And then there's me who's one of the warehouse people. The uncivilized, the uncouth art handlers, the pigs, the drunks, the fuck-ups, the whatever. And then there's the suit-wearing people that are chivalrous, like white bread."

Liam's degrees and painting skills dissipate into a vacuum. He never said working at the auction house would affect his potential to be made, but he knows "he's shit." He's netted in debris within the bowels of the system.

It's often argued that artists are distinct from other precarious workers because they have cultural capital. They aren't that exploitable, they have choices, or they work for the love of art itself.[7] You can't get a lease with love. In 2019, New Museum workers voted to join the national autoworkers union to ensure

fair pay as the museum underwent an eighty-five-million-dollar expansion. The museum hired a firm of "union avoidance consultants," which quickly backfired, resulting in an open letter of protest signed by curators and artists.[8] Art workers, like Starbucks and Amazon employees, are often college-educated. Workers able to decipher antiunion rhetoric with nothing to lose by revolting. There's always another crap job available.

Moving a seven-million-dollar photograph in a custom two-hundred-and-fifty-pound frame involves muscle and precision. Because art handlers carry and hang weighty objects for eight to ten hours a day, they sometimes visibly sweat, which is unwelcomed. Perspiration, like dirt, is repellant within sterile art ecosystems. A human hair appears as out of place in a Chelsea gallery as it would on a plate at Le Coucou, a French restaurant in SoHo. Latex gloves mask art handler's greasy hands like doctors holding organs that can't risk contamination with pathogens. The consummate handler will also *possess a developed sensitivity for interacting with clients and understanding of job site decorum.* When the very important people—gallery directors, tycoons, a curator from the Whitney—enter the space, handlers must disappear into the walls. It's a Goffmanian performance of self on a hygienic stage, a balancing act and a magic show.

Art workers participate in the theatrics of staging art and are often familiar with art history and theory. They know what's going on in contemporary art scenes, from the top of the corporate system to the underfunded broke bottom. If they're mounting shows and curating events at artist-run spaces and also working at major institutions, they have a 365-degree perspective, but they look like bums.[9] Many know how the work is made, especially those who have technical skills and MFAs. Art dealers and collectors probably don't, although the making

part isn't interesting (imagine watching someone mix paint). People don't consider where, how, or by whom their Birkin is constructed. Karl Marx theorizes that human labor is obscured in the process of commodification, imbuing objects with magical properties, a life of their own. Possessing art is pure fetish, nobody wants to see art workers attached to the object. It's like imagining a pornographic actor grocery shopping for cereal.

Expertise doesn't translate. Liam said: "There's times I've been asked by people that are supposedly specialists in materials, 'How do you think Salle did this?' And I'm just like, 'Oh, it's latex paint with a loose binder over it.' You can just see—it's just like one, two, three, constructed like this. Because I've spent so much time doing it."

The "low-hanging fruit" know their knowledge is irrelevant.

"There's this notion that if you want to get representation, get sales, have some modicum of success, then you can't be seen as a worker," I said.

"No. No way."

"Why is that?" I asked.

"Well, I'll tell you right now in one sentence: Because no one is going to buy a painting for a million dollars by the guy who sweeps the floor," Billie said.

"Unless they're Henry Darger," I said.

"The word is *stigma*. There's this stigma, and it comes with being associated with the common man," he said.

"Someone average who works a regular job?" I asked.

"Yes. If you are a *professional* artist, you are uncommon. The things you make are uncommon because they're valued. This thingy, tchotchke, sculpture, whatever, it can't be created by the hired hands," Billie said.

"There's a distinction between the person who builds the crate and an artist with a capital A."

"For sure," he said. "And that's a lie. In one way it's a lie because they're pumping the artists out of art school and they're all learning the same shit. Where's the distinction?"

"Okay." *I'm losing control of the direction of the conversation.* "But I'm really getting at social class. That's what I'd like to talk about," I said.

"Nobody ever talks about it. I'm not going to go around complaining about my loans or how I can't afford rent. People making art all the time without working a job and selling their art are from the middle class or affluent. Like the kids of bankers and financial analysts or oil barons I saw in art school. Now they make art full time. I don't think they're living off NEA grant money or totally off sales," Billie said.

"They just make art," I said.

"They have time to do it." Billie stopped and looked directly at me. "But what do they have to say about anything? Maybe they're making beautiful objects to ponder. Stuff for the foyer that fits the collector's aesthetic. That's the world they know, where they live, so there's a place for them and their art. . . . Also, their family's friends or business associates will buy it, so they start their career with the advantage that someone rich will collect their work. Do you think this is lost on galleries that need sales?" he said.

"Who are you making art for?" I asked.

"I feel like I'm painting for God, but I don't believe in God," he said.

Art handlers and security guards commune with the sacred. It's intoxicating to have access to invaluable objects, to be alone with them, to touch them, to be so close. Olive said of working at the Metropolitan Museum of Art (MoMA): "You're working in an institution that values art. Period. I just stand around and I look at art all day." Imagine spending hours, weeks, and

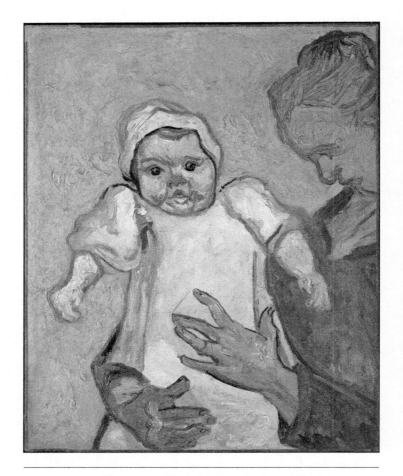

FIGURE 13.1 Vincent van Gogh, *Madame Roulin and Her Baby*, 1888, Metropolitan Museum of Art, New York City.

months of your life with van Gogh's *Madame Roulin and Her Baby*, staring into the infant's haunting eyes, the child of a local postman whose entire family van Gogh painted. Or contemplating Rembrandt's *Self Portrait*, his devastated face, the creased brow, ruddy bagging skin, weary eyes. Rembrandt was fifty-four

when he painted it; by then, he was bankrupt, his wife and child dead. Olive said: "I'm the closest. I spend the most time with art than anyone in the building, even curators. It's always the security people. I really look at the collections." She stopped for a moment, "I've been looking for twenty-two years."

Billie said working with certain artists is rewarding: "If I'm helping an artist see their vision, I get joy in that aspect . . . seeing other artists and being around like-minded individuals who are the same as me. And they know it, unless they're idiots. . . . They know that they're one in a million and that they got lucky. Because big artists have gone to the same schools as nobody artists. If they talk to me about what they're up to, it's a community."

I think there may be camaraderie among people who've had the same experiences, but within a competitive, irrational system, I wonder what community means. Working with a crew, speaking the same language, and enduring managerial slights creates a bond, like ties that form in dysfunctional families. They share a social identity. Recognize each other as artists first and coworkers second, bound by a deep longing.

This isn't a tell-all. People ask if I've heard any dirt about dealers and curators. When powerful people misbehave it's lurid, there's more at stake. I don't have much to write and that's not my angle (I favor the underside). Art workers don't have much to say after signing confidentiality agreements; everything witnessed or heard is private property. Their museum and gallery memories classified. Some defer like domesticated creatures, careful not to nip the hand that could toss a spot in a low-stakes group show. Such scraps (opportunities) are often thrown in July and August, when the city is putrid and the moneyed are on Majorca.

Artists represented by megadealers are aided and abetted in every conceivable manner. Staff nod and beam, tolerate bizarre

and obnoxious behavior. Indelicacies excused, their every quirk and desire honored without question. Art handlers, like assistants, find themselves as the subject of, or witness to, tantrums and meltdowns. Missing from the job description: *The ability to liaise with artists who exhibit signs of intermittent explosive disorder is preferred. Poise and discretion are essential.*

A seasoned Chelsea art handler was charged with the task of keeping an eye on Frank, a midcareer art star, while he made work for his upcoming exhibition directly on site in the gallery. Frank, a legend, is an unpredictable alcoholic known for his less-than-professional behavior, which includes, but isn't limited to, explosive screaming fits, throwing and smashing nearby objects, wielding a golf club, and intentionally or drunkenly destroying his own work. Frank's persona, his mania, seamlessly pairs with his signature garbled aesthetic. Frank's art has attitude and is collected by celebrities with attitude.

Here's the story. Someone in charge, let's say a senior partner, determined that Frank shouldn't be trusted to paint alone. "Nobody in the shop wanted to do it; they foisted him on me," said K., Frank's handler, who sat in a single chair in the enormous gallery, monitoring Frank while he painted. K. was told to, "just hang out" and assist, like if Frank needed a sandwich, and more important, act as security guard in case he started pissing in the corner. K. said, "It was so awkward sitting in one chair in the gallery, so I just started drawing."

Frank did acknowledge his handler K. by asking if he was an artist, the elephant in the room. Frank behaved that day, dutifully painting in situ without incident. K. said it was cool to get to hang out with Frank and watch him work. "But also fucked up if you think about it . . . when you would kill to be the person who doesn't feel like being there, in one of the best galleries making art in your house slippers."

The front and face of the gallery aims for political correctness, champions human rights and inclusivity. The minted make sexist, racist, and homophobic observations. They didn't mean anything by it. Like when Hunter, an entitled "artist on the rise" represented by a mega gallery said to M., a queer art handler, "I'm not into that," while pointing to one of his own works composed of sundry penises and porn-style images depicting gay sex. M. laughed it off. Emotional labor is often demoralizing, but it's just part of the job. Hunter's art has been accompanied by a trigger warning in galleries and museums. Offensiveness is his aesthetic, human misery his inspiration.[10]

Occupational sexism in art handling is as ubiquitous as the floated gray concrete floors of galleries. I've only met three women art handlers, and they didn't last nearly as long as the men, some of whom were lifers.[11] Marzanna, a freelancer, was fired for mislabeling an art crate being prepared for shipping, a forgivable mistake she saw her male colleagues make, all of whom continued to work at the gallery. Two other women quit, exasperated with the "bro culture" in the shops. Anika, a sculptor, tried to work in fabrication studios and galleries. She gave up on it.

"It was tough because I was trying to get a production or art-handling job for a while. As a young, female-bodied-person, you have to work harder to get in," she said.

"Let's talk about the gender thing," I said.

"Oh, that's fun," she laughed. "It's pure macho; imagine being in shops with dudes that aren't used to working with women. I had my share of confrontations with dudes that were trying to school me: 'If you're going to use this machine, you make sure that you put the safety on, make sure you wear glasses,'" she said.

I have worked with many dudes. If deemed too feminine, too masculine, too competent, too serious = bad fit.

"I didn't realize how gender biased the art world was until I started going on job interviews in New York, and people look at you like you're young and dumb because you're soft spoken and petite. It made me livid," Anika said.

"You have to amplify everything, which is exhausting," I said.

"It is. That's partially why I was like, 'Fuck it,' you know what I mean?"

"I do," I said.

"I'm not even interested in trying to fit into that male art world. After a certain age, when I hit thirty, I wanted to create my own thing. I'm never going to fit in because I'm female."

Getting in and fitting in is the work of women. MoMA PS1 was forced to settle curator and editor Nikki Columbus's claim of gender, pregnancy, and caregiver discrimination. Motherhood and family life are welcomed as artistic subject matter but not as lived experience. Female workers slam into a glass ceiling, or a lactation ceiling, as Michelle Fisher, former curatorial assistant at MoMA, said, "To argue for basic human rights—including the right to a family life, and to paid leave in order to pursue that—seems to be *just* acceptable when spoken of by artists in the museum galleries, but not the art workers whose labor underpins such projects."[12] Speaking of pins, artist Emilie Lemakis, a veteran MET security guard, made pins for herself and fellow workers to wear as an art project. A commentary on work; how time is money, how a person's social value is reduced to their income, how underpaid most people are. Hers reads: 27 Years/$22.65 HR.[13]

It's the second summer in and masks are optional. All the windows and doors are open. Black Lives Matter protests are winding down, as city workers, mostly NYPD and FDNY, protest

vaccination requirements in the name of freedom. Broadway opens (tourists!), museums open (tourists!), and my musician friends are playing inside again. LES galleries survived. I'm outside an opening at ASHES/ASHES on Eldridge Street, eavesdropping on three painters who've earned the MFA, done the residencies, been employed in the back rooms of the art world for more than a decade. They're talking about the virus, comparing how their bosses treated them, who got laid off from Matthew Marks and Gladstone, who got to live off the six hundred dollars before it ran out. Some were fired (let go); some were called back to work for less money and no benefits as freelancers. Tommy Orange writes, "When the old white monsters at the top threw crumbs and ate heartily from the ridiculous plate that was the stimulus package, you felt the sick need to stop everything and watch it all burn, watch it lose its breath."[14] We watched the monsters take a deep lungful of air and grow stronger. U.S. billionaires gained 1.3 trillion dollars in wealth since March, 2020. PPP (Paycheck Protection Program) loans were received and forgiven in full to blue-chip mega galleries, including David Zwirner ($6.9 million), Hauser & Wirth ($4.5 million), Gagosian ($3.5 million), and Pace ($3.4 million).[15]

I write down pieces of the conversation.

"I want to quit, give notice properly, but I think it might be tricky." D. says to Z.

D. is jealous of his friends who got laid off from galleries and museums. He never took a break, working through the pandemic for a celebrated artist. An essential art-world worker.

"Impossible. I've worked for three different artists and it never ends well, *ever*. They're so egotistical they don't see it as you moving upward, following opportunity, but as disappointing them. Like you are personally causing them a problem." Z says.

"When I told XX (the artist Z. works for) that I got a high-profile residency, he didn't even congratulate me. He mockingly said, "*Okay, ARTIST.*"

"It's like they never had a job outside of the art world," D. deadpans. The artists they work for have always been artists—never waitresses or sex workers. In their studios, they blithely talk of being raised by nannies and the special southern dishes they cooked, the drivers, the second and third homes, their personal art collections.

Z. stares at the goo-stained sidewalk.

D. asks, "Well, should we take this to a bar?"

"Nah, I want to go to bed early and get to my studio by nine," Z. says.

"You should come through and check out my new paintings."

"Yeah, hit me up next week. I'm still in Bushwick."

The sociologist Gary Alan Fine describes being an artist's assistant as a door opener, a strategy. Maybe that was true during the Renaissance or the twentieth century but not now, not in New York. I've yet to meet anyone who worked for an artist who made a direct introduction to their gallery on the assistant's behalf. Said to their dealer: "Listen, you should look at my assistant's paintings. I think their marvelous, as significant as mine, that is, the paintings my assistant makes, which I sign reluctantly because signing work is such a psychic drag."

It looks good after the fact. After the assistant-artist is added to a gallery roster or sells out at an art fair or is reviewed or mentioned in one of the tabloid-like clickbait articles: "10 Artists on the Rise" or "30 Artists Under 30 You Need to Know." Of course, they're great. They worked for an *artist*.

Harper said: "After somebody gets attention and sales, [they] can be an artist full time. If they were an assistant to say, Dana

Schutz, that becomes part of their bio. It's like geniuses attract or they learned some secret from the so-called master." A slog becomes a coat of arms.

At this level, artists are institutions. They run art factories, not like Warhol's, more like Roald Dahl's. One percenters have their own staff: studio managers, personal assistants, art handlers, and people who make part of their art or entirely fabricate it from start to finish. An art handler said that the assistants who work for Jeff Koons's studio are "extremely talented craftspeople" immediately recognizable as "affectless bearded lumbersexuals in a uniform of red wing boots, leather belts and jeans."

Their disposition and costume echo the workers in the chocolate factory as they vigilantly monitor the installation of Koons's massive sculptures, ensuring their precise assembly with custom lifts. Koons employees more than a hundred people to make his work, and according to *Dazed*, "He's been open about his collaborations with artisans across the globe."[16] Interesting spin, his employees are *collaborators*, and when working for Koons, artists become *artisans*. Craftspeople, technicians, and paint mechanics with Ivy MFAs.

Assist with what? It's impossible to know. Assistants may work with an artist for decades on time-contigent projects, part time, full time, or work on call. Some assistants are paid a living wage and have health insurance and 401(k)s, while others work off the books. Beyond making art (painting, pouring, spraying, grinding, sanding, taping, drilling, gluing, sewing), duties include household and studio maintenance, cleaning, feeding animals, buying toilet paper, paying bills, running errands (post office and UPS), and other kinds of essential reproductive labor. The artist may want you to be friend-ish, jocular,

detached, professional, critical, and intellectual or able to sense what emotional labor is to be performed in the moment. Try to leave with a good reference.

 I was an artist assistant for four months when I first got to New York. I watered anemic plants, chipped food gunk off kitchen counters with a steak knife, edited the artist's essays, transcribed interviews and notes, and, once, attended a brunch meeting with the artist's London curator and New York dealer as a stand in. They looked at me like, *why are you sitting here eating poached pesto eggs with us?* I looked down at my discount shoes and wondered the same thing. The artist called me at eleven o'clock at night to talk or to task me with another assignment, which would be due the next day by nine in the morning. The artist talked smack about the other assistants working for them. Tore apart the ones who dared to leave. I never contemplated asking for a reference.

 Some assistants make their bosses work from beginning (the idea) to end. When Governor Cuomo shut down New York, Billie worked as one of Claude's assistants. Claude instructed him to continue making his work in his own apartment and studio. Claude's art was essential. During the first weeks of lockdown, when the subways closed for the first time in one hundred and fifteen years, when New York stood almost still, when the governor was giving PowerPoint presentations on television and taking charge, when refrigerated trucks housing the overflow of the dead idled on the street, Billie drove on the deserted BQE to Claude's studio to pick up materials to make Claude's art, while he sheltered on a vast estate in a desolate area that the virus hadn't reached. Billie said that if the police pulled him over, he'd tell them he was getting medicine.

 "The only time Claude touches the work is to sign it." Billie said.

"Do you think he thinks about that at all?" I asked.

"Deep down inside he does. He has to. There is something fundamentally wrong with it."

Why? *If you make work that is priceless, if you are lauded, lionized, don't you hover off the ground by the pull of ego, wealth, all that genius gas?*

"It makes you a bad artist because you have no real relationship with the art. Too far removed from the object's construction." Billie said.

"Do you think if all of Claude's assistants left, he could make his work on his own?" I asked.

"No, he doesn't have the skills. Well, he could try, but he'd have a hard time. We invented his process; sometimes he asks us something about a material, but then he forgets. He'll ask a few months later like, *How do we do this?*"

"We," I said.

"Yeah, me and the other assistants are the *we*."

"At least Claude doesn't say how do *I* do this," I said.

"He knows how to e-mail, micro-manage, write-off seven-hundred-dollar dinners. I will never have assistants if I make money—I'll work eighty hours a week," Billie said.

"The irony is that the artist is the brand/self, but they are disassociated from all of it," I said.

"Exactly, like they're on autopilot."

The painter and author Roger White explains art-world insiders know that 1 percent artists don't construct (craft?) their own work. It's not the Renaissance; we're post-Warhol and late-stage Koons. It's a naive question, the kind that an out-of-touch sociologist might ask at a party, "Did you know that some artists don't make their own work?"[17] Chuckle, chuckle. Billie does know, and he's disenchanted and without health insurance. A painting Billie made, with Claude's signature, was acquired by a museum.

"I have work in MoMA's collection. People disparagingly say, 'I could have painted that, or a kid could,' but I can say, '*I did paint that*,'" he said.

A friend e-mailed me three months after reading this section. She wrote: "I just don't want to see a reader say, well, so what? How is this any different from the apprentices/assistants who worked under the Renaissance guild system?"

Right, but we don't live in the fifteenth century. It's pointless to compare the art system of Renaissance Italy with the contemporary global art market. There's no equivalency. I don't know what it felt like to be Rubens' assistant, but I know what it feels like to be Billie.

He said, "You'd think making a famous artist's work would fill you with pride, but it's the worst feeling in the world. It turns the artist in you into a fool for hire."

I wrote this for Billie and other art workers. I hope some of it rings true.

14

MELANCHOLIA

Lesson number one: you will likely be poor. I ask the students which social class they belong to, winnowing it down to three categories—working, middle, upper-middle. I avoid the words *poor* or *rich* because they're too moralistic and televisual. The rags-to-riches story, Honey Boo Boo, and keeping up with the K's. Almost all hands raise when I say middle class, the pillow politicians use to comfort voters. The middle has withered since the seventies, but lives on as a persistent ghost category in the American imagination. On Halloween, kids dress in costumes, parade from house to house, knock on doors, and yell trick or treat, hoping their bags will fill with candy.

A student wearing Maison Margiela Tabi boots feels, "privilege guilt." The upper middles, the minority, are uncomfortable but not ashamed. Students raised in NYCHA complexes and basement apartments, the commuters who work full time and give half their paycheck to their families are silent. We're at a state school that educates first-generation college students, offering a "seamless pathway" to community college transfers. We're told that becoming educated will increase our social mobility, grant us access to the world. We act as if there is a seamless pathway.

The poor as a collective social identity, like *the artist*, is an invention. Rooted in essentialism and stereotype, the poor are a perpetually idle, shiftless caste. Values out of whack. Get on board (bored). Get with the program. The artist has the same problem. Making art and brokenness go hand in hand. *I'm good with my hands* is said by a person looking for work. Can do, will do, anything for a job. Needs money now. Artists are exceptionally good with their hands.

From Jerry Saltz's lessons on how to be an artist: "Only 1 percent of 1 percent of 1 percent of all artists become rich off of their art work. You may feel overlooked, unrecognized, and underpaid. Too bad. Stop feeling sorry for yourself; that's not why you are doing this."[1] Self-help, boot-straps, finger-wagging, tough-love. It's all about the art, not the money.[2] He's right of course, every artist battles self-doubt every day.[3] Saltz was an artist, but he turned into a critic. Now his success is quantifiable; he doles out advice to more than a million followers. He lost the battle. That's why he's doing this.

Violet said: "Why am I an artist? I don't know how not to be an artist. It's why my bedroom is tiny and I'm living in a place that I hate."

Olive told me: "If you need to make things, you will make things under any condition." Emphatically she repeats, *under any condition*.

I ask: "Wait, hold on, what do you mean by under any condition?"

Olive said: "When I separated, I got divorced. I was nomadic. I was still doing something." A dissolving relationship. No permanent address. In a state of disorder, making art is *doing something*. Every other activity is the work of getting by, making do.

The myth of the starving artist spread with the birth of modern capitalism, when art began to be viewed as a higher calling

rather than a skilled trade. A divine conviction called artists to work without a commission, without the guarantee of a paycheck. The myth lingers on today, but nobody wants to talk about being broke. I always want to talk money, who sweats it, who's got a trust fund. This makes people uncomfortable—my shamelessness. Writers must always talk about things that embarrass them; money embarrasses us.[4]

My family said the word *broke*, not poor. They said, s*he's broke, but she's riding around in a new Cadillac!* The broke must lay low and be modest, know their place, respect a penny. Don't be ashamed to bend over and pick up a nickel off the ground. I never could feel proud of my broke-ness because it left me broken—worn-out, ruined, damaged. I appear bourgeois. I pay most bills by the due date. I have an office and, for now, a good credit score. But my habitus is working class and wrecked. You can't take pride in being broke in the middle of the professionalization of everything, not in neo-gilded New York.[5]

I'm jealous of people who don't think about money. I'm not one of them obviously, but I write this without sarcasm. I wouldn't write about class if I was born into wealth, had enough money to not think about money every day. I've been told that if I left New York for some place more affordable, I could "live good." I wouldn't be as alive, so I stay and pay the price.

I write to you as a prole, as I've written before and will write again. In the past, when I didn't have enough money, I didn't feel ashamed. I felt rage. I still feel blasts of rage, but they're tempered by waves of melancholia. Plato and Aristotle believed the body was a system of four fluid humors, that poets suffered from melancholia because of an excess of black bile. My class melancholia, my black gloom, lingers in my body and lives in my core. Generated by external conditions, a system existing before me. I was sorted out before I even got started.

I become furious when I'm told social class is not so black and white. A scholar who anonymously reviewed this manuscript wrote that I "portrayed a romanticized starving artist with working-class roots rejecting capitalism, on the one hand, and vapid rich philistines destroying the city, on the other. It's tempting to skewer the rich, but it's not novel." I'm not trying to be novel. I'm trying to be honest, and I am *fucking furious*. The reviewer also wrote: "The book would be stronger if, instead of painting angels and demons, it spent more time on capturing ambivalence and the way in which these groups of people are in fact intertwined." Seriously. Imagine being told to capture the intertwined ambivalence, the nuance between Jeff Bezos and an Amazon worker who spends ten hours a day standing on concrete, retrieving and sorting packages alongside robotic arms, in a titanic windowless sortation center on the outskirts of town. Bezos gets paid $8.6 million for one hour; Amazon warehouse workers earn $15.15 for the same hour. Capitalism *is* angels and demons. Heaven and hell.

To willingly enter a system that rewards a few lucky geniuses is to commit to finding the needle in the haystack. What a lazy idiom. Get it, get it, get it. Sven Sachsalber spent more than twenty-four hours searching for a needle in a haystack at the Palais de Tokyo as an "artistic expression for futility and freedom"[6] and a commentary on the "human desire to complete arduous tasks."[7] The hay came from a French farm and a gallery director hid the needle. Approach the absurd in earnest. Sven told me he once had a job selling doorknobs and that he would *stop at nothing* to become a successful artist. When he died unexpectedly at thirty-three, they called him a wily artist on the verge of fame.[8]

A BFA in the hands of a doctor's kid is a different degree in the hands of a sanitation worker. According to a study, for every ten thousand dollars in additional family income, a person is

around 2 percent more likely to go into a creative occupation.[9] A family income of one hundred thousand dollars makes it twice as likely that a person will become an artist, compared with someone from a household earning fifty thousand dollars. If a family makes one million dollars a year, they're ten times more likely to have a family member enter the arts than if they made one hundred thousand dollars. This makes sense: when basic human needs are met, it's easier to be productive. If your building is sold, you have no savings and only two weeks to find an affordable apartment, making art seems impossible. Artists *choose* to put up with it, when they could just get a *real* job and stop *complaining*.

According to lifehack.org, making conscious choices restores your freedom. The bad-choices paradigm gainfully discredits those with little social value. It's like when conservatives condemn economically disadvantaged women who choose to have children with nothing, no child care, no money. In the 1980s, President Reagan called them welfare moms, welfare queens. Their lives defined by negligent choices, rather than by a lack of resources, housing, education, health care. Their bad choices framed as a moral or personal deficit, demonstrating they deserve poverty's mortifications. The problem is always you. Few people willingly choose to live in poverty (monks and off-the-grid types); there is nothing romantic nor moral or immoral about it.

I have never talked to an artist whose goal is to amass wealth, become a billionaire, or hot-rod on a rocket. They want recognition from critics and institutions, to be accepted, to be seen. They want to pay: rent, loans, utilities. They don't want to freak out about the cost of a medical emergency, and they want to make the work, but you can't have it all.

This is no secret. Attaining a version of middle-classness— defined by the stability that comes with owning property, rent-stabilization, and saving money for the future—isn't in reach for

many working people born after 1980, those born without the foothold of familial wealth. I need to repeat myself, again and again, to raze class *un*consciousness. Once-normative aspirations are now illusory. This is fact, not theory.

There are rewards, albeit intangible to many, that come with having a studio and regular practice. A room of your own in a basement (with drop ceilings) or a coshare with a depressive who uses a belt sander, is more valuable than comfort or safety. The trade-off seems irrational, especially for artists in illegal converted warehouses or sublets. If the hot water doesn't work, they keep quiet rather than risk reaching out to a landlord who may evict tenants who "complain." When thirty-six people were killed at the Ghost Ship warehouse fire in Oakland, artists in New York said that it could have been them.[10]

You can clandestinely live/work. Violet worked out of her bedroom, which was like a bin: "When I look at living rooms in apartments, that's a waste of space . . . my friend Candance, who I want to get an apartment with, was the first person who was like, 'I don't need a living room.' And I was like, 'Thank you.' Can we just turn it into a studio?" Practical, but most landlords are reluctant to agree to live/work situations. They fear damage, noise, and toxic smells, which might not apply but could. Complications or trouble—artists are a red flag for both. If you find a place to work in, do your best to keep it under the radar of management companies, building supers, and neighbors who might not want artists living and working near them. It's common to work from home now, if work consists of Zoom meetings and the like. We'll say yes to the art but not to the material conditions under which it is made.

"I just don't want to ever have to think about if I have enough money to go to the dentist to get my teeth cleaned. I don't want

to be food poor. Having these basics covered would be a big deal," Harper told me.

"What do you mean by food poor?" I asked.

"Eating in New York on a few dollars a day or less, or one meal a day I guess, which is totally doable." She shrugged her shoulders.

"Yeah, pizza's cheap. There's cereal." We're both aware that we're comparatively well fed. It's difficult to speak of wanting more of anything, when people are being evicted, arrested, beaten, caged, forgotten.

"I'm not saying I go hungry at night," she said. *I know what you are feeling.* "But it would be a marker of success if I could go into a grocery store and buy food without looking at the prices. Or go to a restaurant once in a while and not stress it. That kind of freedom from calculation."

The conversation stalls.

"I don't know if that makes you rich, what that means, but maybe just less . . . ," she trailed off, We're trying to talk about having enough money to forget about money. We're two people with advanced degrees, tripping over words to explain our class position. A generation living near the edge of destitution and eviction. We read about it. It's over there, for now.

Harper said, "The ability to buy food like it's no big deal might be the actual measure of an artist's success, not gallery representation."

Nothing in the tank. I ask myself why anyone would read a book about disappointments with degrees who work seven days a week. Nothing in the bank. The year after John Cage's infamous score "4'33"" premiered (the composition missing musical instruments), Cage was evicted from his West Side apartment building. Unable to afford an apartment in the city, he moved

upstate, where he rented two rooms for $24.15 a month. He became an amateur mycologist. He didn't have anything to eat.

In an interview, Cage said he was "poor as a church mouse." He said: "It wasn't until the late '50s that I had any extra money at all. When I wrote the 'Concerto for Piano and Orchestra,' I wrote that out in the country, I was living in Stony Point. And, I didn't have any money. And my music was not published." Cage got a ride into the city and went to a cocktail party, where he ran into Elaine de Kooning.

She said to Cage: "'I have always wanted to commission a piece from you!'

de Kooning gave Cage a hundred dollars and it came in the mail. It was a great deal of money then. Cage dedicated the 'Concert for Piano and Orchestra' to her. And she wrote back 'It was so beautiful.'"[11]

I dare you: make a living off avant-garde compositions and multidisciplinary collaborations.[12] Cage once said, "I wanted to make poverty elegant."[13] He was unashamed.

PART 3

15

YES

What do you do?
I'm an artist.
What gallery do you show at?
Ahhhh.
Well, what kind of art do you make?
Ahhhh.
Like abstract?
Yeah, it's abstract.

Liam tells me: "Sometimes I'll say I'm an artist and when I do I feel weird. I'm like, I'm not really an artist. I'm just a painter. And then people are like, 'For houses?'"

Andre and I visit my mom in Florida and get invited to a holiday party at a neighbor's house. It's in a palm-tree-lined cul-de-sac, and like other houses nearby, larger inside than it looks from the outside—an architectural trick mirror. We're struck by the spaciousness and the light. Andre admires the A-frame indoor pool area attached to the cathedral ceiling living room. He tells the homeowner he would love to paint there.

"No way," she says, "I'm looking for a someone to paint these dingy walls!" I see the expression on his face shift, patience drain, shoulders sag. Tiny movements, but they somatically register. The weight of an innocent remark.

Andre says: "I'm not a painter. I'm an artist."

"Ohhhhhh," her eyes pop open. "Did you meet Bob? He does community theater." She grabs Bob. He's wearing a Christmas vest and a single red ornament dangles from his ear. We spend the rest of the evening pretending to know what Bob is talking about.

2019 Notebook. Idea for McSweeny's: Satirical answers to the questions well-meaning people, often family members, ask artists who have no representation, no proof of sale: I'm a post-gallery artist. Or, it will be worth a fortune when I'm dead. Andre paints as if already dead.

I abandon the idea. Then I locate a class called "Humor Writing I" at Gotham Writers, a workshop that promises to teach "how to turn sentences into smiles" and combine good prose with the "X factor: being funny." X factor sounds like an intimate splash for men, a nineties nail polish color. Meme funny. Dad jeans funny. I scratch with a dry pen—*can't make funny.*

Making art messes with your mind. The painter and author Brad Phillips writes: "Never not working, never not thinking about not working, no reason to ever stop, nobody telling you to start, no reliable paycheck, no pension, no medical."[1] Living the artist's way is speculative fiction. Obsessing over the meaning of a painting that people may ignore, obsessing over a sentence that may never be read. Working four hundred hours to sell a painting for four thousand dollars, if you're lucky.

Sociologists have been surprisingly silent about luck. In art, luck seems like a condition. The luck to be the daughter of a blue-chip painter father and photographer/filmmaker mother, raised in Brooklyn and Connecticut. The luck to be the granddaughter of the former president of Rhode Island School of Design (RISD), raised in a SoHo loft by radical

cashmere-communist parents. The luck to be at the right place at the right time. How many of us have time to be at the right place.

When you commit to losing twenty pounds or learning a new language, there's a discernable goal and an end point. When the weight drops and you demonstrate fluency, it's recognizable. You look great; you sound great. Most artists finish a piece and then reckon with what they've done. Created an object that has no place—a slab of unmoored self.

You can't pitch a painting like an article. Commercial galleries don't have yearly open calls, there's no submittable. Although smaller galleries and artist-run spaces do do this (have open calls asking for a fee to cover costs). A way to scrape up extra money to keep the doors open, grow the followers. Submission fees can also be a money grab—an unethical hustle and an insult. Andre's take: "I have to *pay* you to look at my work? Oof."

Work without a deadline on the frontier of hope and anxiety. Someday, someone will see it and be awed, but maybe not. Maybe it's not good. Maybe it's not done. You don't know anymore. The discernable parameters of beginning and ending don't apply. Ending can be just as bleak as beginning. Andre will milk finishing a painting that he's spent months working on; completion insinuates failure. "I slow down near the end because I know what happens next. I have to wrap it up and turn it around." He puts it into a stack of other paintings—a pile of productivity and discomfiture. "I can't look at it anymore, and I focus on the next one," he said. To confront the painting is to see a manifestation of the laboring I. Not you (I) made this! But rather, look at what you (I) did. Deal with it, find a dealer, find a place, post it on Instagram, get a few hundred likes, or put it in the pile.

A sculptor who earned an MFA from RISD, who doesn't regularly show their work in galleries, posts a photo of a work in progress on Instagram with this text underneath:

> Turns out one of our many jobs is to say yes to ourselves. You make something, you set it aside. Make another thing, set it next to that. Each work requires that belief no matter how frayed. Yes to the preceding effort and yes to the succeeding one as well. Turns out that being an artist can feel kind of like Indiana Jones when he is walking across that invisible bridge . . . without the benefit of the gravel he throws on it, which maybe is cheating who knows? But no, we all want the gravel. We all want traction. So as tiring as it may be, try to keep saying yes until someone else says yes to you.

I was struck by the honesty, how they laid it all bare on social media: a breakthrough, a crack-up confession, honesty breaking the fourth wall. I was lucky the algorithms brought me this message in a bottle. I wondered what preceded the post, but I didn't DM them because it felt skeevy. Analyzing diaristic writing as social scientific data felt like taking fieldnotes after attending an NA meeting with a friend. I did that once. I vividly remember after the meeting people asking me how many days it had been since I used. "I'm not an addict," I said nervously chain smoking.

The ideal logical end is public recognition—a visible yes. Art is validated after it's filtered through the system, turned into a commodity, contemplated by a critic. Most artwork is set aside and ignored. When it accrues, the meaning begins to shift from a material representation of artistic productivity to a token of defeat, a problem that takes up space. Artist's studios, or in some cases, storage spaces, accumulate work waiting to be seen. I sometimes anthropomorphize the objects, paintings huddled

in the dark: *pick me, pick me.* Across the city, Manhattan Mini Storage and Cubesmart containers lodge art in purgatory.

Comedians have a formula: Tragedy + Time = Comedy. What about artists and the objects of their labor. Art + Time = [?] The paintings are piling up. There's no place for them. We must make room. Where will they live? Was this a waste of time? What is a good use of time when the average amount of time a person spends online is six hours and thirty-seven minutes a day? How many parents have said, "I hope your art degree doesn't go to waste!"

A sculpture or painting is a physical badge; a material reminder of what you have accomplished and what you failed to do. After making the work, you deal with what to do with *your work.* This is a mind fuck. It's also an endurance test. If you can do this for ten, twenty, or thirty years without stopping, you've passed. The sociologist Howard Becker says that maverick artists, the ones who make something truly original (his example is John Cage), aren't accepted because their work doesn't translate. A new generation of critics and gatekeepers might get it, or the cultural zeitgeist may shift, and now your art is legible. Art writers will say it's prescient. You'll go from a nobody to a national treasure.

Unwelcome art is awkward. It may end up in a family member's garage, wedged behind grandma's chair with the broken arm a few feet from the litter box. It adds to the clutter in that room they've been meaning to clean out, the one they put the dog in when company comes over. It grows old and irrelevant in moldy basements. The accumulations of objects, silent conversations in the dark. Be persistent, be patient, stay alive, and wait. Keep saying—Yes/Yes/Yes/Yes/Yes/Yes/Yes/ Yes/Yes/ Yes, Yes, Yes, Yes, Yes, Yes . . .

Yes.

16

HIERARCHIES OF DISTANCE

A man with a van. Near the end of the month renters migrate. Local traffic gets clogged by double-parked U-Haul trucks, their back doors open like zippers exposing private things—mattresses, winter coats on hangers, cat-haired brown and beige couches. On the sidewalk, valueless stuff stacks up. Signs say FREE: textbooks, sneakers, mugs, warped containers, filthy vacuum cleaners (works). Occasionally, there's a painting. It takes me six seconds to decide what's trash or worth collecting. When I'm in an artist's studio or a gallery, I imagine the art laying on the sidewalk. Would I collect this thing from the pile and bring it home? It's a callous metric—the trash test.

Andre spotted a painting left like a lid on top of a garbage can on Monroe Street. He collected it. "It looked like real art, and it's odd," he said. On one side, a portrait of a face wearing a hat. The other side, another portrait, another hat. Two for one. In the corner of the painting, the artist wrote:

the interesting
~~pa tra~~ portrait
Rick Borg
12–94

We searched for and discovered a biography. Borg was from Ohio, had shown in folk art galleries in the Midwest, and was once, in the artist's own words, "a mediocre pro golfer."

"I told you this was art," Andre said. It may have hung in a gallery. I imagine the painting's story, how it got to Brooklyn, who looked at it, who tossed it out. The provenance was of less interest to me than the artist's failed golfing history.

FIGURE 16.1 Rick Borg, *The Interesting Portrait*, December 1994, side 1. Andre Yvon, 2023.

FIGURE 16.2 Rick Borg, *The Interesting Portrait*, December 1994, side 2. Andre Yvon, 2023.

Traded a golf club for a paint brush. We constructed a discovery narrative and hung it in the hallway near the bathroom.

The gallery is the antithesis of a retail store, with its displays of multiples and prices. In the restaurant of the Williamsburg Hotel, named "The Restaurant," I listened to the organizer of a pay-to-play art fair, The Other Art Fair (the other meaning

"undiscovered" and "emerging" artists). She said: "My advice to you is not to over hang your booths. Less is more. Your booth shouldn't look like an antique store." She told the amateurs, many of whom appeared to be leisure painters and economically secure hobbyists, to make their eight-by-four-foot stalls in the Brooklyn Expo Center look like galleries. More wall than art. Hang work carefully, with a measured eye at sixty-inch center. Putting it all on display turns your rented white cube into Pier One. It makes art look like junk.

Junk can look like art. Inside the gallery, the economic and cultural value of everything amplifies; an ashtray can become an "aesthetic conundrum."[1] The gallery is an aesthetic, an ideology, an idyllic nonspace place. As the artist and critic Brian O'Doherty writes in "Inside the White Cube," "the outside world must not come in." Ideally, the gallery will impose a quiet monumentality: high ceilings that soar and fortify, skylights that access divine light, and seamless poured concrete floor. Within the architectural void, the construction begins—contour, color, texture—the most insignificant detail comes into focus. As a prank, two teenagers baffled by an exhibition at the San Francisco Museum of Art (that included two stuffed animals on a blanket) left a pair of glasses on the floor. In a few minutes, they watched visitors gaze down at the glasses, and a guy kneeled on the floor to photograph them.[2]

When you walk into Gagosian Gallery, for a moment, it feels as if you've broken the seal on a jar of perishable food. You're the potential bacteria that could spoil the contents. Make no contact. The space is clean for practical reasons—temperature control, no dust bunnies, and no greasy fingers or graceless bodies. The art is worth a mint, more than most people will earn after fifty years of paychecks. The atmosphere performs the heavy lifting.

I've been in galleries that resemble mausoleums and grand nineteenth-century banks. Andre, who's worked as a registrar and art handler, said: "The vault is in the backroom, but up front the money is on display. A painting may have intrinsic qualities, but it's also like staring at a huge stack of cash." Reductive, but also true. "Beyond being a store of value, there's cultural cache in bragging about owning a painting that nobody else owns" he said. Art is the only portable commodity that can increase in value after you take it home. I appreciate how Jay-Z spells it out in *The Story of OJ*: "I bought some artwork for one million, two years later that shit worth two million, few years later, that shit worth eight million, I can't wait to give this shit to my children." I think of the viral photo of Jay-Z and Beyonce at the Louvre standing in front of the *Mona Lisa*, behind the black rope that separates the priceless from the fanny-pack tourists. The art system is about hierarchies of distance.

We take the L train to the end of the line, get off at 8th Avenue, walk a few blocks south toward downtown and in the opposite direction of Chelsea. We're looking for an address, a gallery we've never heard of in the West Village. Around and around and then we find it. Two rangy women costumed in heels and black tube dresses stand in the doorway holding clipboards. They greet us as if they have been told to behave professionally. It appears as if we need to be on the list to get in.

"Were you invited?" they ask.

"We know some of the artists in the show." They look at each other, double-checking their power.

"That's fine. Do you want to be on the mailing list?" they ask.

"No thanks."

Odd. This is the first time I've experience this sort of meat-packing district bouncer greeting at a gallery. We walk up one

flight of stairs into an open gray space with windows on each end overlooking the West Village tourist clamor. On one side of the room a DJ is set up at an oversize DJ booth—like a stage to showcase the fact that a DJ is there and highlight its significance. On the other side, a bar manned by bartenders dressed in black, aspiring models who also cater-waiter. The art is mostly black, think squares and triangles, except for a hybrid collage painting sculpture reminiscent of early Rauschenberg and some colorful ironic Matisse-shape paintings with matching benches. I think of Target. A parody of an art gallery. One thing rings true, nobody is looking at the art. As an artist-curator said: "At an opening in New York it's always talking to the right people; you never see the work. Someone's looking over your shoulder to see who the fuck just walked in, maybe they're more important. I fucking can't stand that."

Also odd is an arrangement of black leather couches and chairs, a sitting area that could be a waiting room in a plastic surgeon's office, with an oversize white lamp in the corner. Could be a lampshade sculpture. Two guys, probably deep in their forties, slump on one of the couches. They look less young than everyone in the room. I sit down and make small talk with the one named Johnny. A mélange of tattoos and eroded leather. I ask him if he's an artist. With a sigh and a side-eye, Johnny tells me he isn't an artist, but *he makes things*. I wonder if he's famous, and I've failed to discern his fame. He's blasé because I haven't incentivized him to act otherwise. I've nothing to give Johnny personally or professionally.

I'm irked. I want to get out of there. We spot two artists we know from Bushwick. They remark at how off this scene is. One says it's like a *Sex and the City* version of what a New York City art opening is. Now, I'm engaged (ha! ha!). Maybe I'll get another white wine. We stay in the TV gallery until Andre

confirms he can't find the curator/art consultant who told us to come—the one who might sell his paintings to some random rich people. End of episode.

The neighborhood is so quaint it's perverted. Andre's circling around the block looking for a parking spot. Low-rise Hansel and Gretel brick houses line both sides of the street. Porches with unchained chairs and yards plotted with rose bushes and geraniums. In front of our building, there's a cement square and three garbage cans manacled to a fence. *Look at the frog sculptures*, I scream pointing out the window. It looks like a small town in Pennsylvania. Walking on the sidewalk, I trip over buckled tree roots, the only sign of visual disorder. We're in Queens.

There it is. An artist couple, casual acquaintances, are going in the front door. We follow them and enter a wood-paneled vestibule, and my feet sink into the matted brown carpeting. It smells like the seventies, vintage mothball. Near the staircase, a white paper plate instructs us to "take off shoes." To the right of each stair, one pair of shoes after another leads up to the apartment like a dare.

It's happening, but I hear no noise. At the top of the stairs on an open landing, the artist whose work we came to see holds a paper plate sprinkled with mushroom bits. The grinning couple in front of us takes some as they enter the apartment. By the time it's my turn, the plate is empty. I don't mind. I'm here to look at a painting hung over a bathtub.

Before I go into the gallery (bathroom), I walk into the curator's bedroom to see who's there. Mostly painters I know lounging on a half-made bed and a Craigslist sectional couch. The ambiance is wrinkled but tidied up. A slow-mo atmosphere. Padding around in socks and bare feet, it feels like we're trying to get away with something. The curator tells me that he wants

it to be comfortable: "Going to gallery openings can be stressful because of the social anxiety and it's hard to look at the art." I agree. It's never about looking at the art.

I join a musician friend at the windowsill; he's smoking and staring out at the panoramic Manhattan skyline levitating above the garages of Ridgewood. In the outer boroughs, Oz is always in sight. He asks, "cinematic right?" A few feet away, a laptop rests on a low wooden dresser. The curator bends down and types, James Taylor song starts playing. Ironic or sincere, I'm not sure. No one flinches; soft chit-chat continues.

I leave the bedroom to see the show. The artist is standing inside the bathroom, and I ask if he's nervous. "A little. The shrooms might have something to do with it." He avoids my eyes. The gallery is spotless—soap in the dish on the sink and a bouquet of flowers on the toilet. As a space-starved New Yorker, I notice a tub and a separate shower stall *and* a window. Three people can comfortably stand in this bathroom. I marvel.

A painting, large straightforward picture of a hand with an egg, is installed above the tub. I think of graduates of the New York studio school who are taught old-school painting techniques, and it registers as semireverent kitsch. There's a reflection of the painting in the vanity mirror above the sink, a reproduction. I take a photo of it, two degrees of separation. I sit down on the toilet and talk to a painter who's sitting on the tub about the exhibition. *Cool. Looks good. Made for the space.* Then she asks: "Do you mind if I go to the bathroom?"

The founder of the bathroom gallery is against corporate gallery aesthetics. He finds it to be "painfully tired, awkward, uninspiring, and conceptually and contextually barren." I agree. White-cube galleries sometimes remind me of luxury duty-free shops at JFK airport: laser-beam lighting, buffed floors, glass vitrines, sales associates in heels. He's more interested in

witnessing "a dialogue between an artist and a bathroom, or a doorknob for that matter" than watching an artist "negotiate the intricacies of a windowless white box with uniform track lighting or runaround fluorescents." It was never his intent to recreate a traditional gallery space in miniature. He's "more concerned with the displacement or liberation of art from that kind of prison." In the hallway, I write in my phone: "we are well beyond the white cube." But we aren't. The show is within the conceptual radius of the institutionalized system. Everyone there is birthed from it (BFAs or MFAs), and I imagine they wouldn't mind an invitation to return as artists.

At 10:30 the curator says, "OK guys, time to go," but we're already at the front door slipping our shoes back on. We drive our friends, a painter and a musician, back to Brooklyn. While everyone is talking, I zone out imagining openings at Gracie Mansion—the eighties fashion, the coke, the afterparties, and "the inspired intangibles of creativity run amok."[3]

I consider the possibility of liberating art from the confines of the white-cube art world. I think most artists chase the white cube unconsciously because everyone wants to be made, even artists who curate shows in apartment bathrooms. We all need to get paid. Capitalism is a hungry beast that feeds on everything and off of everyone, even the artists who reject it. Art for art's sake is so noble, so necessary, but also naïve (impossible) in the context of New York City. How can artists (and art) break free from capitalism and convention? Maybe it all comes back to agency, which is a form of freedom. Through Michel Foucault's lens, the antithesis of domination is not liberation but simply *the ability to resist*.

17

FISHING

Future Feminism, a thirteen-night performance and exhibition series, "came to fruition" at the Hole, a downtown gallery.[1] An artist collective[2] created thirteen tenets for the event, each inscribed into a rose quartz stone, hung in the gallery like tablets of law. There was also a video and twenty-five dollar t-shirts declaring "The Future Is Female." On the first night, artist Mira Schor was present, Tweeting her way through it:

> Around 9:05PM: @miraschor Future feminism. Preview: is there something more basic than feminism 101? So naive & essentialist it's all I can do not to walk out.
> Around 9:50PM: @miraschor The feminist wheel has to be reinvented all the fucking time.

Schor describes the mansplaining, the equation of woman with nature (female creation, mother earth), and her exasperation with the flimsy utopian celebration in the hot windowless gallery, recently painted white and reeking of paint fumes.[3] Beyond the ahistorical deployment of feminism, "they looked it up in the dictionary and it seemed perfect," Shor was irked

by the politics of the collective, noting that at the start of the event the Future Feminists said they were a collective, but later said they were "an affinity group, of friends, *who took time out of capitalism to talk.*" That's fine, talking about capitalism, "but if you get up in front of people you have to have a bit more to say."[4] I assume by now they'd say the future is fluid.

To make and distribute art outside of institutions (corporations), the future will also have to be self-organized. According to the manifesto, "There Is No Alternative," artists and institutions must present alternatives to dominant systems: "Merge, get organized, disorganize, flow together, join forces, exchange experiments, experiment with yourself, get rid of yourself, slowly, start synthesizing, synchronizing, syncopating, shaping structures, play with weapons, stray research labs, converging forms of communication and collaboration, anti-property, no-property, property-less . . . dump your expertise, experiment, no program, force open the archives, inhabit histories, dig the bones out of the rubble . . . activate conflicting utopias, realize oneiric knowledge."[5] I'm conflicted. One day I read this and say, "yes, I want to *get rid of myself* and *force open the archives*," whatever that means. But on another day, I think it's all style, hollow revolutionary babble, because I know firsthand how difficult it is to self-organize. It's thankless ceaseless work.

From the first draft of this book, I wrote: "As artists negotiate the increasingly exclusive global art and real estate markets, they find agency, identity, and a sense of place through creating their own art economies, spaces, and scenes." *Is there something more basic than self-organizing 101?* I also wrote this: "Artist-run spaces are fluid; they use different models to fill in cultural gaps, providing opportunities, launching pads, testing grounds." I must have been listening to NPR. As I read this today, it makes me

wince. Running an artist-run space is like writing a book. You feel like you're digging a hole in the earth with a ladle.

I want to avoid the tropes of resistance. In *This Is Not Art*, Alana Jelinek cautions against resistance cliches like collaborative practice, using ephemera, street art, graffiti, squatting, and trespassing.[6] Just because people collaborate, it doesn't mean something radical will come of working together; collaborative or participatory practices can replicate social inequalities. Just because people do it themselves, it doesn't mean they will destroy all monsters, kill their darlings, or blow your mind. People self-organize for all kinds of reasons, and sometimes it's because "fuck it, why not."

Catbox Contemporary is a gallery in a carpeted cat-tree in an artist's apartment in Ridgewood, Queens. P., Catbox's founder, also paints there, sharing the apartment with his wife, cat, and dog. It's about as live/work as you could imagine. I imagine when nobody is around the cat paws the art, stares at it directly for forty minutes, and then ignores it. At openings, smoked sausages from Morscher's Pork Store, a local institution, are served on a coffee table a few feet from the gallery. The cat's in the bedroom. P. explains the concept behind the gallery is a "riff on a traditional gallery space, not a slight or an 'anti' but a means to an end," connecting to an "art historical lineage with Dada or Fluxus, existing in its absurdity and intrinsically linked to it." It plays with familiar conceptual weapons. There's an amount of "jovial fraternization"[7] in art spaces in absurd places; being in on a joke together is a bonding experience. Audiences delight in sharing an inside joke, even if the joke's on them.[8]

At its core, Catbox "is about facilitating an energetic and active dialogue about art and the people making it." P. hopes the absurdity is disarming, so viewers sincerely "suspend disbelief

and engage with the work and the space." Peering into one of the carpeted cat-size rooms, "the wall of hyper intellectualism and over-academic reading can fall down." The gallery is affordable and portable: the rent never increases and you can throw it in the back of a car.

Even though the cat-tower gallery revels in its multitiered beige banality, the work is displayed, installed, and lit accordingly. Diminutive paintings and drawings installed; baby metal sculptures and ceramic figures situated. As Catbox evolved, artists began to challenge the boundaries of the gallery itself, using the entire cat tower, the outside walls, and then abandoning the space entirely. That said, gallery norms are followed, including press releases and social media promotion. The openings sober, even though alcohol is served. P. is committed to posting Catbox artists and shows, dominating the algorithms; it's his way of luring other artists and curators toward his work. Throwing an image on Instagram is like dropping a fishing pole in an ocean.

I struggle with how to categorize artist-run galleries like Catbox—divergent? They aren't entirely alternative, and apartment galleries aren't new. Leo Castelli famously turned the living room of his 77th Street apartment into a gallery in 1957, and Gracie Mansion's bathroom was legendary. In the twentieth century, there was stability on the edges of the art world, more space on the ledge. Now it's crowded with cur-artists, and a tech-inspired do-it-yourself ethos. Someone new, connected, and bathroom-selfie hot is on your fogyish heels with their absurd idea.

When a divergent space stays the same for too long, say three years, the dynamism and excitement fades. It starts out as a novel space to do cool shows, but after a while, it's just Josh's apartment. There's faith in the art to transcend, but over time, normalization and routinization drag it down to earth. Apartments can be transcendent for only so long. I think this has to

do with the relationship between repetition and domesticity in the private sphere and the fact that artists sacrifice studio time to organize shows. Cur-artists are always compromised because of the tension of being multisited—simultaneously acting as curator, painter, and art worker. A divergent space is like an oxygen tank with a fixed amount of air. With money problems, interpersonal problems, and neighbor problems, the air is bound to leak out.[9]

Looking forward to an art show inside of a dumpster. It's one night only, as advertised in an Instagram post: a picture of three fishing pools leaning on plywood inside a garage. The details are written in screwy font, which I take to be a critique of Helvetica, favored by the PR teams at corporate galleries.

I imagine a large industrial dumpster one or two car lengths' long, deep enough to disappear in. These banged-up containers are all over Brooklyn, waiting to cart away the past, portending the future. I imagine the art, or artist, will be inside doing something with, or to, the dumpster. We'll peer over the edge in anticipation. We may get wet; we may be soiled. Trashing the white-cube ideology. Got it.

I was wrong. The show is in a large warehouse garage space, with colossal ceilings, concrete floors, industrial lights, and open metal rolltop doors. Inside are two dumpsters packed with ice—one filled with beer and the other with oysters arranged on top. People are on an elevated wooden platform trying to fish with fishing poles with magnets attached to hooks. I ask the artist-curator if this is institutional critique or relational aesthetics. He laughs at me, "that's so four years ago," and locks eyes with someone else. I stand around and watch people film and photograph the attempts at fishing. They angle for beer, hooking the oysters is of less interest. Despite it being early evening, it's

still in the low nineties, and the air across Brooklyn smells like a murky aquarium.

I walk outside and talk to Tori on the sidewalk, she used to work at the Zwirner front desk. Illegal bikers are circling the block—one on a lime green dirt bike and the other on a three-wheel ATV. Two of her friends walk up, and Tori introduces me. We say a few words about the machismo of the bike guys and agree that it's unlikely that they could have a rider on the back. When they pop up the front end, it's at a ninety-degree angle: "They almost graze their back to the ground, like a dangerous hard on." One of the friends asked if they had drinks. "There are beers, but you have to fish for them," Tori says. "I think I'm good for now then." The dirt bikes roar around the block again, as we are gently dared to perform and be documented. I write a note in my phone *floors are concrete but nobody breaks anything*.

As it gets darker, more people catch beer and oyster fish; it's getting looser. They're warming up to making the art, performing while being watched, photographed, filmed. I like the idea of having to exert some effort to get a drink, pushed to activate the scene. When I was organizing shows, I always resented people asking me for beer or wine at our openings, especially when I was talking to someone: "Hey, great show. Got any beer?" I passed out too many cans and poured wine in too many plastic cups. I bought thousands of drinks, and I don't think they would have come to openings if I hadn't. I begrudged the order: beer first, art second.

I saw what they did, and I got it. Andre did, too. The next day we got tacos at Tres Hermanos in Bushwick, a tortilla factory with a small restaurant up front. The menu is short, we write our order on a piece of paper and hand it directly to the cook. When the

food is ready, a worker behind the counter shouts *Murry*, and we carry our food on paper plates with a red plastic tray.

"What did you think? Have you ever gone to an opening where people fished for oysters and beer out of garbage dumpsters?" Andre asks.

I shake my head no.

"Do you ever think you will do that again?" he emphasizes. *He's trying to make me see what he saw. He's making a case for art. A singular experience.*

"Ha, doubtful." I shrug and shout over the music and tortilla assembly line motor. I'm too blasé.

"Artists are different than other people who go out to a movie or a bar on a Friday night," he gestures to the mostly young people eating three-dollar tacos sitting around us. The ones who look hot hungover and are permanently drawn toward the light in their hands. A cast of urban stereotypes—hipsters, postcollegiate, trust-funders—who are probably passing through before they settle into adulthood and relocate somewhere else.

"We make up our own things to do. We invent experiences . . . we don't just buy it," he says, each *we* growing louder, establishing the distinction between *us* and *them*.

Andre's gesturing to me because we've curated and produced dozens of shows together. I'm part of the *we*. The we who invent experiences. The we seeking encounters. The we fishing for aura.

18

GROUP CLUB ASSOCIATION

They asked how I funded it, and I said out of pocket. They asked if it was sustainable, and I said hardly. Concerned faces: Can you apply for grants? Can you get a backer? I could never adequately answer these questions, nor did I try. They couldn't grasp why Andre and I would put ourselves—all our energy, all our money, including the change jar—into a gallery that didn't make a profit. After all, we didn't call it a project or a space: we said *gallery*. Activity that doesn't court capitalism is suspicious and unprofessional. I sensed skepticism, a vein of pity. Irving Sandler, who managed the East Village's Tanager Gallery in the fifties, said: "I was not expected to sell work, although it was assumed that I would try, and I did. In my three years in the job, I succeeded in making only one sale."[1] In four years of organizing shows at Group Club Association, we made four.

It looks simple. Find some art, hang it, invite people. Although I can't speak from firsthand experience, I imagine this is similar to planning a conventional American white wedding: locate a site, conceptualize the experience, conceive the aesthetic, design the invitation, choose the booze. Someone must pay. Someone (we) needed to figure out how to transport the art (car, Uber, rented

U-Haul truck); prepare the space (paint, hardware); install, photograph, promote. Then we could settle into the emotional labor. We'd speculate if anyone would come, if we did everything we could, if the artist was happy. Sometimes skeptical, sometimes certain, we told ourselves the show looked perfect the night before every opening. Like an incantation, I'd think of the bumper sticker that said *Art Saves Lives*. Repeat and replay once a month for four years.

Group Club Association began at a laminate wood table that came with my apartment—a doomed suburban object too clunky to move. Its legs painted white, a big sooty burn mark off-center, like a black eye that never healed. Instead of watching television or going out in public, Andre and I collaboratively wrote exquisite corpse and blackout poems, made drawings, and embroidered canvas patches with metallic gold

FIGURE 18.1 GCA patch. Andre Yvon, 2012.

rickrack trim. At that ugly kitchen table, we sewed *in a pickle* inside a green pickle and *pulling teeth* alongside a bloody molar. We mailed the patches as a token of friendship and as a membership badge to our kitchen-table club—Group Club Association. Three words that meant the same thing. An initiation letter accompanied each patch we sent. The first line said, *I am pleased to inform you that you have been chosen as one of the premiere members of the Group Club Association (here to four* [sic] *known as GCA)*. The last line said, *We look forward to a future.* The recipients of our mail art, in our minds, became a part of our collective. A patchy community.

We talked about Gordon Matta-Clark's restaurant Food, and the punk kids we used to know in Food Not Bombs. We imagined a Fluxus-style performance called "Toast." It would be easy. Bring a table and two toasters, extension cords, bread, and butter and set up near a busy Myrtle Avenue subway station in Brooklyn. Sit there and make toast for commuters: free toast. We thought, who wouldn't like an unexpected piece of toast on the way to work, the doctor's office, the corner store.

We e-mailed a proposal for a GCA exhibition of "Toast" and mail-art patches, I can't remember the details, to a new artist-run space in a hallway. We thought, for sure, the gallery would see the genius and give us a show. We never heard back from them. Not even a thanks, no thanks. Ghosted by a hallway gallery. We never made "Toast."

A few months and dozens of drawings and patches later, Andre's studio mate moved out of her half of their shared studio. He was relieved. She used drilling machines that blanketed his meticulous oil paintings with sawdust. Instead of finding another studio-mate, he looked at me with crazy-eye excitement and said, *Let's turn the other half of my studio into a gallery! We'll hang some lights, show whatever the fuck we want!* I said yes. We were off.

As financially futile as it was, GCA became the center of our lives. Our gallery crowded into our bed and our heads, we became an art couple. We operated as if making shows was like sex, eating, and sleeping, *élan vital*. Andre would say, "Some people watch movies, we make art shows." I said, "If you can't put it on your CV, it's not worth doing." It was only one line on ours, but it connected to other lines, like the spoke of a spiderweb. I read that spiderwebs have a stronger tensile strength than steel, but are at the same time ephemeral. Some spiders replace their webs daily; they'll eat the silk threads and start again. Artists deleted us from their bio, a minor injury we noted, but we kept spinning.

Openings at GCA. All chaos and anticipation: we'd escape our jobs early to buy drinks, get ice, set up the table in the hallway with a book and pen, drag out the industrial garbage can and stock it with canned beer and, on occasion, LaCroix. We had props, we were professional, and we made sure the music worked. We built it, they came. Mostly artists who were friends or artists who wanted to show work at GCA. A core crew reliably stayed for hours. I'd go into the back room of the gallery (Andre's painting studio) and find them sitting on the ripped suede couch, a secondhand gift. Openings were from seven to ten, but people always stayed later, always lit a joint, begged to smoke out the window, and I always said yes. I watched the whites of their eyes become pink and veiny, mine did, too. We met a lot of people during the GCA period; you become incredibly interesting if you've got something to offer an artist.

Always affable, doling drinks, and introducing people, we were invested in the artists we showed, but because we weren't doing it to earn a living, it devolved into a party.[2] People want

FIGURE 18.2 Montgomery Perry Smith, *Suspended Animation*, GCA Opening, 2014. Author's photograph. (163)

to party, but a gallery shouldn't *be* a party. The elation, the romance, was temporary. Two weeks before an exhibition opened, the artist was in love, and so were we, but the excitement fades faster than a banana turns brown. I learned openings are about the future: sales, connections, reviews. Visitors

always asked what exhibition was coming next. Just small talk, but Andre became frustrated. He'd say, "Why can't anybody focus on what's in front of them right now?" As in erotic relationships, the cultivation of desire is the best part. Art is always on to the next thing.

We never counted heads, but if a hundred Budweiser cans were emptied well before the end, it became our metric of a good turnout, validation.[3] Maybe there wasn't anything else happening that night, combined with free alcohol. It didn't matter. Making people look at what you think is worth looking at is a rush. Andre didn't want to be that person who goes to gallery openings; he wanted to make people come to him.

I asked why. "I have a gallery in New York City. Once a month, I get to say to the entire art world, 'this is art.' And that gives me agency within my own work. Granted, I'm showing other artist's work, but that doesn't matter to me. Showing whatever I want is defining the territory," Andre said.

"That sounds grandiose, but I get it," I said.

"Artists, at some point, gave over their agency of deciding what art is and gave it to institutions and people with power. And that is so fucking true in my street-level experience. The moment we started GCA just out of my studio, I got that high of saying, 'Wait a second. I get to decide this is art. I create my own institution.'"

"Do you think anyone cares, you're just another painter?" I said.

In retrospect, I think my questions were cold, possibly cruel.

"Granted, the 1 percent isn't looking at what I'm doing today, but at least my colleagues are. And that simple construct keeps me from being deluded. From being super saddened." Andre said.

"What do you mean by deluded?" I asked.

"Deluded into thinking I have no agency when it actually buttresses my agency. It matters to me as somebody prone to be stuck in the binary of power and powerlessness."

"Well, you don't have economic freedom, so this allows aesthetic freedom if that's the right word?" I asked.

"Look, everyone I know is hurting for agency. And if they're not, a lot of times they're also deluded in the fact that they're little rock stars. They're pretentious, too big for their britches kind of thing. They think they have this, but they're twenty-six right now. I want to talk to them when they're thirty-six. See where they're at then," he said.

A year later, Andre reads this in print and squirms because he says agency five times. *What's wrong with the word agency?* "I'm saying what I think a lot of artists feel, but it sounds cheesy. I sound too vulnerable," he said.

I had expectations. B., an artist-curator told me, "If you have expectations, I think it sets you up for failure, but I'm cool with failure." I was never cool with failure, but I experienced it. I learned how to work with artists, meaning I understood I could never get it right. Just as I left some of my previous informants angry because direct quotes never sound articulate enough, or my framing was off, there are interpretation issues. I often felt I was failing them.[4] I speculated artist's unhappiness could be nerves and rawness, or they think they're doing you a favor, or they know they're better than this. You probably didn't do enough for them, you misrepresented their work, or they're having difficulty coming to terms with your invented gallery as an opportunity. I've never asked why some were boorish, why they never said thank you. *Can I ask you a question for my book: why were you so impolite and entitled? I need to know for the sake of social inquiry.* I did speak to artist-curators about the phenomenon of

incivility and the economy of gratitude. A few responses: "some people are assholes," "artists can be dicks," and "you can never give them want they want."

"What do they want?" I asked.

Exhibiting in an artist-run space is better than nothing. Maybe it's too close to nowhere, a reminder of their position in the art world.

We objectively helped some artists receive exposure to move onto more legit galleries, get reviews, and transcend our teeny Bushwick world. Only one artist acknowledged GCA helped their career. I overheard them in the hallway outside the gallery talking to two people who'd never been there: "You don't know this space? They've been doing shows here for a year. It totally helped me get invited into other spaces." I winked at them as I wiped up beer and picked up crumpled cans. Lucky, I was in earshot performing custodial duties.

You vouch for an artist, images are posted on Instagram, someone with more prestige and cultural capital vouches, and on and on. Artist-run spaces can serve as a lower-level discovery filter.[5] I interviewed Victor, an artist-curator, about how artists don't stick around after they get their show, how a community never forms if everyone scatters. He said, its partially the "artists' fault." I asked him to explain.

"Because, they're now chasing the fame, these devious things, fame and money, entered the art world that were never there before. You look back at Pollock and de Kooning and the AbExers when Pollock got on the cover of *Time Magazine*, de Kooning said, 'well, it was too soon, or this is the end of us all!' Because that's when fame and art started to really dance together. Now you've got artists who get their first show with an artist-run space or a small gallery and they get swept up. You used to grow with the gallery, it was a partnership," he said.

"Yeah, the idea that an artist and a gallery equals a classic union. Like Basquiat, he gets picked up and then someone's like, I'll give you this basement? I can't remember who . . . ," I said.

"Annina Nosei," he said.

"And Basquiat was like, 'Fuck yeah, I'm going down in the basement, I'm going to paint there day and night.' Does that happen anymore?" I asked.

"I don't think so. I think the last time that happened was Dana Schutz and Zack Feuer, to be honest. He picked her out of Columbia grad school, then he became LFL gallery, and then she took off and LFL took off. Schutz was there for a hot second and then she left," he said.

"Having a gallery that tries to earn a profit is impossible, impossible," I said.

"But I never wanted to be an art dealer, like that's not my thing," he said.

"Art dealers can't care about art," I said.

"They care about whatever collectors want or need," he said.

Andre and I cared. We were doomed, but it didn't stop us.

After working with more than fifty artists, I'd call four of them friendly acquaintances. People I'm psyched to run into, who I'd like to catch up with if I had time. *Let's get a drink.* We never created a community. We were part of a gallery scene in one Brooklyn neighborhood, and GCA was its own micro-scene, nested in that scene, like the Russian dolls getting smaller and smaller. Artist-run spaces have a limited shelf-life; scenes are tenuous, they fracture, they can't hover forever. At least they live online, if you pay the yearly fee for a website domain. All that work uploading install shots, documenting, and archiving— I can't delete it.[6]

There's burnout. Juliette, an artist-curator, said, "Artist-run art spaces are by necessity fixed in time, partly because all of us wear two hats. We all want to be successful on our own as artists, and we want to be part of a community." When you're pushing your own work, in my case writing and a full-time faculty position (the tenure test), you can't help but wake up in the middle of the night and think *why?* Does any of it matter? It does. Well, it did, at that moment in time.

As Juliette put it, "Artists run out of gas running galleries because they're really interested in their own work. You have ambitions for your own work. It's hard to do that, the lines get confused, you start being thought of as gallerist, but you really want to keep being an artist." I wanted to be a writer. Andre wanted to be a painter. Nothing's changed.

For us, mounting shows was gesture of friendship, of solidarity. Friendship hinges on emotional, financial, and practical (helping someone move), support. It's showing up. The artist-curator Celine Condorelli writes that friendship is "an essentially political relationship of allegiance and responsibility. One of the best definitions of cultural production is perhaps that of 'making things public': the process of connecting things, establishing relationships, which in many ways means befriending issues, people, contexts."[7] Artist friendships form through action, but people scatter, circumstances dissolve, and new scenes blow up. The production of culture in New York City is ruthless (delirious) given the scarcity of slots. A pack of starved wolves don't work together to find food and equally distribute it. If there's an opportunity, artists pounce.[8] It's Darwinian.

19

PAY FAUXN

A port-a-potty sits on the sidewalk near the T-Mobile store. I take a picture of it and text Andre, "Our next gallery. Laughing/crying face." He replies with three thumbs-up emojis. A temporary construction site toilet has four walls just like a gallery. The art world adores satire. A hundred thousand people waited in line to use Maurizio Cattelan's *America*, a six-million-dollar gold toilet installed at the Guggenheim. Then came *Comedian*, the "fresh banana" duct tapped to a wall at Art Basel. Editions of three, one hundred and twenty thousand dollars each, sold out. The port-a-potty gallery is too ironic—a rough draft. I let it go.

For months, I walk past the pay phones on my way to Bravo Super Markets and never see them. Why would I take notice of two metal husks at the B44 bus stop. It's about getting from here to there with efficiency, without incident, without stepping in dog shit. I also don't pay attention to the nursing home behind the phones; a massive institutional brick. When it abruptly closes and its gates permanently lock, I scan the grounds for missing residents. I can't fathom how they disappeared. The phones come into focus, tagged with stickers and graffiti—SULK, MARS, DINK, SOIRR. In the city, any

abandoned container can be repurposed as a garbage can. Coffee cups, cig butts, straw wrappers, drink cartons, crumpled envelopes, and empty potato chip bags accumulate as people queue for the bus. Like an urban archeologist, I began to visit this site and document the phone's contents. Weeds and trash pile up at their bases. New York City's contract to maintain eight thousand pay phones expired in 2014.

CABS nursing home, like the phones, is abandoned and deemed useless. I learn it was purchased by the Allure Development Group, which lied about promises to keep the home operational. Instead, they evicted the patients—the sick, elderly,

FIGURE 19.1 Pay Fauxn, business card. Author's photograph, 2016.

and economically strapped—with the intention of turning the facility into modern residences for the financially agile. Those who sociologist and TED Talker Richard Florida calls the *creative class*, educated and employed white-collar professionals in tech, design, media, and advertising who desire off-street parking and amenities, a gym, and a bike and stroller area in the lobby.[1] Allure did the same thing at Rivington House nursing home in Manhattan amid controversy. As the value of land increases, nursing homes and churches across the city are flipped, shaken of their human contents, and turned into revenue-generating assets.

I declare the phones a gallery and myself the director. I name it Pay Fauxn, a nod to the term *fauxstalgia*. If I say it's a gallery, then it is. Each one has three walls, a floor (the ledge), and a kind of ceiling (the top). I start an Instagram account, make a website, and compose an anti–white cube manifesto. I post a fake review by Jerry Saltz hailing it as an "impure post–white cube gallery in the anti-formalist tradition." I keep telling myself anything can be flipped.

June 2016 Notebook (self-interview):

What right do you have to declare these abandoned phones a gallery?

None.

In what ways does your curatorial project engage with the local community?

None. I assume engage implies to help, fix, inspire, speak to, or make better.

What is your vision? Why do you want to do it?

Because I can. It's a clever idea. It's an "art project." An experiment that blurs the lines between vandalism and something. I don't know what the something is.

I conceptualize my gallery as political theorist Jane Bennett's *Vibrant Matter*. We think of objects—things like a rock, a bench, or a phone booth—as passive and inert. Bennett suggests that things themselves can alter the course of events. The phones did evoke a reaction. I kept moving toward metaphor. They are gravestones. They are dead media and *media is a device that transfers a message between human beings.* The phones called me.

Every time I come across a loose CD in a moving box, I toss it. There's satisfaction in throwing away charmless twentieth-century media. Unlike records, they're flimsy and make a dumb sound when dropped. They sit in awkward towers and ugly black sponge cases. CDs smell like the nineties and show my former tastes, notching time in an uncomfortably specific way. Thirty years or so from birth to death. I witness the cycle. I am dated. But some technology is harder to say goodbye to and more difficult to dispose of.

Dead media really dies. Like the Rongorongo glyphs discovered on Easter Island no one knows how to decipher or even understands why they were created, or the telegraph with morse code, now a useless artifact. Other media forms refuse obsolescence. Some media are abandoned, linger, and are culturally resuscitated: loved in their youth and again in old age. Records are curated analog collections, vinyl to discover at a record store—the first pressing of N.W.A.'s "Straight Outta Compton" or a six LP box set of the short-lived industrial band Chrome. Aside from the currency of discernment, records are materially needy. Gingerly held and dusted; they're bound to the domestic, sheltered in their sleeves on shelves and in crates.

Pay phones are communal; they live and die in public. A memory dump, they absorb conversations and collect human residue, the prints of grimy hands, bacteria from stale breath.

A temporary sanctuary designed to protect us and the stuff we carry around, a miniature shelter, and an impromptu office space. A sign, an index of changes in landscapes and technology moving faster than our ability to dispose of it, from essential media to recalcitrant eyesore in the span of a decade. Now coffins, empty containers waiting for a body.

The phone was easy to hijack but harder to theorize.

I grant myself curatorial freedom. I make up the rules and break them. The shows will be short-lived and the artwork unprotected, free to any collector on the street. A working model in a manageable format, rent free, and two blocks from my apartment. Artists squatted in abandoned buildings in the East Village. I'll channel this lineage and Henri Lefebvre's *right to the city*. I'll exercise mine, see if I get away with it.

When I tell friends about Pay Fauxn, they assume the gallery is in a phone booth you can enter. They imagine a vertical glass enclosure with a folding door. Some kind of other white cube, a pedestrian ready-made, an art terrarium.

"Cool, I didn't know those even exist," they say.

"It's not a stand-in one, more of an empty metal shell."

"Oh. That's still awesome, so the work is just kind of outside," they say.

"Almost anyone can do whatever they want with it."

I don't look like a threat to public order or decency. I resemble the new gentry—the renovating class buying up the housing stock. Another urbanite with the resources to own a car and sometimes pay for a six-dollar lavender oat milk latte at the vegan cafe nearby. In the city, it's sometimes impossible to tell the difference between a state worker saddled with debt and a Harvard legacy with a trust. A renter and a brownstone owner look alike now. Andre said he would make us t-shirts that said RENTER.

GEOGRAPHIES

Pay Fauxn is on Nostrand Avenue. Avenue is not the right word. Nostrand is a channel of chaos, a nine-mile urban corridor that runs from Williamsburg down to Sheepshead Bay, linked to the A, C, G, J, M, Z, 2, 3, and 5 subway lines. It's also the path for the B44 bus, shuttling 41,446 passengers on an *average weekday* in New York. During rush hour, cars, city buses, delivery trucks, work vans, and helmet-less motorcycle crews, race from stop light to stop light in an impossible contest of speed and rage. Realtors plug it as a high-traffic area. A block from Pay Fauxn, a speeding car smashed into the front window of a coffee shop in the afternoon. In juxtaposition to the big-box, corporate serenity of Chelsea, *NYC's premier contemporary-art district*, it's a curious location for a gallery.

The gentrification of Bed-Stuy is built on brownstones. As the story goes, you'll find stately Victorian brownstones and enormous maple, ash and ginkgo trees. You'll also find boarded windows, empty Patron and Hennessey bottles on the sidewalks, and green pressboard fences graffitied with building permits. Much of the neighborhood has *good bones*, if you have the capital to clear fifty years of poverty and neglect. A brownstone with intact architectural detail—frothy mantels that resemble wedding cakes, wood carvings, ornamental plaster ceiling designs—is a grave digger's paradise. If you can find one, act fast and bring cash.

Hypergentrification is manic. Bidding wars between buyers are common; they sling hundreds of thousands of dollars back and forth until someone drops.

The phrase *Bed-Stuy, Do or Die* appears in Spike Lee's 1989 film "Do the Right Thing," set and filmed in the neighborhood.

Two decades later, the restaurant Do or Dine opened, a riff on Brooklyn history made palatable through a cinematic gaze. As Lucy Sante writes, "Instead of disappearing, local history has been preserved as a seasoning, most visibly in names of bars."[2] It served foie gras filled doughnuts and seven-dollar frozen snickers bars served in their wrappers. Do or Dine unexpectedly closed in 2015, but resurrected as the bar Do or Dive. Dine or dive, these places ironically poke. Gentrification itself becomes part of commodity fetishism as critique; *almost* everyone is in on the joke in these simulated neighborhood joints, bred for the young and the loud. The transient demographic seems oblivious to the neighborhood's past, they eat and drink it, becoming more cosmopolitan through consumption. History recycled and referenced with a wink.

I rented an apartment in Bed-Stuy a ten-minute walk from Do or Dive, in what my landlord advertised on Craigslist as a "historic town home."[3] Built at the turn of the century, it was technically old, but gutted of any original charm. The stucco-style exterior was painted the color of pale vomit—neither gray, beige, brown, purple, or pink. If forced to call it a color, I'd say puce, the French word for flea. The walls and doors were hollow, and the moist green hallway carpet reeked of beer and cat hair. It wasn't the ugliest building on the street, but the block itself was a hard sale for the shadiest realtors. Windows on the vacant houses were cemented shut, the most effective keep-out sign. There were a few scraggly trees and not much to save and restore. Most of the occupied houses were made of cinder block or simulated brick tar paper; some missing siding and shingles, others with collapsing roofs that attracted nests of ever-shitting pigeons. The subway was two blocks away; the rent twenty-one hundred dollars a month for six hundred square feet of living space.

My geography was bookended by the G train and the Home Depot. The Bed-Stuy Home Depot pulls a wildly diverse socioeconomic mix of people to one place; new brownstone owners, contractors, Pratt college students, Hasidim from neighboring Williamsburg, and long-term renters. Some renovating and upgrading; others maintaining, stocking up on garbage bags and roach bait. I took great pleasure in buying bulk toilet paper and paper towels. I was ready to clean up everything—piss and spillage, rage and resentment. When I passed the outdoor garden area, I thought about buying a twenty-dollar plant for my building steps but figured it would get stolen. Having potted plants and flowers signals that occupants care. I read this somewhere. It also says you have an extra twenty dollars.

You must deal with perpetual change in New York, or you will become resentful and unpleasant to be around. You'll give up on the city and leave. I moved to Bed-Stuy to find an affordable and habitable apartment. A sociologist friend said I was a cause and a casualty of gentrification. That sounded right. Starting the phone gallery was partially a knee-jerk reaction to displacement. At the time, Andre and I were curating shows at Group Club Association, the gallery we started in his studio space in Bushwick. He signed a two-year lease with an increase of 20 percent after year one. The rent hike was disproportionate to our miserly salary increases of 2 percent per year. When it kicked in, we did the math—at the kitchen table, in our heads, all the time. We freaked out over the math. Georg Simmel described the modern metropolis as the "seat" of the money economy, a place where "money, with all its colorlessness and indifference, becomes the common denominator of all values; irreparably it hollows out the core of things, their individuality, their specific value, and their incomparability."[4] We were hollowed out, too.

My footing in the city was eroding. By claiming the pay phones, I could grab a piece of it. I could create another art world; plant my little flag.

IF YOU HEAR MY VOICE CLAP ONCE (AUGUST 11, 2016, 7:46PM)

They beat me to the opening. I turn the corner onto Nostrand Avenue and see my first gallery visitors leaning against the metal fence near Pay Fauxn. City workers in neon yellow vests spray water in the air a few feet away. It's after seven o'clock and time to power wash the glass bus stop enclosure in front of my gallery. I didn't know. A loudly chugging portable generator is hooked up to a nearby city truck for power. They've already cleaned the area around the fauxn and the sidewalk steams. I'm worried I made a mess. Panicky, I run up and we wait.

"What's up? Where's the art?" *It's coming.*

"Your gallery is dirty." *I know. Ha ha.* I force a smile.

"What? Huh?" We all yell, awkwardly.

Commuters are scattered around waiting for the bus, mostly not near us. Two men in slick suits and designer shoes look like they work in Manhattan. I make eye contact with a suit guy, and he looks away. I take this personally, a sign of disapproval. A minute feels like twenty out here. Lee, the artist, and three of her friends finally walk up and it's show time. I give her a white daisy and she puts it in her bag. I'm thinking, *Take this flower. I know it's weird, what I asked you to do.* Strained smiles. What now. Lee's boyfriend gets to work putting the double-sided tape to hang her art, a glass mirror precisely cut to fit inside the back of the phone with black vinyl letters that say "If You Hear My Voice Clap Once." As he calmly attempts to install it,

a friend shows up on his bike, and then another. Ten of us are now on the sidewalk at the bus stop, and the art is not on the wall of the gallery.

I introduce people to each other because I'm the gallery director. I set this in motion and I'm responsible to keep it moving, to orchestrate something. While I anxiously direct the scene, a guy wearing a backward baseball hat comes peddling down the sidewalk on a kiddie bike that's too small for his legs. He bumps into someone, catches himself, and yells, "what the fuck, get off the fucking sidewalk." The gallery patrons are nervous and look away. Twenty seconds of silent meltdown— no art script to fall back on. Ignored, the bike guy pedals on muttering and swearing.

"He's just crazy; he not right. He shouldn't be on the sidewalk anyway," says the spray-washing city worker.

I'm thinking, *Thank you for saying that because I didn't know what to say.* In the moment, I grasp this as confirmation to continue. We're not doing anything wrong; it's only polite and privileged vandalism. Swooping in on this phone with our art, our bodies, our "we can put this here and make a gallery" conceit.

Lee eventually installs her work inside the back of the phone— now it's a gallery. We look quietly and immediately start taking pictures. I've never been at an opening when the art is installed and unveiled at once, breaching the fourth wall. In the legit gallery world, the staging of art is concealed, like a painting was magically hung, placed exactly where it belongs and illuminated by the God light. I tell everyone to gather around. I want to make a speech. I begin passing out envelopes with a poem inside. "Don't open these now. Read it when you get home." My guests stand there with the envelopes in their hands. "Okay, uh, thanks."

This is a way to think about what you saw and what we did.

Traditional gallery openings are scripted: everyone knows their place, what to talk about, how to look at things, and when to leave. This was socially disruptive: the bike guy, the power-washing crew, commuters waiting for the bus, and me with the envelopes filled with a poem about pay phones. I tell a story about the nursing home. This is what I think I said:

> A few words about Pay Fauxn. It's technically on the property of a now-defunct nursing home called CABS that was owned by NYC. It was functioning and good to vulnerable local elderly and poor people. It was sold to a company who then sold it to a real estate developer for profit who kicked them all out—the patients and staff, without going through proper legal channels. Public officials weren't notified. It's an illegal deal and in the courts. The developer applied to build a vulgar luxury condo at the spot. Pay Fauxn's time is limited. It will be gentrified.

They look at me blankly. The opening is now over. We walk up Nostrand Avenue together in two groups toward a local corner bar. At the Pay Fauxn after-party, we sit at two tables side by side on the sidewalk—Lee's crew with the friend who works at *Artforum* and us. It's like high school with in-groups and out-groups forced to inhabit the same space. It doesn't feel like a community; we're not bonded together because we shared an experience. I down my first drink fast. My mind racing: *I've got to find the right artists for Pay Fauxn. Translate it for the MFA art world. Some people won't ever get it. What just happened.* Maybe Pay Fauxn is a performance space or a Fluxus-inspired happening and not an art gallery at all. I'm one of the performers. I'm trying to do magic.

When you go public with your work, you're exposed to the elements, wide open to yelpers. Swallowing fear and anxiety is a

skill you must hone, like developing muscle, transforming a part of yourself from soft to hard. I wasn't afraid to be embarrassed, but don't ever ask: "How was the Pay Fauxn opening?" the day after. Don't ask: "How's your phone booth gallery?" like you're asking about the weather, like your saying ha ha. This project means something to me, and my name is on it. Eileen Myles writes, "never go anywhere near a performer after a show. Not even the week after the show. The performer stands in an insane place on a cliff and if you say hi how are you, you are pulling the cliff right out from underneath the person. You're punching Harry Houdini in the gut."[5]

What I know: We scratched our name in New York City, the global art capital. It's a line on a CV, it's a link on a website, and that's something. It's like what Warhol said, "don't pay attention to what they write about you, just measure it in inches." Artists always need another line.

VIGIL (JUNE 29, 2017, 8:11PM)

My idea of having anti-openings (ten-minute well-orchestrated events) was, at this stage, a failure (see chapter 20, "Pay Fauxn Manifesto"). I couldn't control the momentum, not everyone came at the precise time, like in the beginning. And why should I impose order on a gallery that is two deserted pay phones at a chaotic bus stop.

Andre and I are smoking on the front steps. A black suburban pulls up in front of the townhome. Issa steps out, carrying a cardboard box and hands me a bottle of white wine and says, "thanks for your work."[6] She carefully opens the box. Inside are four nurse candle sculptures cast from a replica of a statue she found in a thrift store. That day we hear that funding for

the elderly may be cut by a proposed health-care reform bill. I'm inspired by the layers of meaning—a vigil for the evicted CABS patients, the potential casualties of health-care reform, and the erasure of the exiled as the neighborhood's upgraded. A comment on displacement, loss, the notion of public space. The form didn't reveal the content in a didactic quick-glance way. The art looked like candles, and it was.

We grab the nurse candles and walk toward Pay Fauxn. Passing Home Depot, Issa notices her friend's van, an artist-curator who organizes pop-up art shows. Looking down the block, I see four other artists waiting at the bus stop. Issa and I race over and remove the wax statues out of a bag, assessing the state of the galleries. There's already an accidental exhibition; a half of a pizza slice on a white paper plate on top of a pile, a rotting banana peel, crumpled cig packs, receipts, and business cards for a car service. The pizza slice falls to the ground as I prepare the gallery for installation. "Maybe we shouldn't touch this stuff," I say pulling out napkins. Everyone shrugs. I never brought art-handling gloves to clean out the fauxn. Someone suggested it as a joke. Whatever Pay Fauxn was, I didn't think of it as satire.

I arrange the pizza slice on the ground with my foot, while Issa installs (throws) the wax sculptures inside each gallery. No fuss. She lights them with a lighter and gusts of wind kick up the flames. Within minutes, the nurse's heads begin to cave in and disappear. The visitors are into the burning and dripping, in MFA art speak, fire functions as both material and process. I tell the story of CABS and nobody pays much attention. By now the script is memorized. The ninth opening, and I'm still uncomfortable giving my speech on the sidewalk while people are running to catch the nearby G train.

This guy Rico comes walking up with headphones on. I'd guess he's in his early twenties.

"What is this?" he asks.

"It's an art show with burning nurse candles; she made them," I say pointing to Issa.

"OK. OK." He shakes his head and processes for a beat. "That's cool." He looks quickly inside each of the galleries while we talk.

I start telling the CABS story again. "This used to be a highly functional nursing home . . ."

Rico interrupts me: "I was supposed to tear that place down. But the job got called off."

It was his job to make it disappear.

"This is what happens with gentrification. It's something happening in the courts, a lawsuit or some shit," he says.

"Yeah, yeah, the developer is greedy and he made some illegal moves," I say.

"What are you gonna do? I've been living nearby my whole life. It's out of control. I know that. That's a fact. It's hard making enough money to make a livin' even from workin."

"Yeah, a living wage is like an oxymoron," I say.

Rico doesn't respond to my comment. We watch the candles melt.

"This is dope though. Good luck with your phone gallery." He fist bumps me, gets a light off the art, and walks away.

I turn around and see my neighbor George coming up the sidewalk. Born and raised in Bed-Stuy, George is our old head, watcher of cars, and UPS packages. He knows every person on my block, taking great pleasure in shouting out to me from a different building stoop or window. He gains entry to do odd jobs or to sit and shoot the shit until he's too drunk to work or keep watch of the street. I speak to him every day. I once saw George on the other side of Bed-Stuy, miles away. I asked him why he was off the block and he shot back: "Got to keep my

FIGURE 19.2 Allison Wade, wax nurses with pizza and trash. Sonya German, 2017.

eye on you. Make sure you're stayin outta trouble." He made small talk sincere. George was everywhere—one of Jane Jacobs self-appointed public characters, who didn't need any special talent or wisdom to fulfill his role, beyond a desire to know everyone.

George looks puzzled. *This is an art show?*

"You want one?" he says gesturing to the Dunkin' bag in his hands.

"No thanks; if you eat too many, your neck will turn into a big fat donut," I say.

"You're always crackin' me up with your sayings," he says. George looks behind me at the base of the nursing home. He's distracted, noticing a rat poking around the bolted and chained entrance. It's still daylight. When rats walk around in the day, it's a sign that they've taken over the building. When they find a stable home, they become brash and undeterred by people, just like on the subway platform. An unnerving reminder of how human and animal quality of life can be a feedback loop.

"Check it out: a rat came to your art party," George says pointing.

I see another one race along the edges of the building.

"Yup, we got a big rat problem here. There's kids all around. This ain't right with what is happening here. It ain't right," he says.

I've never seen so many in one spot. Ominously, four more rats attend my art party, reminding me of how the project's life was capped from the start. Pay Fauxn's clock is ticking.

"The city needs to take control. Someone's gotta fix this, it's someone's job to fix this." His angry plea drifts in the air. The art keeps burning.

"I gotta take a shower. See you tomorrow," he says and walks away.

Gallery visitors are busy taking pictures with their phones. They don't pay attention to George and me.

In the twenty minutes we're there, the light morphs from orange to cobalt blue. Fireflies begin to blink in the tall weeds at the base of the gallery and near tree branches that connect the fence and

the nursing home. Male fireflies light up to attract the females who stay on the ground and watch the show. They flash back if they're interested. The interspecies dramaturgy of humans, rats and fireflies feels like a real New York thing, like we plugged into an electromagnetic frequency at a bus stop half a block down from Home Depot.

On cue, fire truck sirens begin blaring and the channel changes. The candle flames are two inches high and rising with the wind, flapping around. I don't think there's anything that could catch on fire in the phones, maybe the greasy paper plate. I keep looking up at the tree branches swaying a few feet from the abandoned building and panic. *The nurse sculptures light the fire that burns down the nursing home.* The fire truck booms past, stirring up a hot street trash tornado. Pay Fauxn presents minor threats, low-level risk management, strained sociality, and no trespassing signs. We're disobeying but not in any real danger.

Blip, blip, blip. I hear another siren chirping in the distance and within a few seconds a cop car weaves down Nostrand directly toward us. *This one's coming for us, for me.* It slows, drives by the gallery, and cuts left on Kosciuszko Street. I imagine sitting in the back of a police car, looking out at my friends on the sidewalk. If a younger Black or brown person, especially a man, was tagging the phones or even hanging around, the police might notice. A bunch of white people at a bus stop isn't cause for alarm. Issa and I agree that the opening is over after she anxiously jokes about being arrested for arson.

We blow out the art and leave it for collectors to take and walk around the corner to a place called Swell Dive. I buy Issa a margarita, and we sit at the bar by ourselves. "I seriously can't believe how many people came to my opening," she laughs. It's already oppressively humid and too hot to be standing around a bus stop at the end of day. Most New Yorkers are cooling off

somewhere, in a local park or public pool. Others are upstate or on Long Island, summering or weekending. Getting fifteen people to meet at the bus stop seemed improbable. In that moment, we were buoyant because we pulled it off, and because it felt like community, for a few hours.

What I know: Pay Fauxn isn't social practice art, it's not changing any systems, it's not righting wrongs. Isn't street art, faux graffiti, or a public service announcement. It's something we invented, something else, and I don't want to try to sell it. We made something that isn't for sale.

CODA

I organized twelve shows at Pay Fauxn over fourteen months. The nursing home compound had yet to be demolished, even after the court case settled and developers agreed to pay a fine. Accumulating weeds and some old-school graffiti, it looked more feral and out of visual control. With each new tag, its days were numbered. The graffiti wasn't selling anything commercial like jeans or vodka, just the name of the person who wrote it. Highly stylized, mainly for, and decipherable to, fellow writers, it was a clear quality-of-life violation. A throwback to the broken-windows era, when politicians could placate conservatives by drawing attention to the small stuff. Soon the apartment complex would be erected and graffiti *artists* would be commissioned to do a mural on the rooftop deck or as wallpaper in the common area behind the pool table and leather couches. Come live in an artist simulacra.

Pay Fauxn officially ended three months later when the gallery was invited into an exhibition of "divergent spaces" curated by MFA grad students at Hunter College. Other spaces in the

exhibition *The Big Short,* included a gallery in a microwave, a magazine featuring 3D exhibitions in simulated environments, and a miniature model of a traditional gallery with tiny artworks ironically made for the little white walls. The micro gallery was placed on the center of a couch. All these experimental spaces defied the norms of where art should or could be shown. They were now assembled at Hunter and presented to the art faculty as legitimate, for the sake of an assignment. Pay Fauxn was institutionalized, kind of.

I couldn't detach Pay Fauxn and drag the shells uptown for the show. It was site specific, obdurate, and unmovable. Recreating a mini version of the gallery or making something with a real phone was obviously too obvious. After brainstorming with Andre, we figured it out. He'd make a painting that captured the Pay Fauxn ethos out of a cardboard sign from a Bed-Stuy tire shop. He noticed the sign when he rode his bike past on his way to work—NO FREE AIR in black spray paint. Other words were later added "No air for bike" and "No air for ball."

"Hey man can I buy that sign from you?"

"What do you want with it?"

"I'm an artist."

"Ten bucks."

Andre vacuum sealed the sign inside a clear industrial bag. A gigantic zip-lock baggie to protect the ready-made piece. Now it was a painting, installed on a white wall at Hunter. Bent and warped, the edges refused to lay flat. It was canny, a word overused in press releases, because it was divergent as a painting. It was at odds with the wall. Out of place, the message didn't translate.

At the opening, people looked down inside the mini galleries and at the computers displaying virtual exhibitions. They smiled knowingly; they took out their phones to take pictures of the

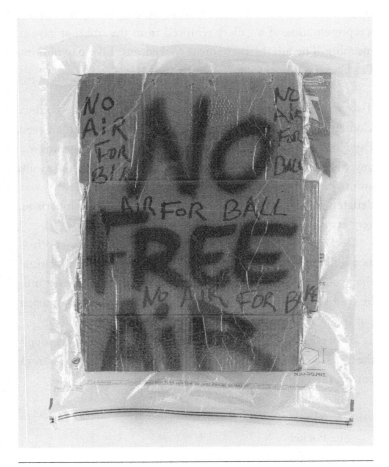

FIGURE 19.3 Andre Yvon, *No Free Air*, 2018. Andre Yvon.

screens and dioramas. Nobody noticed the Pay Fauxn painting. I watched a woman back up against it, her coat made contact with the plastic. It crinkled as she flattened it, unaware she was smooshing art symbolizing an art gallery. It was illegible. The project didn't belong there, and the painting as stand-in didn't

translate. It was too divergent for a show of divergent spaces; a representation of a gallery removed from the site that gave it meaning. The air, the excitement sucked out. Like pay phones, Pay Fauxn was over.

Two years later, in 2020, I met a Belgian artist at Catbox Contemporary, the apartment gallery in Ridgewood. He'd seen Pay Fauxn on Instagram or heard about it. He said he knew a guy who made a gallery in his coat pocket. "He would just walk around and open his jacket; it was dope." How brilliant. I was deflated. Pay Fauxn was stodgy and place-bound in comparison, very 2017.

Declaring any object—a coat, microwave, or phone booth—as a gallery is and isn't easy. It requires more labor and time than you imagine. And you must be careful, you don't want it to be read as pure mockery or "like Banksy territory" as an artist put it.[7]

Before I disabled my Facebook account, I scrolled through the archive of posts. What was on my mind? I found a post from 2018 in the form of a multiple-choice question.

Who's starting a gallery in their:
 a. Mind
 b. Pocket
 c. Toothbrush
 d. Cat's Asshole
 e. Both b and d only

This got 23 likes from my 998 Facebook friends. One of these friends said I was "hilarious." I forgot that I'd already conceptualized the pocket gallery.

20

PAY FAUXN MANIFESTO

ANTI-OPENINGS: openings must be no longer than ten to thirteen minutes (allow for seventeen under unusual circumstances, keep it moving).

SOCIALITY: director must warmly greet every visitor and introduce them to each other and the artist. look them in the eye.

PR: don't invite more than a handful. announce day of or before, never give address. anti-PR conforms moderately to convention. (update January 2018—NO PR.)

PROP FOR THE HAND: there is a beverage. when people stand around awkwardly on a sidewalk, just as in a white cube, it helps to have something in your hand. notice smokers light up right away—awkward. bring drinks for everyone. *hand people a can for the hand.* (update January 2018—NO BEVERAGE. give necklace sculpture to artist. put it around their neck.)

POEM/GIFT: do something unexpected. visitors get an envelope. open when they get home and are alone. a directive—pay phones invite public (mis)communication. users re-purpose the phone. have sex in it, sleep in it, pee in it, throw garbage in it. reflect on pay phones and changing relationships—technology and multispecies inter/intra-actions. (update January 2018—THE ARTIST IS THE POEM.)

21

MIRACLE

I experience little pleasure attending openings. I go to back the artist. I go to celebrate what they've made (alone in their studio) and to honor it in public. I go in a support-the-arts-for-the-greater-good way, as a curious observer, a broke patron, another body to fill up the space. I appreciate how much work goes into making one painting (sculpture, object, video) and what it takes to make a cohesive exhibition.

Art doesn't leap out of a studio and onto a gallery wall—quite the opposite. There's tedious planning and coordination, transporting, truck renting and driving, bubble wrap, packing tape (the special art kind), nailing, and measuring. The gallery wall itself might be made of concrete or flimsy drywall and in need of four coats of paint (switching from black or hot pink back to white). The wall could be crumbling brick or the back of a metal mailbox. Apart from conceptualizing and figuring out the show's title, it's mostly putting out fires. An art show at an underfunded gallery in New York City is a miracle.

On Norfolk Street, I slouched near the door to a project space that's directly underneath a commercial gallery. I've come to prefer galleries that are underground, built into the bedrock of

New York. I'd been there for at least an hour, which amounts to three hours of doing any other public activity like having drinks. I'd run out of things to say, people to talk to. An artist-curator I know well, someone who I like, sees me and we both step toward each other and lean opposite shoulders forward, a half-hug. We run through the how-are-you, what's-going-on script. He tells me he stayed up late photographing a show that's opening in a week. He runs, curates, and organizes three different spaces; one is a gallery in his apartment. His bloodshot eyes are framed in khaki green circles. He looks like a vampire. He tells me the upcoming show *looks tight*, but the artist isn't great to work with because they're aloof, indifferent. I sympathize with him. We talk about how lonely curating can feel, even though you bring people together. We talk about how distant, even though every show you organize is personal, a part of your story.

I said: "I don't think any of my curatorial projects created a community. I think the idea of an arts community is obsolete." I do the air quotes when I say "arts community" and make a face.

He nodded: "I couldn't agree more. After a show closes, I usually never hear from most of the artists again. They just disappear."

"Totally. I thought I would become friends with people, at least friendly-ish," I said.

"I know, I think they just get what they want, get their show, deal with you, and then they're off on a new trip," he said.

"Artists are like sharks; they're forever circling around for food. They follow the chum and the blood." This isn't an official interview, I'm speaking freely. I've had two glasses of wine.

"That's a good analogy. Maybe artists have shark brains, reptilian brains," he said.

"Eye on the prize only," I said.

"No doubt," he said. "But it's totally addictive. It's obviously bad for your mental health, and it's a total time suck and eats money, but I can't stop doing it."

"I get it. It's hard to describe how good it feels to make an art show happen, the initial adrenaline, the 'I made shit happen' feeling. But talk to me again in five more years," I said.

"Yeah. It's more complicated than it seems. The little victories and dark zones. You should write about this," he said.

"I'm trying to."

22

OBLIQUE ATTEMPTS
(TOWARD A CONCLUSION)

If my perspective seems shifty, it's because I changed. A book is an accumulation of the self over time, an accretion of the I and me. Imagine the courage it takes to release and invite others to look at it.

I missed the mark on purpose. It kept moving, and I didn't try to pin it down. This is dangerous because even though you may be advised to just go with the flow, you may be drawn into a whirlpool and like it. You can't drift forever, or maybe you can. Honor thy error as a hidden intention.[1]

I will not wrap up the city—it's too queer and erratic. It will always escape you and the insufficient ways you narrate it. How would you have written it? I look forward to being shown the way. I will never tire of New York stories. Tell me more.[2]

I will not systematically argue for the emotional or moral benefits of art. I will say that art is a human condition—illogical and gorgeous. Without it, we are monstrous. Of course, the most important thing is the thing most easily forgotten.[3]

I will follow the artist who makes something that transcends living. I will make a casserole of confusion. I will use an unacceptable color. I will never touch the center. I'll go slowly all the way around the outside.

POSTSCRIPT

The age of Covid, or post-Covid, we aren't sure. The age of devastating wildfires anywhere at any moment, Canada and Hawaii charred. The age of post–*Roe v. Wade* underground networks, abortion pills smuggled from Mexico. The age of insurrection and indictments, probes and charges. The age of invasion, the danger of nuclear bombs and the Third World War. The age of chatter and babble, X and Threads. The age of wokeness and anti-wokeness, cancellations and acts of contrition. The age of AI, rapidly evaporating workforces, tech oligarchs becoming absolute Gods. A brutal time—monstrous and fathomless.

I settled on the title *Art Monster* in 2020, inspired by Jenny Offill's description of an art monster in *Dept. of Speculation*: "My plan was to never get married. I was going to be an art monster instead. Women almost never become art monsters because art monsters only concern themselves with art, never mundane things. Nabokov didn't even fold his own umbrella. Vera licked his stamps for him."[1] I wasn't the only author drawn to Offill's art monster, which presciently pointed to this zeitgeisty moment. In April 2023, Claire Dederer's *Monsters: A Fan's Dilemma* was published, and in November 2023, Lauren Elkin's *Art Monsters: Unruly Bodies in Feminist Art* was released.[2]

The social conditions that fertilize art, the invisible labor of others, the necessity of selfishness, and obstructed ambition. I first thought of an art monster, as concept and character, in this way. With time, I drifted. I began conceptualizing the metropolis and the New York art world as a late capitalist monster. I reeled in the word *monster*.

I've been thinking of these monster books, published within roughly a year of one another, as an accidental triadic dispatch—postcards from a monstrous age. From the Latin word, *monstrum*, an omen.

METHODOLOGICAL APPENDIX

CHARACTERS

ANDRE

Born in Maryland. Living in New York City for sixteen years, earned an MFA in painting from Rhode Island School of Design in 2011. Upon graduation, moved in with me and designated us *spiritual life partners*. Worked at Chelsea galleries, managed a commercial art studio, and quit his job as an artist assistant to paint full time. Andre and I started a gallery out of his Bushwick studio called Group Club Association (GCA), opened a gallery in a pay phone called Pay Fauxn, and ran a black-cube basement gallery in Chinatown called Bible. Made a ton of drawings together. Forty-two years old as of this writing.

ANIKA

Born in Kiev, Ukraine. Earned an undergraduate degree in philosophy and an MFA in sculpture from Rhode Island School of Design in 2007. Has worked as an art handler, security guard at the Met, and fabricator. Owns a small fabric design business

and lives with a sculptor in Bushwick, Brooklyn, in an industrial space where they make art and care for their child. Mid-thirties at the time of interview, which took place at a bar in Bushwick during the daytime.

BILLIE

Born in Appalachia. Earned an MFA in painting from Columbia University (date unknown). Worked in New York for almost two decades in many jobs; as freelance art handler in museums and galleries, installer of art in private collections, art shipper/truck driver, and artist assistant. Late-thirties when interviewed at a Lower East Side park.

HARPER

Born in Oklahoma. Earned an MFA in painting and printmaking from Yale University School of Art in 2011. Worked as an adjunct painting instructor and artist assistant. Often lived illegally in studio buildings that didn't permit artists to live/work in the same location. Was in her mid-thirties when I interviewed her at an empty coffee shop in Bushwick on a Sunday morning in August.

HOWARD BECKER

Sociologist, musician, and photographer who pioneered the sociology of art. His book *Art Worlds* explores art as a division of labor, a collective activity carried out by a network of people (workers who make paint brushes, truckers who ship materials, and assistants who stretch canvases), who follow established

conventions to make things classified as art. His writing on art, culture, and social deviance has shaped my thinking.

JACKSON

See chapter 11, "Neighborhood."

LIAM

Born in Ohio. Earned an MFA in painting from Virginia Commonwealth University in 2014. Worked as an art handler in the New York branch of an international auction house. Had a studio in Ridgewood, Queens, at the time of the interview and was approximately thirty years old, possibly younger.

OLIVE

Native New Yorker. Earned a BFA at the School of the Museum of Fine Arts, Boston. Worked as a full-time security guard at the MET for almost two decades and plans to retire with a good benefits package. Was fifty years old when I interviewed her on her day off from the museum at a café on Avenue A in the East Village. I sensed she would have rather been working in her Red Hook studio.

VIOLET

Born in the mid-Atlantic. Earned an MFA in sculpture from the University of Pennsylvania in 2015. Worked as a lecturer at the School of the Art Institute of Chicago and a fabricator in a prop shop while living in New York. Has since left the city to

live in rural New England where time may be easier to access. A staunch feminist and lover of metal, Violet viewed her body as a medium in an objectively hard-core way. Was in her early thirties when I interviewed her at a café in Bushwick.

XENOPHANES

See chapter 4, "Will You Listen to the Problems of a Stranger?"

ON METHODS AND ENTANGLEMENTS

Ethnographers try to show how people live, decipher their actions, and grasp what they value. It's impossible, but they earnestly try. They're trained to immerse themselves within the *field* and describe what they see, offer an analysis or theory to make sense of it, move from the concrete to the abstract. Unlike journalists, ethnographers interpret what they witness and account for the messiness of their participation as well as the inadequacy of their interpretation. I'm interpreting through the I, and I agree with author Lili Anolik when she said, "objectivity seems embarrassing now."[1]

Ethnographic fieldwork can take place anywhere: a sidewalk, a prison, an airplane, a tattoo shop, a YouTube channel. Any environment is fair game, but some research projects are more clear-cut. Sometimes it's about access (getting in) or translation (getting the language right). When the sociologist Lisa Jean Moore and I wrote *Buzz*, a book about the rise of beekeeping in New York City in the wake of the Colony Collapse Disorder (CCD), a crisis threatening honeybee populations, I struggled to get into the headspace of beekeepers and bees, my non-human informants. After a year of fieldwork, I began to get how and why people are enmeshed and, in some cases, emotionally connected with bees. Trudging across

tar rooftops in Brooklyn in late August to watch beekeepers do hive checks was an activity I at first tolerated. Later, I looked forward to hanging out with thousands of dazed and rightfully angry insects. Peering into the hive, it was thrilling to watch them work like maniacs. When they landed on my body and didn't sting, I was secretly proud. I wasn't a bee whisperer, but I didn't get hurt. I learned to value bees, to see each one. There's nothing objective about ethnography. Everyone—the researcher and the respondents, human and sometimes nonhuman—is touched by contact with the other. Academics call this entanglement.

When I started research for this book in 2014, I was already in. I had what sociologist Max Weber calls *verstehen*, an in-depth understanding of the meanings people give to their worlds. I had a shit-ton of notes (written on napkins, my phone, old black-and-white composition books). I need art, and I'm empathetic toward humans who possess the drive to make it, even if it appears idiotic from a practical, economic standpoint. I've come to see a link between bees and artists as pollinators. Bees are essential to urban landscapes: they help fertilize diverse plant species as part of the ecology of the city. We assume bees will always be there. Likewise, artists are indispensable to the cultural ecology of the city and seem to naturally belong to the urban. I use the word *naturally* with caution, as the meaning of the word nature is something entirely human. But artists and cities might as well be bees and cherry blossoms; they do something to each other that appears to be both instinctive and inherited. I see what I've done here—incarnated the city. To me, New York City is as essential as a glacier or a rainforest, and even though it's a destructive human intervention on the natural environment (all the building material, the energy, the waste), its people, buildings, parks, and trees must be protected as an irreplaceable resource.

Einstein is credited with saying that if bees go extinct, humans will be next. They're a twenty-first-century canary in the coal

mine—a postcard from the Anthropocene. As I studied how bees were threatened by global capitalism and industrialization through the combined forces of industrial farming, monoculture, pesticides, and climate change, I continued reading stories about New York City artists under threat. Like other vulnerable New Yorkers, human and nonhuman, they were being trampled, squeezed out. Pushed from SoHo and Chelsea in Manhattan, and then Williamsburg and Bushwick in Brooklyn, evicted from communities they cultivated in forgotten neighborhoods. I saw it happening to my artist and musician friends, and it happened to me. What if working artists go extinct? What if they flee to Detroit or Portland? What would New York City cultural life look like if visual artists, musicians, actors, writers, poets, and filmmakers left? I've never answered any of these questions directly. I invite you to imagine it. I see more chains, restaurants, banks, and flagship stores, teeming with influencers, brunchers, American tourists, and selfie-takers. Manhattan as a consumption strip filled with human Weeble Wobbles who *just want to get what they pay for.*

We need bees to pollinate the foods we've come to expect—almonds, blueberries, avocados.[2] Likewise, we need artists to pollinate New York, to fertilize and piss all over it. Underfunded artists are still in New York, but like bees, having a harder time doing the work they're instinctively compelled to do. They're forced to live under the weight of increasingly hostile conditions—always on the run. Running from landlords, student loan bills, crummy credit scores, and a profound feeling of powerlessness. There is a darkness. It's allusive and hard to capture: some call it neoliberalism, the billionaire economy, hypergentrification, postempire, or postindustrial capitalism. Whatever the label, the social contract is shattered, and cities teeter on the edge of cultural and environmental collapse. The promise of the city, the *right to the city*, is becoming anachronistic and embarrassingly romantic.

We may be coming to the end of an era in which artist is synonymous with urban. To quote Darren Walker, president of the Ford Foundation: "Without artists in many ways the city will be without life. Artists are essential to the cultural landscape of the city.... We need artists for New York to be New York." And artists need the city.

A final note: Art doesn't directly save lives or end injustice in a tangible way like an affordable universal health-care system or prison reform. Art is a distinctly human activity, one of our profound accomplishments. It helps make sense of a volatile world; it allows us to speak our stories, make our marks, trade brutality for beauty; and maybe it even *saves lives*. Art is fundamental to our humanity, a report on the human condition, and evidence of our uniquely productive urges to make beyond what we need for our basic survival (what Karl Marx calls our *species being*). Grasshoppers and cats don't paint on stretched linen, write librettos, or sculpt marble and wood, but humans do. Sometimes, we sacrifice our physical comfort and sanity to try and do it all the time, to make art our life's work.

ON SCROLLING AS FIELDWORK

I've been told Instagram "can be a voice," "a platform," or "a way to stay in touch with people." Social media is frequently described as an online community.[3] I've never heard an artist call it that. If *community* means commerce, private conversations, acquiescing to surveillance, lurking, and self-promotion, then sure, it's a particular kind of community. One built on the norms of producing and consuming images, the seductive pull of visibility and recognition as a linked in self-industrial complex. Why leave the office, studio, apartment, bed; your community is in your hand (head).

Let's get to the data. In five years of virtual ethnography, or online participant observation (lurking?), I never came across a post that boasted of being hungry and broke. I've seen myriad images of artfully arranged dinner plates, sculptural pancakes, and nodding house cats in warm afternoon light. For a time, artists seemed to agree that Saturday was #caturday on Instagram. Adorable pets do show up in the feed, especially Bertie, a Pomeranian who works at a downtown NYC gallery, but empty cans of soup and half-eaten bowls of macaroni and cheese are absent. I never saw a post of a frozen pizza box, although artists have painted the iconic take-out pizza box to greater and lesser effect. Andre said everyone does that in undergrad art school.

The look of prosperity clouds reality. Studio shots of paintings in progress carefully edit grim signifiers. The starving artist has currency as nostalgia. Whatever the precarious economic circumstances of the present, life is often presented as one that is a #WIP—a work in progress. In 1956, the sociologist Erving Goffman theorized that society is made of dramaturgical interactions and that humans constantly perform and present different version of the self to others—the presentation of a life as always becoming, worked on. It's life edited and revised or, as Jia Tolentino says, *optimized*. Cook up the best life for hungry followers; wait for them to feed.

I've observed New York–based artists, their friends, and friends of their friends abide by similar posting norms. More homogeneity, more likes. Sociologists call these normative strategies "ideal types" of accounts. I've categorized five:

1. Only (Your) Art. Also pics of working in the studio, or an object in progress, but mainly completed and professionally-photographed art. #WIP
2. Artist Curation. Post your work, images from friend's openings, studio visits, artists who inspire you. This is what I do,

my influences, my own curated art world—evidence that you constructed or participate in an art community face to face and online. #NAMEOFARTIST

3. Aesthetic Persona. Post art sprinkled with things from everyday life or a Google search that yields an image that is either absurd, confusing, silly, ironic, or aesthetically compelling. These disparate images may be juxtaposed, further signaling an artful stance. There is often dark humor, resistance with a wink. Dumb memes. No hashtags.

4. Anti-Instagram. Feature nonnormative, political/cultural commentary that is un-PC, intentionally or unintentionally. No hashtags. (*Note:* I identified the least of this type of post, which tends to garner few likes and even fewer followers.)

5. Artist Lifestyle. Craft an artistic identity but in tony urban or exotic locations, including on the beach in Southeast Asia or a minimalist flat in Berlin. If the artist lives in small town or lesser city, the quirkiness of the locals and their culture may be posted with irony or a lay anthropological fascination. Often includes selfies and selfies with art. Hashtags variable.

6. Instagram as Art. Making art directly for or about Instagram to be consumed on Instagram. Hashtags idiosyncratic or absent.

Artists were the vampires of New York. Now they haunt with an emoji or a word—"dope," "awesome," "soooooo good," "fire," and "yessssssssssss." If you can't show up in person, then like. Always like, like you're liking for real. Resort to a list of emojis: fireworks pow, red flame, heart, heart, heart, clap, clap. Likers often don't bother to imaginatively mess with emojis, I want them to abhorrently comment with two kiwis, three bats, and a bowl of soup. My students say using emojis is something old people do (those over the age of thirty).

Andre is convinced people are morphing into like-bots. He said, "some days I get on and like everything, even the ads

because it's ridiculous; other days I scroll and see so much bad art and dumb pics that I refuse to like any of it." Sometimes his thumb has integrity.

A final note on ways of seeing: The first Instagram post was an unfiltered omen. A bird's-eye view of the face of a golden retriever and part of a woman's foot in a flipflop. The toes look at us or the puppy, and the dog's mouth and eyes smile in the direction of the camera, left of screen. A decade later, dogs would be influencers with Instagram accounts. Anthropomorphized to the extreme, monetized content, like Tika, an Italian Greyhound from Montreal with an extravagant wardrobe, a "gay icon, fashion model and actual bad bitch," followed by more than a million humans. The domestic pet was a symbol of fidelity, love, and loyalty in Western art history. In Renaissance paintings, they curl in royal laps or dutifully at the master's feet.

From the Medieval period to the present, art traveled from the walls of cathedrals, to canvases on walls, to the contemporary churches—museums, the white-cube gallery, the apartment gallery, and now through the iPhone (back-pocket gallery). We view paintings slumped on the toilet or on the bus. Alone in our apartment or propped on a subway pole, our ways of seeing hyperpersonalized and dislocated. Walter Benjamin theorized that aura is a unique phenomenon of a distance between the artwork and the viewer—now the distance between a post and its liker. The Metropolitan Museum of Art @metmuseum has more than four million Instagram followers.

I just opened @metmuseum. The most recent post is a video montage of the MET's grand sun-filled rooms that hold ancient Egyptian, Roman, and Greek sculptures; long pans from above and below, quick edits. The soundtrack plays a clip of "Here Comes the Sun" on loop. The text below the video reads: This #SelfCareSunday don't forget that The Met is a great place to soak up vitamin D in the comfort of AC. Smiling sun-glasses face. Peace sign.

CREAP MANIFESTO

CREATIVE, ENTREPRENEURIAL, ACADEMICALLY TRAINED, PROFESSIONAL

2020 was a drag. Art fairs canceled. Galleries closed. The good news? America is somewhat vaxed, and collectors are collecting again; it's not dire. Don't take my word for it, consider "The Pandemic's Silver Lining for Artists": "Goodbye 50 percent gallery commission check. Hello meaningful, personal connections. Purchasing directly is way less pretentious, and more desirable for the buyer, a theme that arose during my business school research and in what I'm seeing with my current artist clients. These online, direct-to-customer sales are easier to facilitate now as the online tools—Instagram, TikTok, Shopify, and Canva, to name a few—have evolved to enable artists and creative entrepreneurs to succeed."[1]

The artist's key to success is the internet! Become a CREAP. A streamlined checklist is the new manifesto. Successful artist/creatives reject running from reality (see the French writer André Breton). They want to blend in.

Your Art—Option One. Don't be avant-garde (lol). Show skill, render things well, and gently push the boundaries of what is accepted as good art (sellable). If you are a painter, it is best

to paint landscapes and figures (cartoons behaving badly or behaving sexily), or triangles, squares, and/or lines (geometric abstraction). The relationship between figuration and abstraction is still of great interest. Read press releases to find out why.

Your Art—Option Two. If you're an MFA with little or no technical skill, then you must rely on theory: philosophical, sociological, queer, aesthetic, molecular. Spend as much time stiltedly writing about your art as you do making it. This option is equally as valid as option one. Above all, when making art, consider whether it will look good (sick) within the Insta-square (see Your Brand).

Your Means. No matter your socioeconomic background, represent yourself as someone who does not need money or employment. Poverty has no currency. It is a sign that you are unprofessional and makes you look like a drag. Poor people are not interesting or fun; in fact, they are to be avoided. Linoleum floors, black mold, and stained drop ceilings must never appear in your Instagram feed (see Your Brand).

Your Brand. You. Marketing your brand is paramount. Don't underestimate the opportunity social media provides. Instagram is your free public studio and can even be a gallery, too. Think of yourself as an organization, not an individual. If your career is failing, then you must change your business plan (you). Research other organizations and take note of the keys to their success. Steal from others. Adapt to trends. You will be followed.

Your Community. Every moment you are awake and able to hold your phone in your hand is a time to like. Like every post of every artist, gallery, and independent curator who lives and works in every art capital (New York, London, Berlin, etc.). Smash likes with your thumb until it bleeds.

ACKNOWLEDGMENTS

Thank you MacDowell Colony for the space and time to work on this book. Thank you Eric Schwartz, editorial director at Columbia University Press, for standing by this book, which isn't the book I proposed to write. Thank you Lowell Frye, Marielle Poss, Meredith Howard, and everyone behind the scenes at Columbia University Press who designed, produced, and promoted this book. Thank you Alisoun Meehan, Jenni Quilter, Garrett Devoe for your connections, coolness. Thank you Anne Bowler, for multiple readings, meticulous notes. Thank you Chelsea Hodson, for steering me to the I, and for the Abramović-ian accountability of Morning Writing Club. Thank you Sarah Perry, Diana Dube, Terry Lawson, Christine Gardiner, Cesur Kiliç, Linda Bastone, Lisa Jean Moore, C. Ray Bork, Megan Davidson, G. Ace Wang, Sandra Sun-Odeon, Alex Auder, Elizabeth Birdsall, and all the artists who collaborated with me. Thank you to my mother and father, who were nineteen and twenty-two, when it started. Thank you Andre, my co-combatant and pandrogyne. We are just getting started.

NOTES

AUTHOR STATEMENT

1. The preface is inspired by Chelsea Hodson, "Artist Statement," in *Tonight I'm Someone Else* (New York: Holt, 2018) and the writing constraint "I Could Live Without Speaking: After *Autoportrait* by Edouard Levé," published online at *Hazlitt*, in which Hodson uses at least one word from each of Levé's sentences, following the order and number of sentences (https://hazlitt.net/autoportrait).
2. Bonnie Wertheim, "Chris Kraus, Author of 'I Love Dick,' Returns to the Bronx," *New York Times*, May 11, 2017, https://www.nytimes.com/2017/05/11/style/chris-kraus-i-love-dick.html.

1. OTHER ART WORLDS

1. From a 2016 conversation at Orgy Park, a basement apartment gallery in Bushwick.
2. See Sharon Louden, *Living and Sustaining a Creative Life: Essays by 40 Working Artists* (Chicago: Intellect Books/University of Chicago Press, 2013); and Jackie Battenfield, *The Artist's Guide: How to Make a Living Doing What You Love* (New York: Da Capo, 2009).
3. Julia Cameron, *The Artist's Way: A Spiritual Path to Higher Creativity* (New York: Tarcher Perigee, 2016).
4. "Artist David Hockney Says the Drive to Create Pictures 'Is Deep Within Us,'" NPR, *Morning Edition*, October 13, 2016.

5. For a related discussion see the article by the feminist sociologist Patricia Hill Collins, "Learning from the Outsider Within: The Sociological Significance of Black Feminist Thought," *Social Problems* 33, no. 6 (1986): S14–S32, an analysis of how Black women have occupied an "outsider within" position in white society, working as maids, cooks, and nannies for white families, as well as within academia, where they've been subject to marginalization. Likewise, bell hooks examines the duality of her own Black female outsiderness in *Feminist Theory: From Margin to Center* (Boston: South End, 1984).
6. Victor Turner, "Liminality and Communitas," in *The Ritual Process: Structure and Anti-Structure* (Chicago: Aldine, 1969), 95.
7. I wrote this before it actually happened in June 2023, when smoke from Canadian wildfires veiled the city and the air turned a murky puce.
8. Dodie Bellamy, "Barf Manifesto," in *When the Sick Rule the World* (Los Angeles: Semiotext(e), 2015), 53.
9. I'm paraphrasing Kate Zambreno on the female mess and nineteenth-century Parisian muses: "Oh, the mess. The fucking mess. Maybe that's it. The untidiness of it all. The threat that spills out." See Zambreno, *Heroines* (Los Angeles: Semiotext(e), 2012), 73.
10. Patti Smith, *Just Kids* (New York: Harper Collins, 2010), 28.
11. Michelle Dean, "Eileen Myles: People Just Have to Blow It Up. That's What I've Done for Thirty Years," *The Guardian*, October 1, 2015.
12. According to Bob Nickas, the term *yesterbation* was coined by performance artist Kembra Pfhaler of the band The Voluptuous Horror of Karen Black. Pfhaler's rejection of nostalgia is like Viva's take on the Chelsea Hotel—neither will entertain it. See Bob Nickas, *Komplaint Dept.* (New York: Karma, 2018), 51.
13. I recall a birthday party at Ace Gallery: Phillip Glass was playing a grand piano and then an enormous metal door slowly opens and a prized stallion from Argentina—a gift from the president of Mexico—clip-clops in and everyone claps. Then an opera or Broadway star sang "Happy Birthday."

3. OVER

1. David Wojnarowicz, *Close to the Knives: A Memoir of Disintegration* (New York: Vintage, 1991), 124.

2. The entire conversation can be found online at Pen America, https://pen.org/multimedia/patti-smith-and-jonathan-lethem-in-conversation-2/, and also on youtube, https://www.youtube.com/watch?v=ocHL-VXYSgI&t=3s.
3. David Byrne, "David Byrne: Will Work for Inspiration," *Creative Time Reports*, October 7, 2013.
4. Another 1970s stalwart, Lower East Side documentarian, street photographer, and outlaw artist Clayton Patterson, became an expat in 2014, protesting the city had betrayed him and anyone who cares about art. Patterson's last exhibition was titled "The $16 Burger Show." After briefly living in Austria, he returned to New York and his infamous studio compound, the Clayton Gallery and Outlaw Art Museum on Essex Street, between Stanton and Houston Streets.
5. Michael Schnayerson, *Boom: Mad Money, Mega Dealers, and the Rise of Contemporary Art* (New York: PublicAffairs, 2019), 327.
6. Performed at the Public Theater, New York City, September 29, 2019.
7. According to activist and author Sarah Schulman, yes. In *The Gentrification of the Mind: Witness to a Lost Imagination* (Berkley: University of California Press, 2013), Schulman narrates, through memoir and cultural history, how New York's radical LGBTQ+ culture—artists, writers, and performers—were destroyed by AIDS, and subsequently, by the razing of all the downtown scenes they made. Individual apartments and project spaces were sanitized, rebuilt, and renovated for hetero, homogenous, and wealthy consumers—literally and conceptually. The process of AIDS and hyperdevelopment wiped away a generation that defined downtown life, made it progressively alive. The death of queer artists meant the erasure and gentrification of an ethos born of epidemic and abjection.
8. NYU Furman Center, "State of New York City's Housing and Neighborhoods in 2015," https://furmancenter.org/files/sotc/NYUFurmanCenter_SOCin2015_9JUNE2016.pdf.

4. WILL YOU LISTEN TO THE PROBLEMS OF A STRANGER?

1. Anika, a sculptor, said: "Maybe it's true. The fantasy that there are cities or countries that support artists more . . . places where you could do

your work, live cheap, and matter." It was true for Jackson who told me: "I've gotten gigs in Europe, Japan, and in Asia and realize there are a lot of subsidized places and a lot of happy artists around the world who get enough support and feedback. I realized decades ago you just get shit on in the United States." He added: "It's a capitalist system. The art world is like a magnification of the class system. So welcome to being under-appreciated in this society."

2. Gary Alan Fine, *Talking Art: The Culture of Practice and the Practice of Culture in MFA Education* (Chicago: University of Chicago Press, 2018), 189.
3. Linda Yablonsky, "Barbara Gladstone," *Wall Street Journal*, December 1, 2011.
4. Michael Kimmelman, "The Importance of Being Matthew Barney," *New York Times*, October 10, 1999.
5. For example, he was featured on the front cover of *Artforum* before his 1991 breakout show and was invited to the 1993 Whitney Biennial. By 2003, Barney was the youngest artist to ever have a solo show at the Guggenheim Museum.
6. Janelle Sara, "The Rubell Effect: How the Miami Couple Brought the Midas Touch to Generations of Young Artists," *Artnet*, December 3, 2019.
7. Carl Swanson, "Oscar Murillo Perfectly Encapsulates the Current State of the Contemporary Art World," *Vulture*, July 3, 2014.
8. Randy Kennedy, "For Joyce Pensato It's Not the Same Without the Ambient Muck," *New York Times*, December 15, 2016.
9. "10 of the Most Influential MFA Programs in the World," *Artspace*, April 24, 2014.
10. C. Clayton Childress and Alison Gerber, "The MFA in Creative Writing: The Uses of a 'Useless' Credential," *Professions and Professionalism* 5, no. 2 (2015), https://doi.org/10.7577/pp.868.
11. Ben Davis, "Is Getting an MFA Worth the Price? When You Crunch the Data on Where Successful Artists Went to School, the Pattern Is Striking," *Artnet*, August 30, 2016.
12. Alison Gerber, *The Work of Art: Value in Creative Careers* (Stanford, CA: Stanford University Press, 2017), 90–91.
13. Xenophanes still hopes to be a full-time professional artist. "If that day comes, I'll still want to live in isolation, but it will be somewhere closer

to New York City so I can visit more often. . . . I still think the context of New York is important for artists." He dreams of having a studio in the woods somewhere where he can paint and "grow his own food and shit like that and have a small studio in New York with a mattress on the floor."

5. HABITER

1. Henri Lefebvre, *Writings on Cities*, ed. Eleonore Kofman and Elizabeth Lebas (Oxford: Blackwell, 1996), 27.
2. Christopher Mele, *Selling the Lower East Side: Culture, Real Estate and Resistance in New York* (Minneapolis: University of Minnesota Press, 2000), 13.
3. Lucy Sante, *Kill All Your Darlings* (New York: Verse Chorus, 2007), 27.
4. For a vivid experiential account of the first months of the pandemic, during which the dominant classes left the city out of fear of contagion, and those who stayed reveled and protested in public space, creating a more vibrant and joyful commons, read Jeremiah Moss, *Feral City: On Finding Liberation in Lockdown* (New York: Norton, 2022).
5. D. T. Max, "Hanya Yanagihara's Audience of One," *New Yorker*, January 10, 2022.
6. Peter Berger and Thomas Luckman, *The Social Construction of Reality: A Treatise in the Sociology of Knowledge* (Garden City, NY: Anchor, 1966), 53.
7. Steffie Nelson, "Flowers for Didion: A California Transplant Says Goodbye to Her Idol on a Visit to New York," *Los Angeles Times*, December 24, 2021.

6. ART IN AMERICA

1. Vito Acconci, *Seedbed*, 1972, The Met, New York, https://www.metmuseum.org/art/collection/search/266876.
2. Paraphrasing a review by Jerry Saltz, "Vito de Milo," originally published in *The Village Voice*. Available online at *Artnet*, http://www.artnet.com/magazine/features/jsaltz/saltz4-28-04.asp.
3. *SUB BURB* was built in 1983.

4. Richard Huntington, "Looking Back at Artpark," *ArtSlant* (online magazine that shut down in 2021).
5. John Cage, *Silence: Lectures and Writings* (Middleton, CT: Wesleyan University Press, 2010), 39.
6. Irving Sandler, *A Sweeper-Up After Artists: A Memoir* (New York: Thames and Hudson, 2009), 10–11.

7. ARTISTS I KNEW

1. A version of this list, "The Artists I Knew," was first published in *Rejection Letters*, February 7, 2023, https://rejection-letters.com/2023/02/07/the-artists-i-knew-marin-kosut.

8. ARTISTNESS

1. Nathalie Heinich, "What Is Artification?," *Momento*, August 14, 2017.
2. According to www.verywellmind.com, highly sensitive people tend to feel deeply moved by the beauty they see around them. They may cry while watching particularly heartwarming videos and empathize with the feelings of others, both negative and positive.
3. Bradley Spinelli, "Mediocrity Is the New Black: Penny Arcade On Making It in 'The Big Cupcake,'" October 30, 2014, https://bedfordandbowery.com/2014/10/mediocrity-is-the-new-black-penny-arcade-on-making-it-in-the-big-cupcake/.
4. Artist Relief, "Submit," accessed January 16, 2024, https://artistrelief.submittable.com/submit.
5. Howard Becker, *Art Worlds* (Berkley: University of California Press, 1982).
6. Sinead O'Connor died on July 26, 2023. I spent a day reading the posts and tributes to her: How *influential* she was—a *singular, extraordinary, striking*, and *beautiful* voice. How she affected people. How she was right about the abuses of the Catholic Church, right to rip the photo of the Pope, *courageous*. But while she was *alive*, she remained canceled, ignored, laughed off as "crazy," and was mostly forgotten and invisible in middle age. I loved what Morrisey wrote, as I was thinking the same thing: "You praise her now ONLY because it is too late. You hadn't the guts to support her when she was alive and she was

looking for you." Morrisey Central, https://www.morrisseycentral.com/messagesfrommorrissey/you-know-i-couldn-t-last.
7. See Sharon Zukin, *Loft Living: Culture and Capital in Urban Change* (New Brunswick, NJ: Rutgers University Press, 1989), published more than thirty years ago, it recounts how SoHo transformed from an industrial neighborhood to an area of artist live–work spaces, and, finally, to a boutique destination neighborhood.
8. Susan Sontag, *On Photography* (New York: Farrar, Straus and Giroux, 1997).
9. William Deresiewicz, "The Death of the Artist—and the Birth of the Creative Entrepreneur," *The Atlantic*, January/February 2015.
10. Deresiewicz, "The Death of the Artist."

9. CUPCAKE CITY

1. The crowded and inhumane tenement buildings Jacob Riis documented in 1890, *How the Other Half Lives* (New York: Penguin, 2014), were part of a photojournalistic muckraking project. It was like the very first reality TV show, before TV existed.
2. Tyler Anbinder, *Five Points: The 19th-Century New York City Neighborhood That Invented Tap Dance, Stole Elections, and Became the World's Most Notorious Slum*, (New York: Penguin, 2001), 1–2.
3. Bob Nickas, *Komplaint Dept.: Collected Columns, 2012–2017* (New York: Karma, 2018), 193.
4. Kathy Acker, "New York City in 1979," in *Essential Acker: The Selected Writings of Kathy Acker*, ed. Amy Scholder and Dennis Cooper (New York: Grove, 2002), 134–35.
5. Jeremiah Moss, *Vanishing New York: How a Great City Lost Its Soul* (New York: Harper Collins, 2017), 75.
6. Bruce Kovner, "101 Signs That the City Isn't Dying," *New York* magazine, February, 7, 1972, 31.
7. Kovner, "101 Signs That the City Isn't Dying."
8. John Leland, "Laurie Anderson's Glorious Chaotic New York," *New York Times*, April 21, 2017.
9. Edward Helmore, "New York Mourns the Artists Lost to Covid-19—and Dares to Ponder Its Future," *The Guardian*, April 25, 2020.
10. Technically, New York City is tied with Singapore.

11. Farnam Street, "Is America a New Rome?" *Business Insider*, July 27, 2011.
12. According to the website MarketsandMarkets, https://www.marketsandmarkets.com.
13. Bradley Spinelli, "Mediocrity Is the New Black: Penny Arcade on Making It in the Big Cupcake," *Bedford + Bowery*, October 30, 2014.
14. Spinelli, "Mediocrity Is the New Black."
15. The sociologist Howard Becker's idea of the "integrated professional" fits here. Integrated professionals make work that adheres to aesthetic conventions, but slightly challenges them. The rules are broken, but not enough to render the work inaccessible to audiences. From Howard Becker, "Art Worlds and Social Types," *American Behavioral Scientist* 19, no. 6 (1976): 703–718.
16. Spectacles like Van Gogh are becoming the bread-and-butter of museum management. Building on earlier blockbuster exhibitions, these immersive exhibits are designed to amplify attendance records, bringing in revenue from not only ticket sales but also merch. For an article about the "Faustian bargain" museums made with corporate sponsors and government funding sources as part of the new neoliberal economic climate, see Victoria Alexander, "Heteronomy in the Arts Field: State Funding and British Arts Organizations," *British Journal of Sociology* 69 (2018): 23–43.
17. Ben Davis, "Why I Believe New York's Art Scene Is Doomed," *Artnet*, January 12, 2015.

10. POISON

1. At that time, Williamsburg was a predominately Puerto Rican neighborhood, with European immigrants to the north (Italians and Poles mainly), and Hasidim bordering the south edge. Each ethnic enclave defined its territory, and you could easily tell which block "belonged" to who. I used to take pictures of the Italian flags and Polish eagles. It was a working-class juxtaposition of cultures and ethnic enclaves not unlike other sections of the greater New York metro area.
2. Artists want to produce; they are less concerned with consuming. Liam said, "If there is a place to get strong coffee and a sandwich nearby my studio that's a bonus." He added, "Having a subway stop close by or relatively safe space to lock up my bike also ranks up there."

3. New York City has always been geographically sorted out by class and ethnicity. Urban policies, like redlining (a system of denial) or Bloomberg tax abatements for opulent waterfront high rises (recompense for new rich), caste urbanites into place. I remember when Mayor de Blasio removed unhoused people from a hotel on the Upper East Side. The problem of transients: I'm a semistable transient, a yearly renter.
4. Only a few full-time galleries with regular hours are left today. On the official NYC webpage for Williamsburg, the first sentence reads: "Though it's become more refined in recent years, Williamsburg still has a hipster vibe—as evidenced by indie music performances, gallery shows and shops run by local artisans." The rest of the website is a guide to restaurants, bars, and high-end clothing stores. The oldest gallery, Sideshow, ended in 2018 when the owner died at seventy-one.
5. Jeremiah Moss discusses why in relation to the development of waterfront and real estate investment in *Vanishing New York: How a Great City Lost Its Soul* (New York: Dey Street, 2017).
6. Feargus O'Sullivan, "The Pernicious Realities of 'Artwashing,'" *Bloomberg*, June 24, 2014.
7. The word was coined by the sociologist Ruth Glass in 1964, describing the displacements of working-class Londoners. The process of gentrification includes a complex configuration of structural factors, individual actors, and local and global forces that intersect to redefine a community. Gentrification reflects the idiosyncratic nature of diverse urban localities; it happens differently according to time and place.
8. Kathy Acker, "New York City in 1979," in *Essential Acker: The Selected Writings of Kathy Acker*, ed. Amy Scholder and Dennis Cooper (New York: Grove, 2002), 133.
9. John Berger, *Ways of Seeing: Based on the BBC Television Series* (New York: Penguin, 1972), 107.

11. NEIGHBORHOOD

1. Stephane Tonnelat and William Kornblum, *International Express: New Yorkers on the 7 Train* (New York: Columbia University Press, 2017), 22–23.
2. See also the cigarette cockroach and the taco squirrel.
3. "Gracie Mansion," *People*, December 23, 1985.

4. Top 25 Art Scenes, *New York* magazine, https://nymag.com/visitorsguide/sightseeing/artscenes.htm.
5. Jeremiah Moss, *Vanishing New York: How a Great City Lost Its Soul* (New York: Harper Collins, 2017), 15.
6. John Leland, "Laurie Anderson's Glorious, Chaotic New York," *New York Times*, April 21, 2017, https://www.nytimes.com/2017/04/21/nyregion/laurie-anderson-new-york.html.
7. Helena Fitzgerald, "Punk Poet Eileen Myles on Combating Trump, Capitalism With Art," *Rolling Stone*, September 11, 2017, https://www.rollingstone.com/culture/culture-features/punk-poet-eileen-myles-on-combating-trump-capitalism-with-art-202293/.
8. Eileen Myles, *For Now* (New Haven, CT: Yale University Press, 2020), 6.
9. Mary Gabriel, *Ninth Street Women: Lee Krasner, Elaine de Kooning, Grace Hartigan, Joan Mitchell, and Helen Frankenthaler: Five Painters and the Movement That Changed Modern Art* (New York: Little, Brown, 2019), 289.
10. Gabriel, *Ninth Street Women*, 289.
11. Gabriel, *Ninth Street Women*, 289.
12. Beverley's on the Lower East Side was/is a bar where artists exhibited work, got drunk, and danced. A modern day Cedar with DJs. It closed during the pandemic. Then it reopened. It might be open right now.

12. GOOD HOUSEKEEPING

1. Dee Dee Ramone, *Chelsea Horror Hotel* (Philadelphia, PA: Da Capo, 2001).
2. Sam Roberts, "Stanley Bard, Who Ran Chelsea Hotel as a Bohemian Sanctuary, Dies at 82," *New York Times*, February 14, 2017.
3. Nathanial Rich, "Where the Walls Still Talk," *Vanity Fair*, October 8, 2013.
4. Phone interview with Viva Hoffman, February 8, 2018. I was in a basement Bed-Stuy apartment, and she was at home in Palm Springs.
5. Penelope Green, "A Vintage Life in the Chelsea Hotel," *New York Times*, February 18, 2015.
6. Linda Nochlin, "From 1971: Why Have There Been No Great Women Artists?," *ARTnews*, January 1971.

7. *Living with Legends: Hotel Chelsea* (blog), http://www.chelseahotelblog.com.
8. In her memoir, Alexandra Auder, who grew up in the Chelsea Hotel, mentions fearing that her sister Gaby, a baby at the time, might get hurt by the stucco walls. Alexandra Auder, *Don't Call Me Home* (New York: Viking, 2023).
9. From the film, Tamra Davis, dir., *Jean-Michel Basquiat: The Radiant Child* (2010).
10. Patricia Bosworth, "Hyped to Death," *New York Times*, August 9, 1998.
11. Bohemian as noun as defined by Percy Buttisker, "Bohemian," Urban Dictionary, January 3, 2006, https://www.urbandictionary.com/define.php?term=Bohemian.
12. Dee Dee Ramone, *Chelsea Horror Hotel* (New York: Thunder's Mouth, 2001), 70.

13. HANDLING

1. I read that dark matter is theorized to make up at least 85 percent of the universe.
2. Gregory Sholette, *Dark Matter: Art and Politics in the Age of Enterprise Culture* (New York: Pluto, 2011), 1.
3. The art system relies on an expansive universe of hidden production and consumption, well beyond New York galleries. If students stopped applying for MFAs, if hobbyists stopped buying art supplies, and if painting and drawing classes (drink and draw) and ceramics studios closed, then chains like Blick and Hobby Lobby would be history, couches devoid of sentimental-saying pillows—*Good Vibes Only, Chill Here, Busy Doing Nothing*.
4. This includes self-organized, noninstitutional, informal, and unofficial artists, amateurs, credentialed artists, and everyone who creates parallel art worlds.
5. Scumming work reminds me of the recent phenomenon of *quiet quitting*: doing all the tasks of your job, getting it done, but nothing more. It's telling that so many people were doing more work than their jobs technically required—overworking the norm. Exploitation has been baked into the good-worker ethos, the notion that you are *lucky* to have a job. Fuck that.

6. The popularity of the Instagram account @arthandlermag started by artist/art handler Clynton Lowry illustrates a collective desire for artist/art workers to be acknowledged, to break the code, and to publicly appreciate their labor and the idiosyncrasies that come with the job. It's spot-on, hilarious, painfully honest.
7. The New York artists I know earn their primary income from dead-end low-paying jobs that offer no upward mobility, but they get paid more than most minimum-wage workers in New York City who earn, on average, thirteen to fifteen dollars per hour. They're floating on the same leaky barge with other college-educated workers who can't find stability, don't have health insurance, and likely will never pay the entirety of their student loans or own a home. It's a generational thing.
8. Colin Moynihan, "Workers at New Museum in Manhattan Vote to Unionize," *New York Times*, January 24, 2019.
9. I planned to edit the last clause "but they look like bums," but Andre circled it and wrote in the margins: "kinda really like this as is."
10. Chuck Close was #metoo'd, but what became of it? He's deceased and resting peacefully in the art historical canon.
11. In the art world, there's an unrealistic expectation surrounding employee time and labor—the norm that workers are on call 24/7 during installs, and the romanticized belief that people work in the arts for love rather than money.
12. Michelle Fisher, "Parenting and Labor in the Art World: A Call to Arms," *Hyperallergic*, May 6, 2019.
13. Colin Moynihan, "An Artist and MET Museum Guard Whose New Work Is About Pay: Her Own," *New York Times*, March 9, 2022.
14. Tommy Orange, "The Team," *New York Times* magazine, July 7, 2020.
15. Vittoria Benzine, "It Turns Out Jeff Koons, Pace, and Other Art-World Heavyweights Had Millions of Dollars in PPP Loans Forgiven by the Government," *Artnet*, August 22, 2022.
16. Ashleigh Kane, "Debunking the Biggest Myths Around Jeff Koons," *Dazed*, January 21, 2022.
17. Roger White, *The Contemporaries: Travels in the 21st Century Art World* (New York: Bloomsbury, 2015).

14. MELANCHOLIA

1. Jerry Saltz, "How to Be an Artist," *New York* magazine, November 26, 2019.
2. Ninety-nine percent of artists don't earn high incomes and are often assumed to be white and middle class, choosing to live in poverty for art. Choosing to avoid the yolk of the good job. Of course, even when artists don't have economic resources to fall back on, they likely have more social and cultural capital in comparison to those raised in redlined, communities of color.
3. Jerry Saltz, "My Life as a Failed Artist," *Vulture*, April 18, 2017.
4. In a *New Republic* interview with Jake Blumgart, Eileen Myles said, "I'm proud that I've never stopped writing about being poor. Just the sense that I was not supposed to say that made me want to say that. The poet John Wieners, from Boston, talked about how you had to write about what embarrassed you. Money always embarrasses us." See Eileen Myles, "I'm the Weird Poet the Mainstream Is Starting to Accept," interview by Jake Blumgart, *New Republic*, September 28, 2015.
5. Wealthy New Yorkers live in a class bubble with an opaque bottom. They can't look down, only up. In *Uneasy Street: The Anxieties of Affluence*, the sociologist Rachel Sherman describes Zoe whose yearly income and family wealth qualify her as a millionaire, who says, "New York is a bubble. Everyone that can afford to live here is pretty well off. So you don't see the downside.... You don't see the underprivileged.... It's sad, but it's kind of like the out-of-sight, out-of-mind thing, where you don't think about it in your—everyone's so busy that you don't think about it." Opacity of privilege. What are they busy with? What are they thinking about? See Rachel Sherman, *Uneasy Street: The Anxieties of Affluence* (Princeton, NJ: Princeton University Press, 2017), 35.
6. Nicholas Riley, "Man Literally Spends 24 Hours Finding Needle in Haystack and Succeeds (Because Art)," *Metro*, November 15, 2014.
7. Alex Greenberger, "Sven Sachsalber, Artist on the Verge of Fame, Dies at 33," *ARTnews*, December 15, 2020.
8. Nate Freeman, "Sven Sachsalber, an Inventive and Wily Italian Artist Who Was on the Rise in New York's Art Scene, Has Died at 33," *Artnet*, December 21, 2020.

9. Karol Jan Borowiecki, "The Origins of Creativity: The Case of the Arts in the United States Since 1850," *Trinity Economics Papers* (Trinity College Dublin, Department of Economics, 2019).
10. It happened on December 2, 2016.
11. "Looking Back on John Cage," *Ragazine*, March 2014.
12. Kyle Gann, "From No Such Thing as Silence," *New Music USA*, April 1, 2010.
13. Alec Hanley Bemis, "Zigs When Others Zag: On Alex Ross on John Cage on Poverty in the Arts," *SHC: Arcade, The Humanities in the World*, October 11, 2010.

15. YES

1. Brad Phillips, *Essays and Fictions* (New York: Tyrant, 2017), 117.

16. HIERARCHIES OF DISTANCE

1. Brian O'Doherty, "Inside the White Cube," *Artforum*, 1976.
2. Christopher Mele, "Is It Art? Eyeglasses on Museum Floor Began as Teenager's Prank," *New York Times*, May 30, 2016.
3. Carlo McCormick, "Gracie Mansion Gallery," *Artforum*, October 1999.

17. FISHING

1. Devon Caranicas, "Women on Their Way: Future Feminism at The Hole," *Sleek*, September 18, 2014.
2. Members of the collective included Anohni, Kembra Pfahler, CocoRosie, and Johanna Constantine.
3. Mira Schor, "The Feminist Wheel," *A Year of Positive Thinking* (blog), September 20, 2014, https://ayearofpositivethinking.com/2014/09/20/the-feminist-wheel/.
4. Schor, "The Feminist Wheel," 2014.
5. Anthony Davies, Stephan Dillemuth, and Jakob Jakobsen, "There Is No Alternative: THE FUTURE IS SELF-ORGANISED," *Colouring in Culture*, February 2012.
6. Alana Jelinek, *This Is Not Art: Activism and Other Not-Art* (New York: Tauris, 2012), 5.

7. Jan Verwoert, "All the Wrong Examples," in *Self Organized*, ed. Stine Hebert and Anne Karlson (London: Open Editions, 2013), 131.
8. For example, in response to the *open call* at O'Flaherty's, an artist-run gallery in the East Village for a show titled *The Patriot*, more than a thousand artists submitted and *all* were included. The gallery was packed salon/junk-sale-style, art covering the floor, ceiling, and bathroom (a highlight that was mentioned often: the Dan Colen toilet seat sculpture). No lights and almost total darkness, each visitor given a small flashlight. The artist-curator Jamian Juliano-Villani called it a *shit show* on social media. The police shut down the opening because the crowd (thousands of people, including the artists and their friends) spilled into the street and stopped traffic. The *New York Times* wrote two separate articles about how wonderful it all was—a nod to what the art scene used to be in the edgy authentic East Village, the one I talked about earlier. There was a sense of community created by the shared feeling that we were all getting fooled by the same person, and we liked it, because that is what we appointed Jamian Juliano-Vallani to do when we followed her. I was at *The Patriot* on opening night, and it was chaos, out of control. It felt like art won.
9. The expectation is that if a gallery gets some sales or reviews, then the next step is to apply to art fairs. The push toward the national and international art-fair circuit, meaning commercialization and legitimacy, is incredibly strong. I experienced this firsthand.

18. GROUP CLUB ASSOCIATION

1. Irving Sandler, *A Sweeper-Up After Artists: A Memoir* (New York: Thames and Hudson, 2009), 43.
2. In retrospect, I wish I hadn't been so friendly. The sociality of an opening never turns on the art or the artist per se; both are acknowledged, peripherally. It all depends where you fit within the scene or aspire to position yourself.
3. Well-attended openings are evidence of a success. Because it's not about selling art, success is measured in people. How many and who: artists with heat, commercial gallerists, respected writers. At Bible, our four-hundred-square-foot basement gallery underneath a bodega, the most famous attendees were Mathew Barney, Lucy Raven, Robert Gober,

Bob Nickas, and an artist represented by Gagosian or Gladstone, whose name I didn't recognize. I asked him if he was a filmmaker. He laughed in the direction of my face. After he split, I'm schooled *that's so and so*. I didn't genuflect. I spoke to the artist like he was just another person. It's funny. I can't remember his name.

4. At the book launch party to celebrate *Buzz*, the ethnography I coauthored with Lisa Jean Moore, one of the beekeepers rushed up to me. "My last name is misspelled in a chapter." And, "I'm surprised that there are no other beekeepers here." The misspelling was evidence of our failings as ethnographers to get it right. This, compounded with the absence of beekeepers at the launch, further proved that we got it all wrong. Informants were obviously avoiding or distancing themselves from us. See Lisa Jean Moore and Mary Kosut, *Buzz: Urban Beekeeping and the Power of the Bee* (New York: New York University Press, 2013).

5. Artists compete in a complex field with few resources and opportunities to exhibit work and professionalize. Tensions emerge as people resist power and domination in one field (by founding artist-run spaces or supporting them by showing up) and express complicity in another (jumping at the opportunity to show work at a corporate gallery). I have seen artist-run spaces that are friendly, convivial scenes. But once a commercial gallery picks up an artist or they start to show and sell their work through more conventional outlets, some don't look back. The beginning is deleted.

6. The GCA archive is online at GroupClubAssociation.com, Pay Faux can be found at Payfauxn.com, and Bible's website is Bedandabible.com.

7. Celine Condorelli, "Too Close to See: Notes on Friendship," in *Self-Organized*, ed. Stine Hebert and Anne Karlson (London: Open Editions, 2013), 63.

8. The French sociologist Pierre Bourdieu theorizes a cultural field is conditioned by both class relationships and legitimating ideologies that are created within a particular field. Artistic fields, in addition to any other realm of culture, are autonomous when they are relatively free from outside restraints (such as those presented by church or state) and are heteronomous when they are more susceptible to commercial fields. Artists I talked with are what the sociologist Anne Bowler calls

"organic Bourdieusians"—that is, they are keenly aware of position-taking within art worlds and they calculatedly attempt to increase their social capital. Some artists position themselves within online art worlds if they aren't moving forward in other art-world arenas. Other artists make their own galleries, becoming cur-artists. See Pierre Bourdieu, *Field of Cultural Production* (New York: Columbia University Press, 1994).

19. PAY FAUXN

1. The idea that creative cities attract creative people is so widely accepted it's like a mantra in urban development. Florida, as a paid consultant, has advised city officials on the *three T's* of economic development: *technology, talent, and tolerance,* framing the "creative class," as a target group for urban planners. This class includes a "super-creative core [of] people in science and engineering, architecture and design, education, arts, music, and entertainment." Their "job is to create new ideas, new technology and/or new creative content." These creatives, unlike most artists, are economically stable. See Richard Florida, *The Rise of the Creative Class* (New York: Basic Books, 2002), 8.
2. Lucy Sante, "My Lost City," *New York Review of Books*, November 6, 2003, https://www.nybooks.com/articles/2003/11/06/my-lost-city/.
3. Craigslist, August 2015.
4. Georg Simmel, "The Metropolis and Mental Life," in *The Sociology of Georg Simmel* (Glencoe, IL: Free Press, 1950), 414.
5. Eileen Myles, *Afterglow (a Dog Memoir)* (New York: Grove, 2017), 67.
6. I appreciate her acknowledging what it took to make Pay Fauxn happen. It felt good to be thanked, amid the thanklessness of New York.
7. In this context, Banksy territory is not art.

22. OBLIQUE ATTEMPTS (TOWARD A CONCLUSION)

1. From Brian Eno and Peter Schmidt's *Oblique Strategies* card deck, 1975.
2. Eno and Schmidt, *Oblique Strategies*.
3. Eno and Schmidt, *Oblique Strategies*.

POSTSCRIPT

1. Jenny Offill, *Dept. of Speculation* (New York: Knopf, 2014) 8.
2. Claire Dederer, *Monsters: A Fan's Dilemma* (New York: Knopf, 2023); and Lauren Elkin, *Art Monsters: Unruly Bodies in Feminist Art* (London: Chatto and Windus, 2023).

ON METHODS AND ENTANGLEMENTS

1. Chelsea Hodson, Morning Writing Club, Zoom Q&A December 13, 2022.
2. Nonhuman pollinators assist more than 80 percent of the world's flowering plants.
3. Kelsey Ables, "The Rise and Fall of Internet Art Communities," Artsey.net, April 19, 2019, https://www.artsy.net/article/artsy-editorial-rise-fall-internet-art-communities.

CREAP MANIFESTO

1. Justine Cohen, "The Pandemic's Silver Lining for Artists," *Hyperallergic*, July 19, 2021.

Printed and bound by CPI Group (UK) Ltd, Croydon, CR0 4YY
31/07/2025

14712033-0001